POSTER ART of the
DISNEY PARKS

Danny Handke and Vanessa Hunt
Introduction by Tony Baxter

EDITIONS

New York

For information address Disney Editions, 114 Fifth Avenue, New York, New York 10011-5690.
Editorial Director: Wendy Lefkon
Associate Editor: Jessica Ward

Written by: Danny Handke
Designed by: Vanessa Hunt
Cover design by: Glendon Lee

Artwork courtesy of the Walt Disney Imagineering Art Collection

This book's producers would like to thank Jennifer Eastwood, Nisha Panchal, Alfred Giuliani, and Warren Meislin.

ISBN 978-1-4231-2411-5

First Edition
10 9 8 7 6 5 4 3 2
Printed in Singapore
F850-6835-5-12278

The Official Disney Fan Club
Disney.com/D23

Table of Contents

Introduction

Before the advent of high-tech communication, Walt Disney knew the importance of both creating anticipation for, and extending the enjoyment of, a visit to his Magic Kingdom. To help achieve those goals, he engaged many divisions within The Walt Disney Company to aid in creating a bond between the emerging Park and the legions of existing Disney fans. The company's efforts to raise awareness about the Park began with the weekly ABC television show called *Disneyland*. That original Disney television series framed its opening sequence with graphic animation that both explained and mirrored the Park's physical layout. Children of the fifties were able to understand the magic of Fantasyland and the wonders of Tomorrowland a full year before they would actually get to go there!

In the years since, creative teams at Disney have introduced new ways of extending a visit to a Disney Park well beyond the magical time Guests spend within the gate. Today in a world where "social media" is becoming a way of life, the experiences found at a Disney Resort can be heightened with an ever-increasing array of electronic devices. Technology makes it possible to better plan an upcoming visit, and afterwards, extend the experience with digital memories that will eventually span a lifetime. In simpler times when Disneyland and Walt Disney World were created, tangible souvenirs served as triggers for the emotions experienced within the Magic Kingdom.

After a Park visit, most Guests took their memories home in the form of photos or a modestly priced souvenir pictorial of the Park. Walt knew that the feeling and stories sparked by the booklet would generate repeat visits far more valuable than any short-term revenue from its sale. Each visitor, in essence, became an emissary with a guidebook to introduce Disneyland to their friends. And the souvenir book also served to create an excitement for its owner's future visits. When the day finally arrived for one of those anticipated return trips, the family car would burst with excitement as kids spotted the first evidence of the Park. "There's the Matterhorn," "Sleeping Beauty Castle," or "the Rocket to the Moon!" These icons of Disneyland were more indelibly etched into the minds of mid-century American youth than any real world counterparts.

A massive marquee heralded the entry onto Disneyland property and its playful gothic letters spelling out DISNEYLAND became a meaningful symbol to even the youngest preschooler. The family car joined a train of other such cars and families heading across a vast stretch of asphalt. The slow crawl might have overwhelmed a child with a low tolerance for patience, were it not for the poster cabinets attached to the base of every monorail pylon. Spanning the entire lot was a line-up of colorful posters depicting all the attractions waiting to be explored: Peter Pan, The Matterhorn, Autopia, and The Jungle Cruise. The oversized images with eye-popping graphics appealed to young minds. Just seeing them from a distance as the car passed by, was enough to trigger kids' imaginations and make this final stretch to the main entrance actually . . . thrilling!

Today, when you enter Disneyland there is a good selection of these symbolic posters flanking the portals to the Magic Kingdom. What makes them still so appealing is the "fun and thrills" they project, sparking anticipation for what lies ahead. Back in a pre-1981 world of ticket books, the posters spoke of alluring temptations, each of which would require one of the Guest's precious few "A" through "E" tickets. The ticket book limited Guests to a sampling of only ten or fifteen adventures, but today these posters are reminders of limitless opportunities waiting to be explored as a day at Disney unfolds.

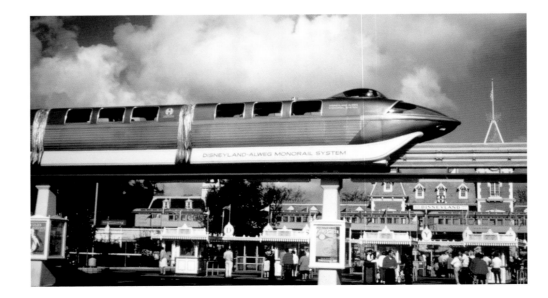

A great poster sells its story from a distance and needs to be glimpsed just briefly to work its magic. Great illustrations on the other hand, can accommodate much more detail and often tell complex stories within the imagery. Many of the reproductions presented in this book qualify as great illustrations, while others define the word "poster," and contain some of the most stunning graphic art images of their day. I leave it to the viewer to select those that, within the blink of an eye, capture the imagination—and have the potential to, do so from a considerable distance. . . . That, for me, is the essence of great poster design.

I once asked a longtime Imagineer why he never took pictures of his travels. He replied, "The best pictures are always those you store in your memory." Likewise, the Park posters are images that came from artistic expression, and represent the unique emotions of each adventure. Some of these images have stayed relevant for over fifty years by reawakening deep feelings people have for Disney classics. Taken all together, they serve up a banquet of images representing joyful moments we have all shared.

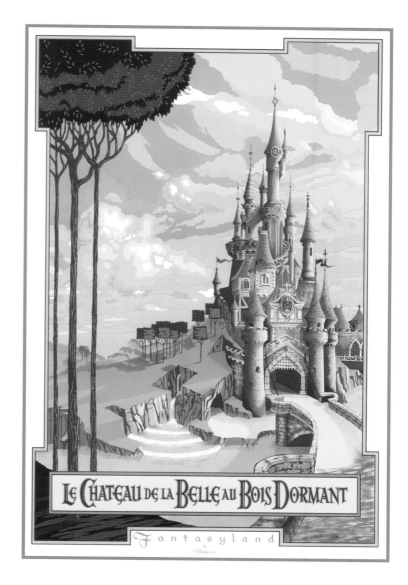

In the early nineties, Walt Disney Imagineering had the opportunity to revisit the art of attraction posters under an entirely new set of circumstances. The challenge was to create the most beautiful "Disney" Park ever, and build it in a rural valley east of Paris, France. In keeping with that mission, the accompanying poster program rose to the occasion. I am particularly proud of the poster art WDI created for Disneyland Paris, my favorite being that of the Park icon, "Le Château de la Belle au Bois Dormant." When you look at this poster you see a castle that is at once Disney, and at the same time reflects on French tradition. Paris is a city renowned for its artistry—which has a direct link to the most sublime examples of poster art at the dawn of the twentieth century. The major artistic influence of the era was known as the Belle Époque movement, which graphically influenced some of the world's most beautiful poster design. See what you think of our graphic reflections created against the context of this European tradition.

Like songs that play in your head long after a visit to a Disney Park, the iconic images you will find in this book have the ability to fill your mind with emotions. When I glance at the vintage poster of Monstro the whale swallowing up a Storybook Land canal boat, I'm ten years old again and anticipating what lies beyond that gaping jaw. When I see the image of the pirate galleon sailing the sky over London, for a brief moment I find myself caught up in a dream that requires no pixie dust for admission.

With this book Danny Handke and Vanessa Hunt have prepared a real feast for your eyes, the most comprehensive look at a very specialized format of Disney artistry. So, without further ado, here is *Poster Art of the Disney Parks*. Enjoy!

Tony Baxter
Walt Disney Imagineering senior vice president of Creative Development

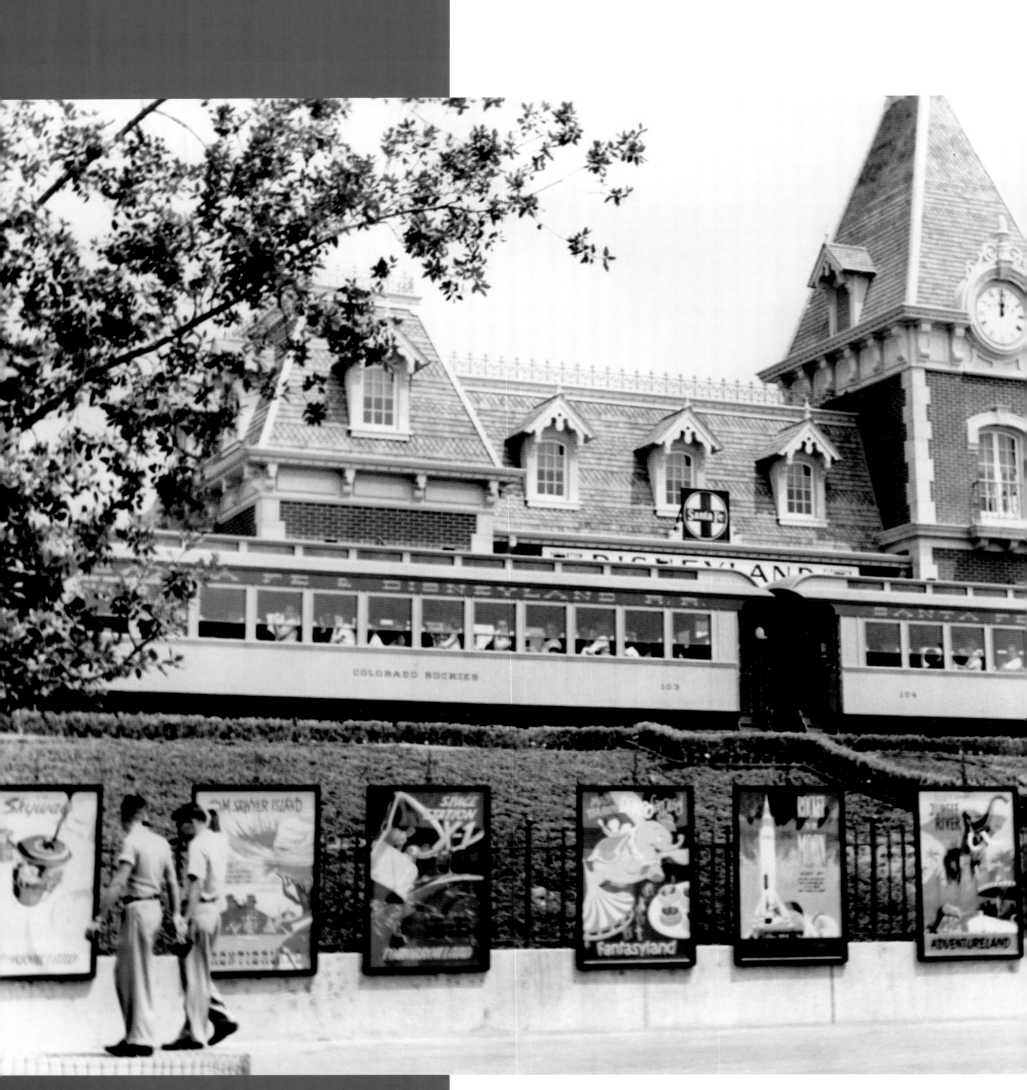

Walt Disney outside Main Street, U.S.A. Station in 1956.

Here you leave today...

"To all who come to this happy place: welcome. Disneyland is your land. Here age relives fond memories of the past . . . and here youth may savor the challenge and promise of the future. Disneyland is dedicated to the ideals, the dreams, and the hard facts that have created America . . . with the hope that it will be a source of joy and inspiration to all the world."

—Walt Disney

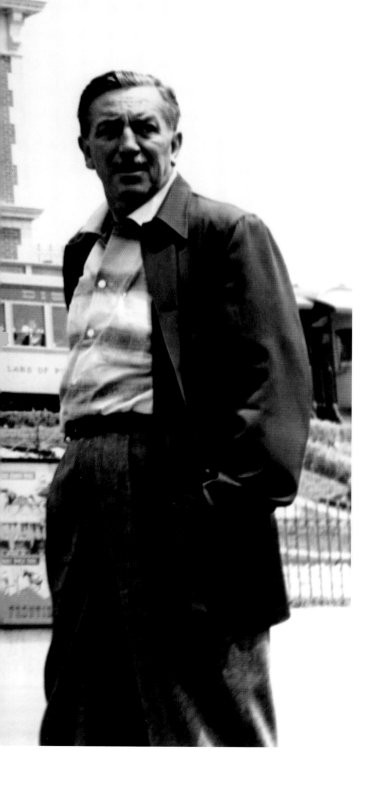

"Here you leave today and enter the world of yesterday, tomorrow, and fantasy." The date is July 17, 1955. A whole nation watches as Walt Disney reveals his dreams of a Magic Kingdom where parents and children can have fun together. What experiences await families inside this magical realm, this innovative theme park?

Although people quickly embraced the philosophy of Disneyland, it was difficult to understand what a theme park was. Walt's Imagineers, the designers responsible for the creation and construction of Disney Parks, soon needed to find a solution to portray their attractions to a vast and diverse audience.

It wasn't coincidental that the main entrance to Disneyland was created like a theater lobby. As a master storyteller, Walt created his vision of Disneyland like a dimensional motion picture. Guests assemble in this vestibule area and promptly travel through tunnels into the "first scene" of the movie: Main Street, U.S.A. It would only seem natural to have colorful posters in this lobby to entice, excite, and educate Guests with a preview of the adventures and experiences inside the Park. It was all part of the show. "A lot of the posters were colorful and beautiful to look at, gave people direction, and an understanding of what was in the Park. Often they were promoting something in the future. They were decorative first of all," says retired Walt Disney Imagineering creative executive Marty Sklar.

But why use posters instead of other advertising media? Posters speak to audiences on the move. They capture the viewer's attention and get the message across in a matter of seconds. Successful posters tell the story quickly, directly, and clearly. It's true that a picture is worth a thousand words, and the first Disneyland attraction posters were no exception. "Just in general there is something so wonderfully fabulous about posters, because in one image it captures the essence of what an attraction is about, it tells the story of the attraction, it's meant to excite you about the attraction, and tell you where the attraction is going to be," says former Walt Disney Imagineering executive designer Tim Delaney. "Like a lot of things at Disneyland, attraction posters are storytelling without saying words."

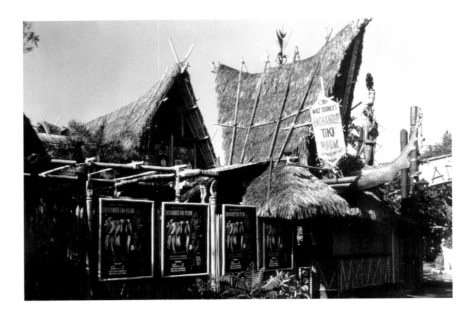

The Imagineers looked to several different poster styles for inspiration, including national park, military recruitment, magic show, WPA (Works Progress Administration), and World's Fair posters. The final result was heavily influenced by graphic artist Bjorn Aronson, who had experience designing travel posters before coming to WED Enterprises. (WED, the initials for Walter Elias Disney, was the name Walt originally coined for Walt Disney Imagineering in 1952.) Travel posters were large, silk-screened graphics displayed at train depots, bus stations, and airports that could be read quickly and easily in a fast-paced society. The style involved a well-balanced arrangement of flat colors with an emphasis on light and shadows. Aronson designed several of the original attraction posters in 1955 and 1956 with this approach. These posters were consistent in style and themed to their represented lands and time periods. The silk-screen printing technique helped make these large posters bright, colorful, and more importantly, attention grabbing.

Santa Fe & Disneyland Railroad, Jungle Cruise, Autopia, and Rocket to the Moon were among the first posters to grace the fence around the floral Mickey, the entrance tunnels beneath the railroad track, and throughout various traffic thoroughfares inside and outside the Park. "Walt didn't want Guests to rest for a minute," says Tony Baxter, a senior vice president of Creative Development at Walt Disney Imagineering. "Right in the middle of the Tomorrowland concourse would be posters for attractions in other lands. So when Guests exit Space Station X-1 or Rocket to the Moon, their children would look at the exciting posters and immediately want to go to Tom Sawyer Island or elsewhere in the Park."

Through the rest of the decade and well into the 1960s, the attraction poster gallery expanded, continuing the tradition but also taking the program in exciting new directions. Artists, including Paul Hartley and Rolly Crump, brought their unique styles and art techniques to the screen-printing process. The 1960s posters for Enchanted Tiki Room, "it's a small world," and the Haunted Mansion became iconic images and were later duplicated for use in other Disney theme parks.

In the 1950s and early 1960s, posters appeared throughout Disneyland as promotional tools to excite and educate Guests about the Park's attractions. Early posters also served as visual backgrounds to add color to vacant or neutral areas of the Park. Shown on this page are posters that were in front of the Disneyland Railroad station, on the construction fence in front of the Enchanted Tiki Room, lining the entryway to Tomorrowland, and adorning the walls inside the Penny Arcade on Main Street, U.S.A.

Attraction posters are commonly found near the entrance to a Disney Park, usually along the walkway tunnels underneath the Railroad station. Featured here are posters decorating the tunnel walls of Magic Kingdom in the Walt Disney World Resort. With tens of thousands of people walking through these tunnels daily, attraction posters are some of the most viewed posters in the world!

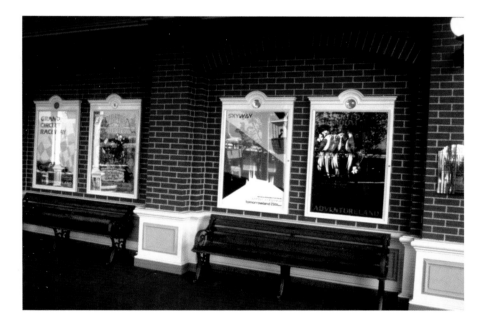

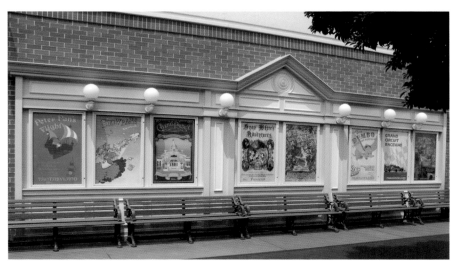

There is no Railroad station at the entrance to Tokyo Disneyland. Instead, the posters appear along the brick walls that line the entrance of World Bazaar, the Tokyo Disneyland version of Main Street, U.S.A., as shown above.

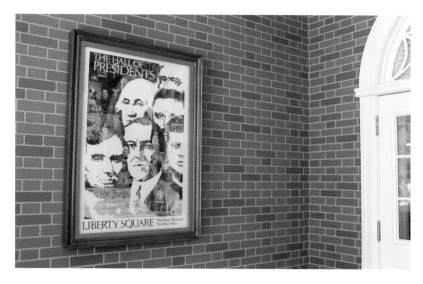

Because East Coast audiences were unfamiliar with the Disney Park experience, many of the first two decades' worth of Disneyland posters were repurposed as a helpful tool for the opening of the Walt Disney World Resort in Florida in 1971. The original art was slightly modified to better work with the Magic Kingdom aesthetic, although a handful of Walt Disney World exclusive attractions—such as Country Bear Jamboree, The Hall of Presidents, and The Mickey Mouse Revue—didn't have existing poster art and needed new designs. These new posters were designed to be more illustrative than their Disneyland brethren, and used a four-color lithography process instead of silk-screening to reduce costs.

In the mid-1970s, Imagineers Jim Michaelson, Rudy Lord, and Ernie Prinzhorn led a talented new group of poster and screen print artisans to create the second generation of attraction posters. Working in the newly formed screen print shop at WED Enterprises, the team developed new posters that updated the styles from the 1950s and 1960s. These award-winning posters were designed in what became known as the "window box" style and featured an attraction scene framed by an elaborate ornamental border and lettering. Unlike the limited color palette from the earlier posters, these versions used over forty colors to offer a highly detailed and interesting look.

The idea was also to create posters that, with a few minor modifications, could be utilized at both Disneyland and Walt Disney World. For example, the posters for the Railroad, Jungle Cruise, and Big Thunder Mountain Railroad had a space at the bottom where the Park logo could be placed for each of the different Parks. This practice stayed in place through the 1980s and was implemented for the opening day posters for Tokyo Disneyland in 1983. "It was very laborious and there were many people involved in making these posters happen," says Walt Disney Imagineering specialty design director Greg Paul. "These posters were a labor of love for many people."

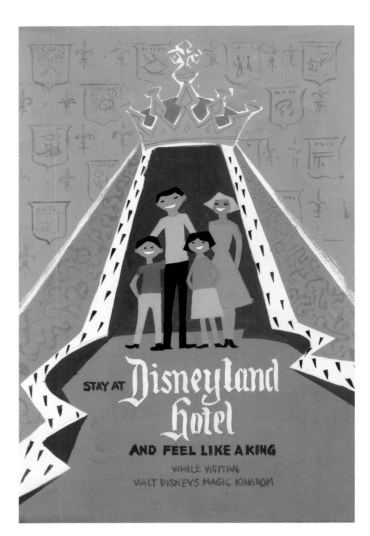

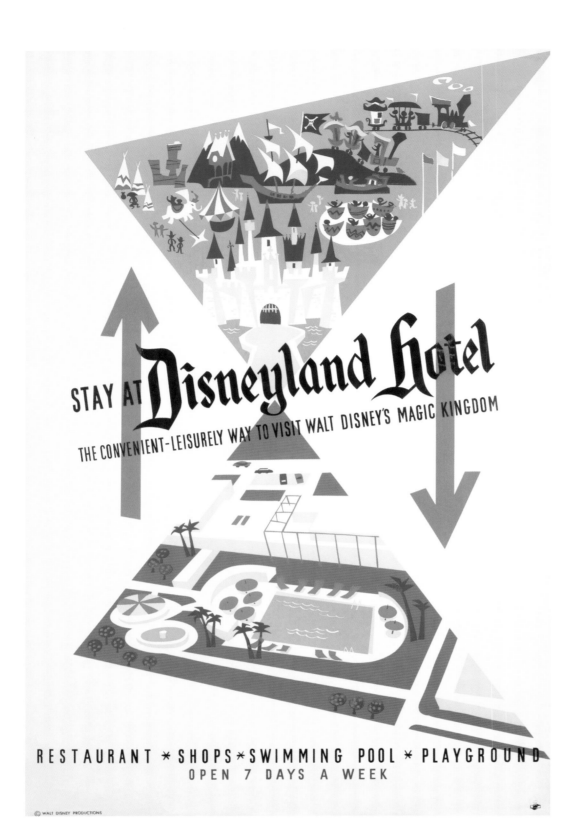

Disneyland Hotel, Disneyland Resort
Bjorn Aronson, 1956

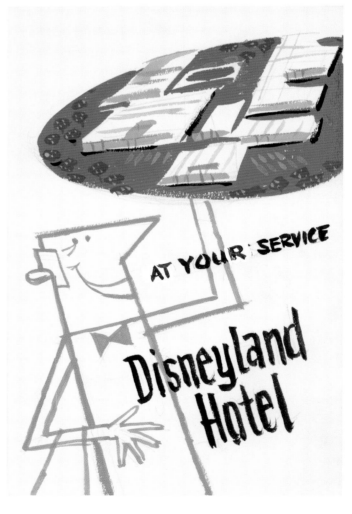

Disneyland Hotel poster concepts, Disneyland Resort
Bjorn Aronson, 1956

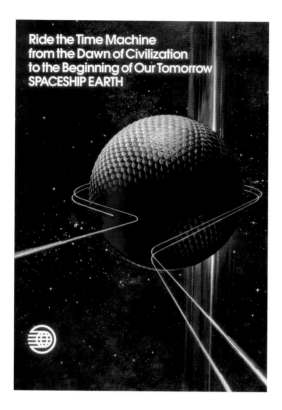

Spaceship Earth, Epcot
Norm Inouye, 1980

Horizons poster concept, Epcot
Gil Keppler, 1980

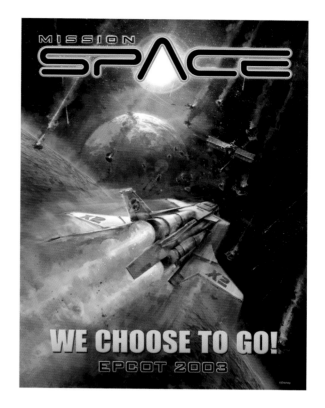

Mission: SPACE, Epcot
Greg Pro, 2003

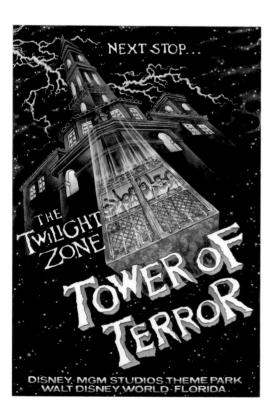

The Twilight Zone™ Tower of Terror poster concept
Disney's Hollywood Studios
David Durand, 1990

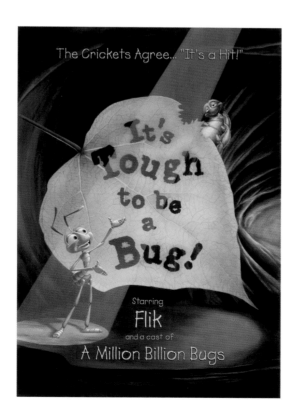

It's Tough to be a Bug! Disney's Animal Kingdom
Nicole Armitage, 1998

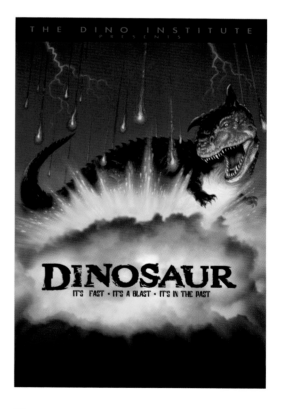

Dinosaur, Disney's Animal Kingdom
Unknown artist, 2000

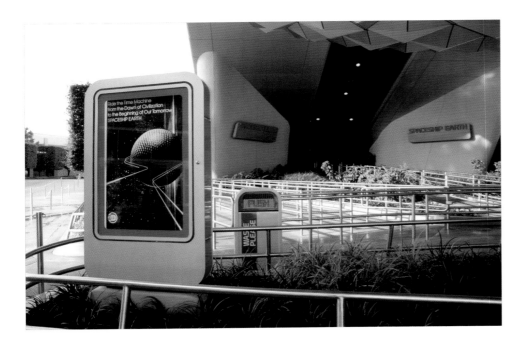

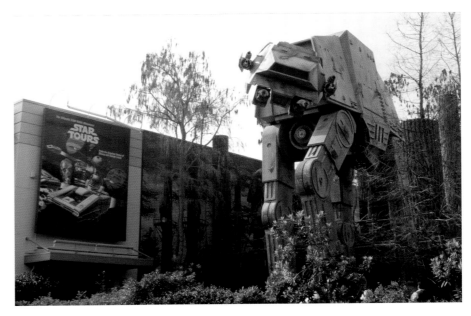

Attraction posters are uncommon in Disney Parks outside of the Magic Kingdoms. In some instances, posters appear in display cabinets outside their respective attractions, as featured here for Spaceship Earth in Epcot (above left) and Star Tours in Disney's Hollywood Studios (above).

In 1982 Epcot opened and represented a major departure from the Magic Kingdom-style Parks—not only in theme and design, but in the practical use and need of attraction posters. "There is less of a transportation departure-point feel to secondary Parks," says Mike Jusko, Walt Disney Imagineering principal art archivist. "The transportation theme is evident at the Magic Kingdom Parks because of the train station. Like advertisements or schedules at airports or subways, the attraction posters in the tunnels reflect the things you can do and places you can go. The entry sequence doesn't really play out this way in our other Parks."

The pinnacle of the attraction poster program came in 1992 with the opening of Euro Disneyland (now known as Disneyland Paris). For the first time since the original Disneyland posters, the Park program consisted of mostly brand-new and original content. Even existing posters, such as Peter Pan's Flight and "it's a small world," received new color treatments. New techniques were developed in the screen print shop to help create the most complicated designs (some with over 100 colors!) ever done at Walt Disney Imagineering. Although it was a labor of love, an Imagineering magnum opus, it was also an expensive undertaking.

"It could take a month or more to do a sixty-color poster. A poster like that could easily cost $30,000 just in labor," says Paul. With silk-screening becoming more and more costly in the late 1990s, a decision was made to shutter the screen print shop and abandon the attraction poster program. The only hope to revive this Park staple was new, cost-effective printing techniques—and luckily the digital age was just around the corner.

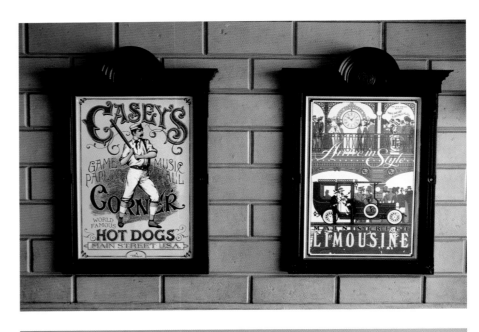

Disneyland Paris features an assortment of exclusive attraction posters not found in any other Disney Park. These visual masterpieces were some of the last newly developed attraction posters to be screen printed at Walt Disney Imagineering.

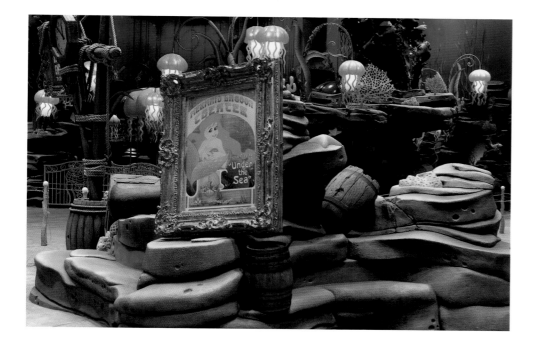

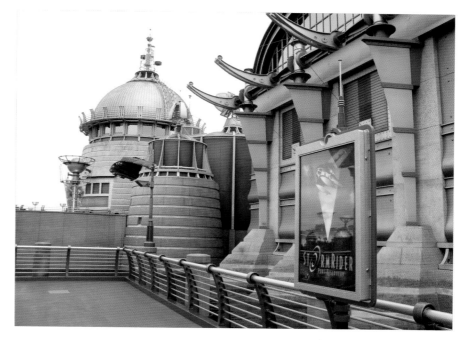

Posters are useful instruments when it comes to informing audiences. For example, the posters in Tokyo DisneySea (above left and right) and Hong Kong Disneyland (below) are designed to familiarize international Guests with Disney attractions and shows.

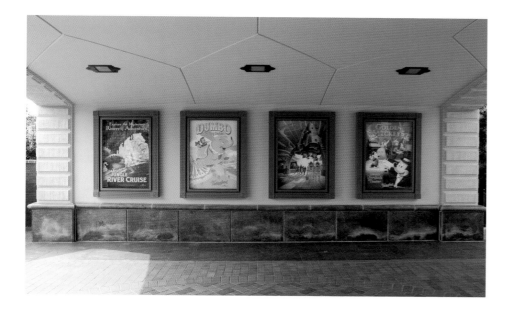

In 2001, the Imagineers opened Tokyo DisneySea at the Tokyo Disney Resort with a poster program meant to familiarize and excite Guests with the Park's unique attractions. After much trial and error, the digital art and printing process became the ideal successor to screen printing. Complex, visually stimulating designs could finally be created and printed without the complications of screening multiple colors. Even classic silk-screen posters could be easily scanned, digitally cleaned up, and reprinted. In 2005, Hong Kong Disneyland referred to the past for its digital posters. Traditional Disneyland designs were redrawn on the computer to capture the original look and feel of attraction posters but revised appropriately for a new Chinese audience. Digital printing opened a new world of design possibilities—and revived the poster program.

Today, attraction posters are viewed as a Disney staple and have greatly influenced graphic designers and art enthusiasts from around the world. They have made such an impact that attraction poster-themed merchandise, from pins and souvenirs to lithographs and T-shirts, is highly coveted by collectors and Disney fans. Even the artists from Pixar Animation Studios have referred to the original 1950s and 1960s screen prints as inspiration for modern movie promotional posters and merchandise. And attraction posters haven't only been sighted in print— classic posters appeared as a hidden tribute in various children's bedrooms and Monstropolis businesses in the Disney·Pixar film *Monsters, Inc.* As long as there's imagination left in the world, the influence and legacy of attraction posters will live on!

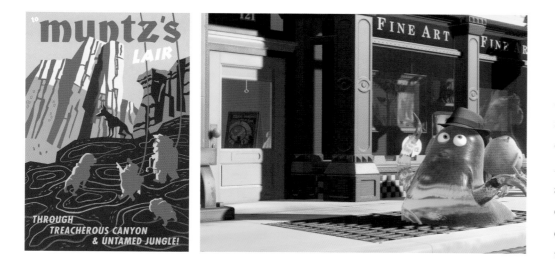

Attraction posters inspire artists and fans all over the world. Pixar artist Paul Conrad created a faux attraction poster for Muntz's Lair in the Disney·Pixar film *Up* (above left). Attraction posters appear as hidden tributes throughout the Disney·Pixar film *Monsters, Inc.*, such as the 20,000 Leagues Under the Sea poster in the Monstropolis scene (above right).

The Imagineering Guide to Screen Printing

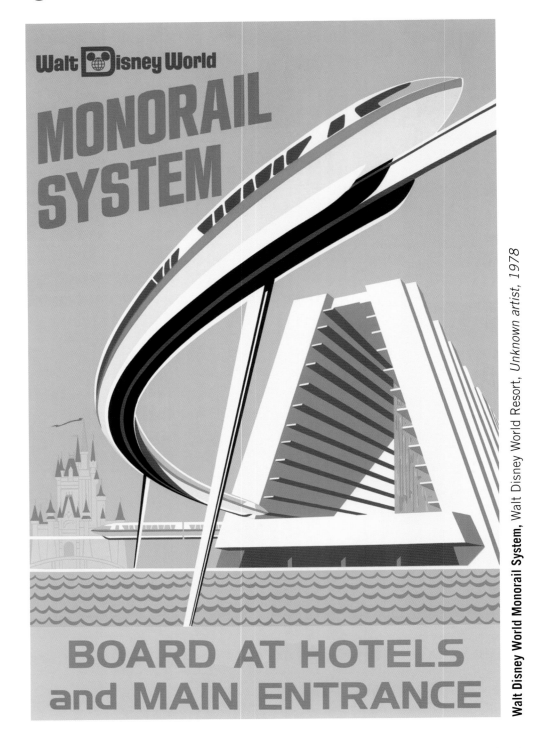

Walt Disney World Monorail System, Walt Disney World Resort, *Unknown artist, 1978*

Screen printing, or silk-screening, is a printing process commonly used for reproducing designs on a variety of materials. Before the dawn of the digital printer, the screen printing process had many advantages over other printing methods. Chief among these advantages were: the ability to make larger prints, the option to print on substrates of various thicknesses and properties, the flexibility to use virtually unlimited colors, and the convenience of producing the design in a reliable and repeatable manner.

The screen printing process involves the application of paints or inks pressed with a squeegee through a stretched fine-mesh screen. By masking portions of the screen, paint can be controlled and applied to the desired areas. Various masking methods achieve an array of styles and effects. The simplest method is the paper stencil, in which a cut paper template is applied to the underside of a screen. A more common and

sophisticated masking method uses a light-sensitive liquid emulsion to fill the pores in the screen. This technique allows for precision details and larger production runs due to the emulsion's durability.

Generally, one screen is used for each color of a design. Full multicolored prints can be achieved by layering multiple color passes together. Careful registration of each screen to the overall design ensures that all the layers will align and appear as a single cohesive print.

The Disneyland posters were originally screened at an impressive 36-by-54-inch size, while Walt Disney World, Tokyo Disneyland, and Disneyland Paris pieces were created at the more economical 30-by-45-inch poster size. Shown here is the eight-color Walt Disney World Monorail System attraction poster in every stage of the screen printing process.

Color 1: Sky Blue

Color 2: Sea Foam Green

Color 3: Orange

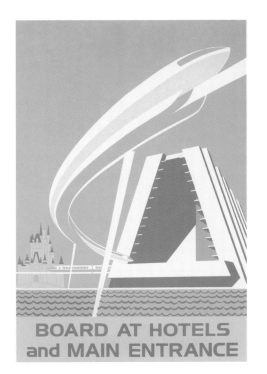

Color 4: Royal Blue

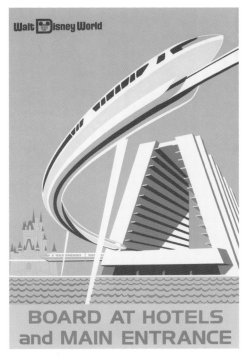

Color 5: Navy Blue

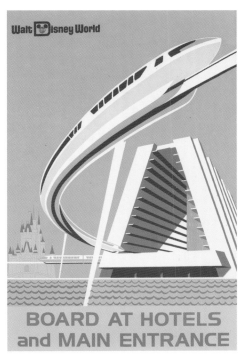

Color 6: Yellow

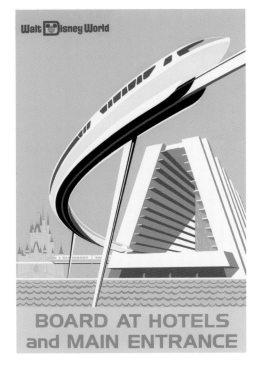

Color 7: Black

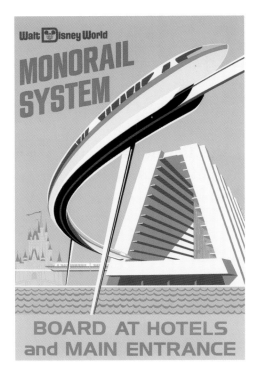

Color 8: Red

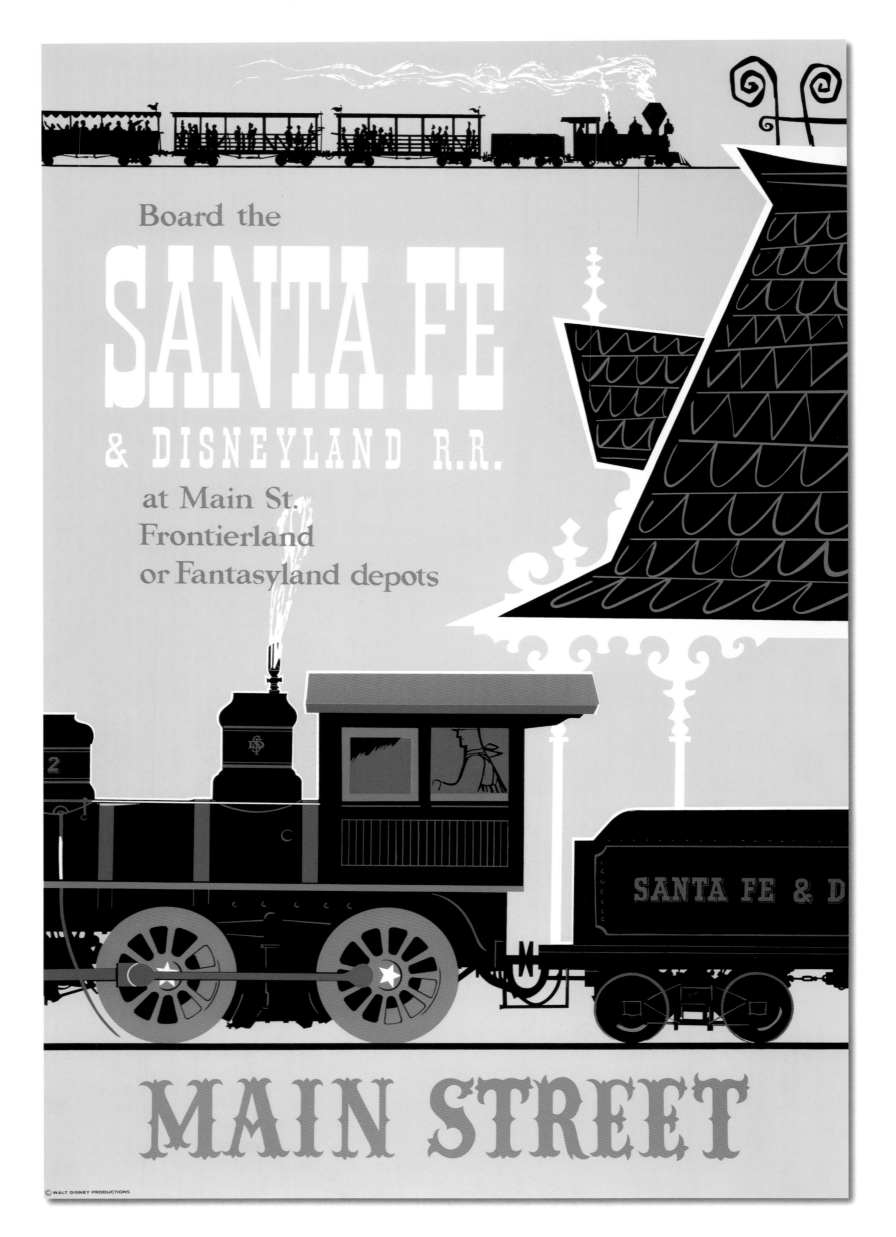

Board the

SANTA FE

& DISNEYLAND R.R.

at Main St.
Frontierland
or Fantasyland depots

MAIN STREET

Santa Fe & Disneyland Railroad, *Disneyland and Walt Disney World, Bjorn Aronson, 1955*

MAIN STREET, U.S.A.

"Main Street, U.S.A. is America at the turn of the century—the crossroads of an era. The gas lamps and the electric lamp—the horse-drawn car and auto car. Main Street is everyone's hometown—the heart line of America."

— Walt Disney

Our grand-circle tour of the Disney Parks begins with the Main Street, U.S.A attraction posters. These posters take viewers on a patriotic trip back to a simpler time adored by Walt Disney. In fact, the land itself is based on Walt's affection for his childhood hometown of Marceline, Missouri. In this fashion the Main Street posters are simple, charming, and appropriate for the turn-of-the-twentieth-century aesthetic.

As the quintessential Main Street attraction, the Disney Railroads have carried delighted passengers in Magic Kingdom Parks all over the world since the first trip of the Santa Fe & Disneyland Railroad in 1955. While Bjorn Aronson's original Santa Fe poster for Disneyland captures the stylistic nature of the 1950s period with its combination of vibrant colors, Jim Michaelson's rich 1976 Disneyland Railroad "window box" poster has become a fixture in the attraction poster gallery—and as such, it has inspired nearly identical variations for the other Magic Kingdom Parks.

Another classic Disneyland attraction, the Main Street Opera House, has had different posters through the years to correspond with its latest shows. Taking a cue from opera house playbills that rely heavily on text rather than graphics, the earliest posters for Great Moments with Mr. Lincoln are far more formal and simple than the other attraction posters from the 1960s. They were also the first to feature photography rather than artwork for the background. The latest incarnation of Great Moments with Mr. Lincoln is a tribute to the original 1964 show at the New York World's Fair, combining new advances in Audio-Animatronics technology with the original voice recordings of Royal Dano as Abraham Lincoln and Paul Frees as the narrator. Even the poster is a throwback to the original show—the acrylic art featured in the poster is from the cover art of a 1964 Great Moments with Mr. Lincoln LP created by award-winning illustrator Neil Boyle.

For the opening of Disneyland Paris, the poster designers emulated the style of the turn-of-the-twentieth-century American artists. "Part of the story of Main Street is that we wanted it to be distinctly American," says Eddie Sotto, show producer of Main Street, U.S.A. in Disneyland Paris. "We wanted the attraction posters in this land to be richer in story—to use them as actual décor." The Disneyland Paris team researched popular American illustrators and artwork from the period for inspiration. Charles Dana Gibson's iconic illustrations of women greatly influenced the poster for the Gibson Girl Ice Cream Parlour; American poster designer Edward Penfield's work resonates in the poster for the Main Street Limousine; and the renowned Spalding's Official Base Ball Guide provided fodder for the Casey's Corner poster.

A similar approach was taken by the Imagineers in creating the posters for Main Street in Hong Kong Disneyland. One example is the Animation Academy poster, featuring Mickey Mouse in a pose influenced by the famed Uncle Sam recruitment posters by James Montgomery Flagg. Illustrator Nicole Armitage, who collaborated with her stepmother, Karen Armitage, on the Hong Kong Disneyland Plaza Inn poster, concludes, "I now own a library of books on women's wear from the 1890s to the 1920s. When it comes to this time period, it seems we're always pulling the Gibson Girl for reference!"

Tokyo Disneyland's World Bazaar serves the same purpose of, and shares the same theme with, the other Magic Kingdom Parks' Main Streets but with a different name. The original 1983 World Bazaar poster by Rudy Lord and Greg Paul was updated in 2002 to replace Towne Clothiers with the Grand Emporium. The magnificent glass arcade that covers World Bazaar is prominently featured in both versions. When he modified the poster art, Walt Disney Imagineering senior principal graphics designer Will Eyerman added a hidden Mickey Mouse using the Grand Emporium exterior to frame the face and the arcade to represent the ears.

From steam trains to newfangled automobiles, from Disneyland to Magic Kingdom Parks internationally, the Main Street posters continue today to be authentic tributes to Walt's ideal small town, U.S.A.

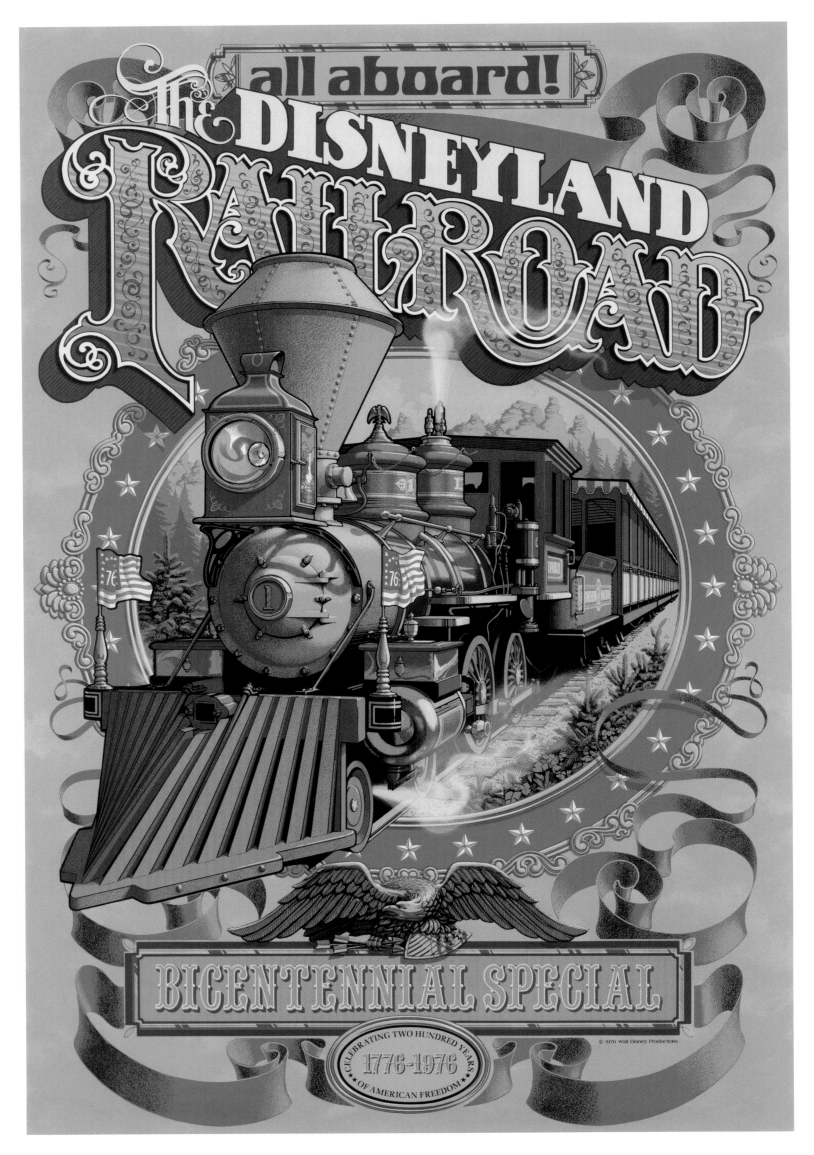

Disneyland Railroad Bicentennial Special, Disneyland, *Jim Michaelson, Ernie Prinzhorn, and Rudy Lord, 1976*

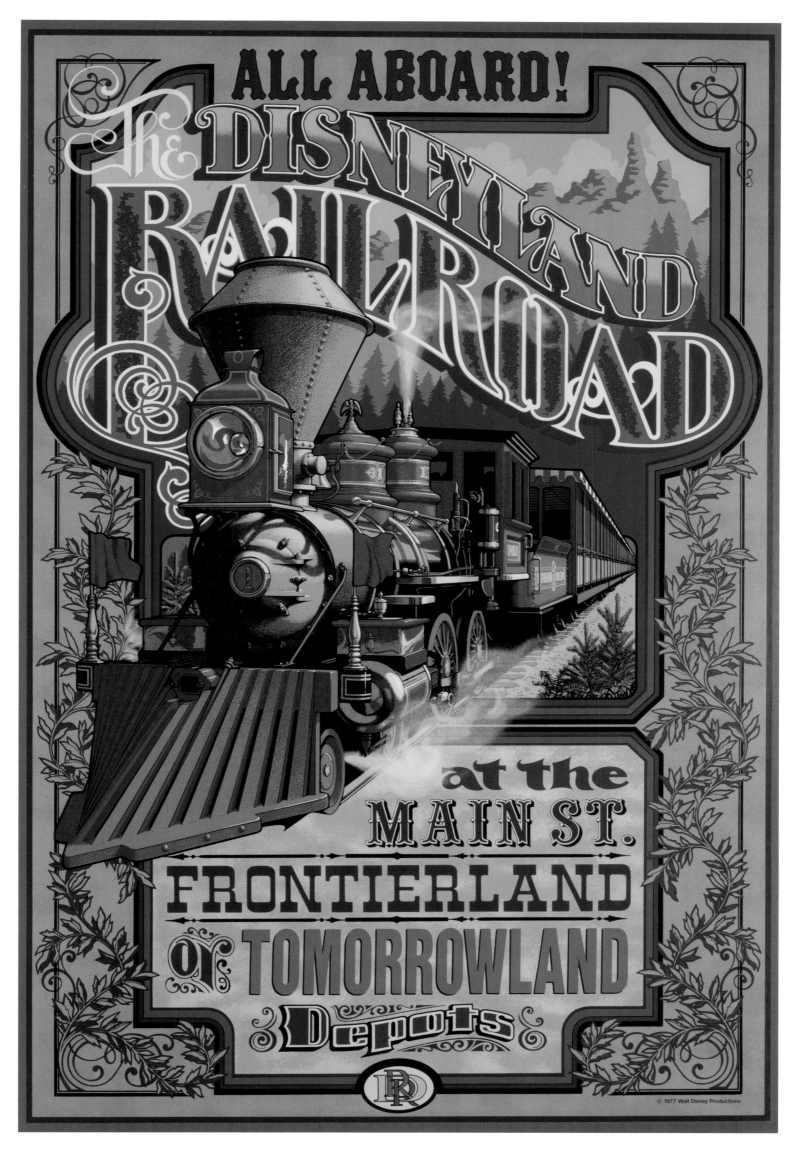

Disneyland Railroad, Disneyland, *Jim Michaelson, Ernie Prinzhorn, and Rudy Lord, 1977*

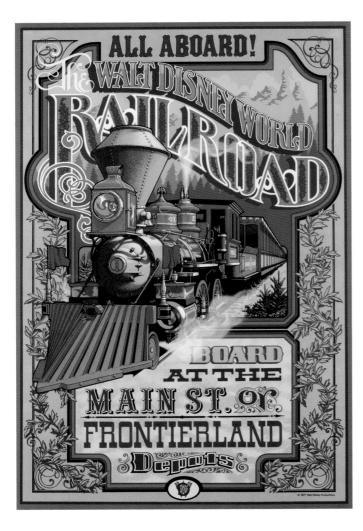

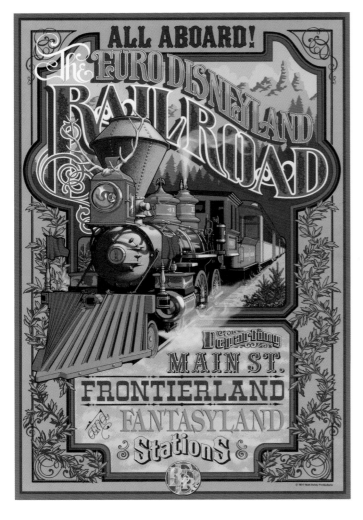

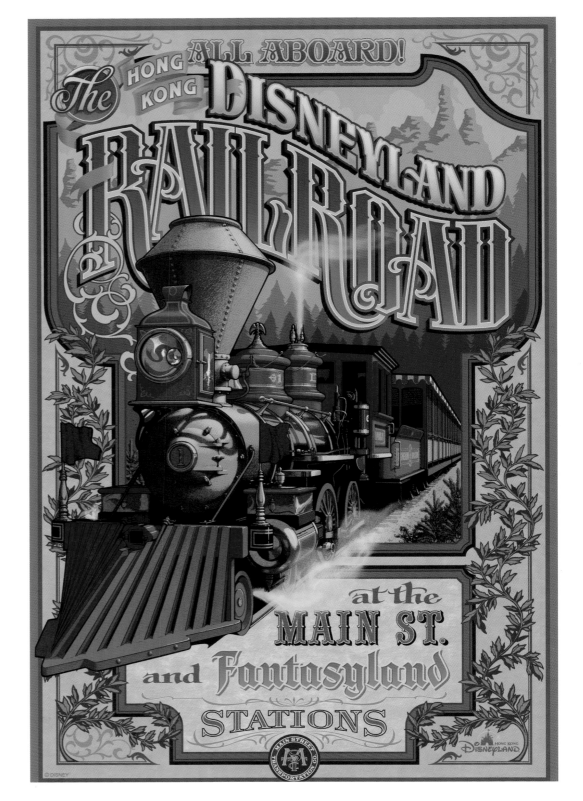

Hong Kong Disneyland Railroad, Hong Kong Disneyland
Adapted by Wayne Clark, 2005

Top: **Walt Disney World Railroad,** Walt Disney World
Jim Michaelson, Ernie Prinzhorn, and Rudy Lord, 1977

Euro Disneyland Railroad, Disneyland Paris
Jim Michaelson, Ernie Prinzhorn, and Rudy Lord, 1991

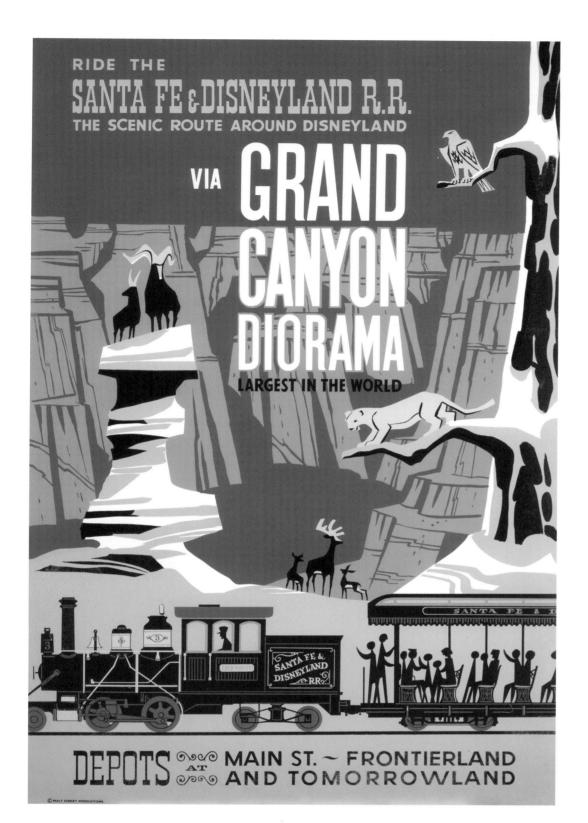

Grand Canyon Diorama, Disneyland
Paul Hartley, 1958

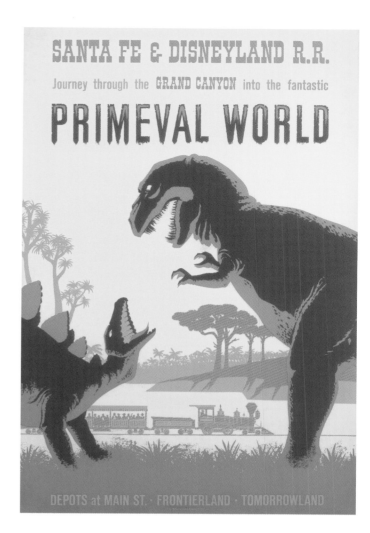

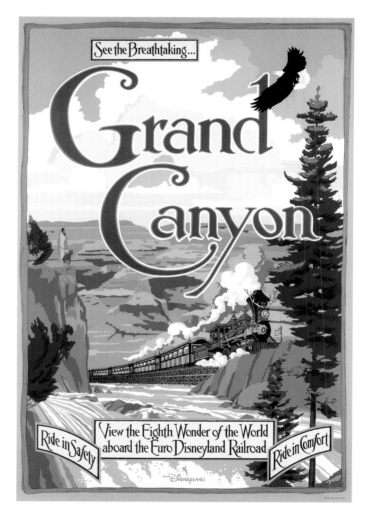

Top: Primeval World, Disneyland
Claude Coats, 1966

Grand Canyon Diorama, Disneyland Paris
Eddie Sotto, Peter Polombi, and Tom Yorke, 1991

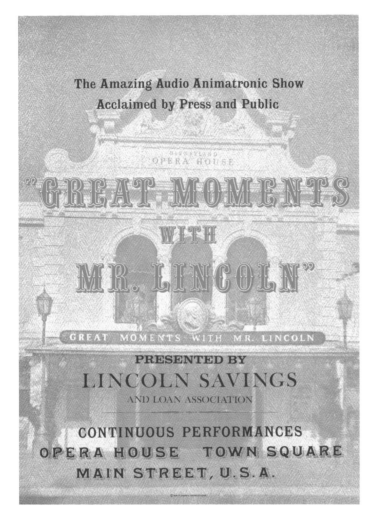

Great Moments with Mr. Lincoln, Disneyland
Unknown artist, 1965

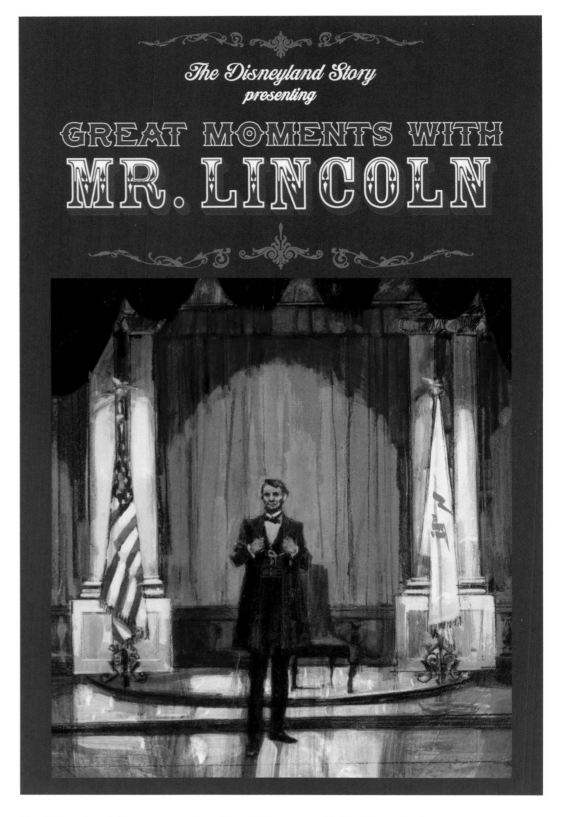

The Disneyland Story presenting Great Moments with Mr. Lincoln, Disneyland
Neil Boyle, 1964; adapted by Warren Wilson, 2009

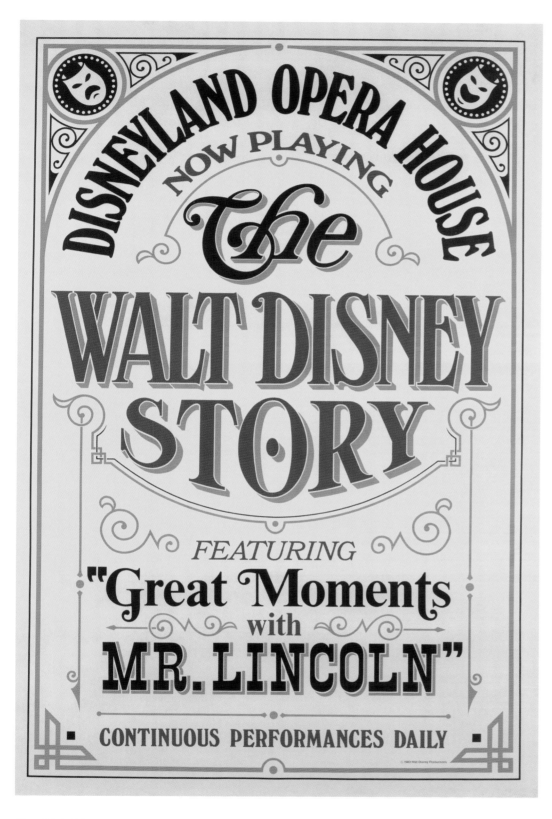

The Walt Disney Story featuring Great Moments with Mr. Lincoln, Disneyland
Bob McDonnell, 1983

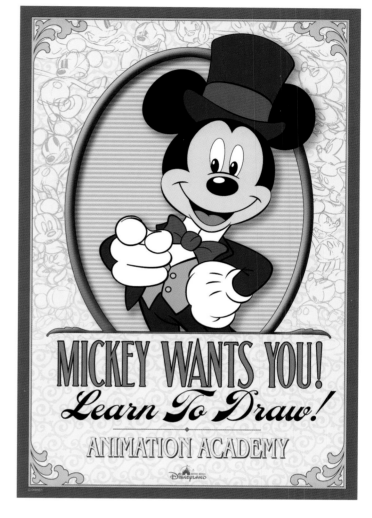

Animation Academy, Hong Kong Disneyland
Louis Lemoine, 2007

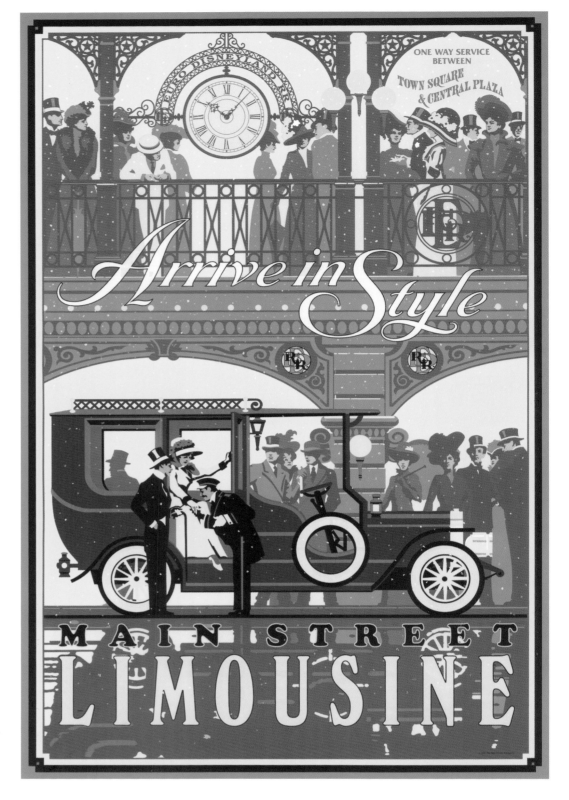

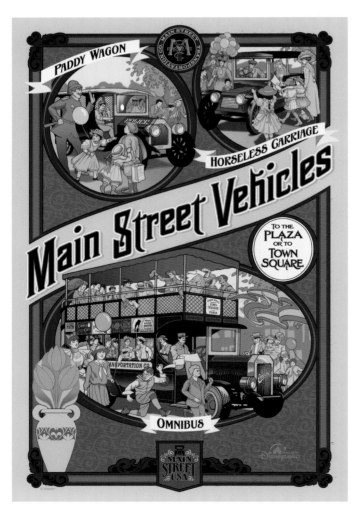

Main Street Limousine, Disneyland Paris
John Hull, Eddie Sotto, and Louis Lemoine, 1992

Top: Main Street Limousine poster concept, Disneyland Paris
John Hull, 1992

Main Street Vehicles, Hong Kong Disneyland
Unknown artist and Louis Lemoine, 2005

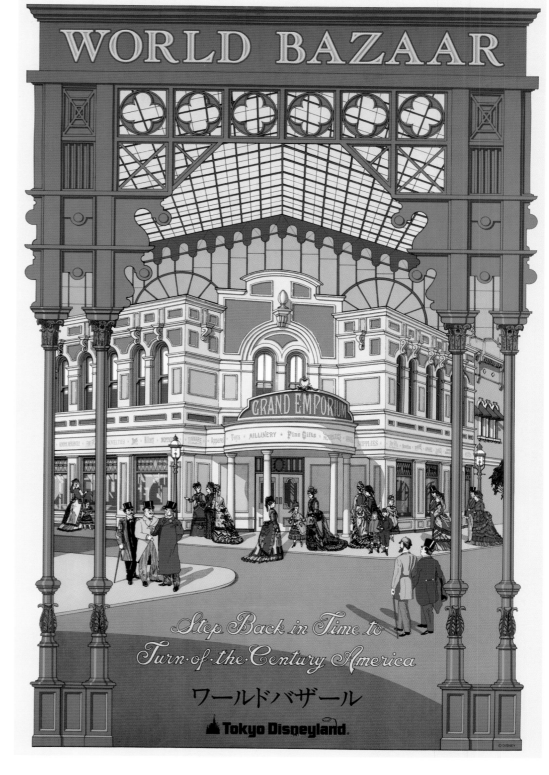

World Bazaar, Tokyo Disneyland
Rudy Lord and Greg Paul, 1983; adapted by Will Eyerman, 2002

World Bazaar poster concepts, Tokyo Disneyland
Herb Ryman, 1983

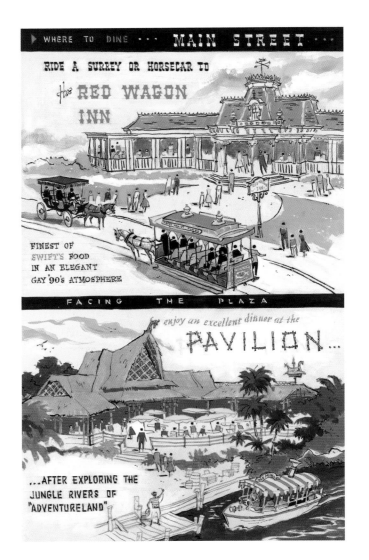

Red Wagon Inn and Pavilion poster concept, Disneyland
Sam McKim, 1955

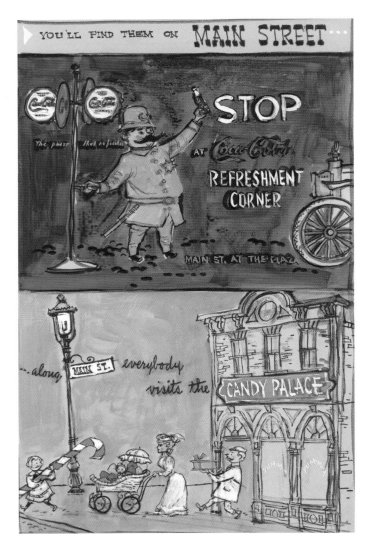

Refreshment Corner and Candy Palace poster concept, Disneyland
Sam McKim, 1955

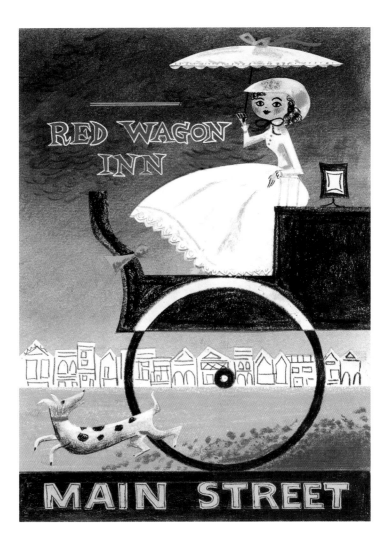

Red Wagon Inn poster concept, Disneyland
Unknown artist, 1953

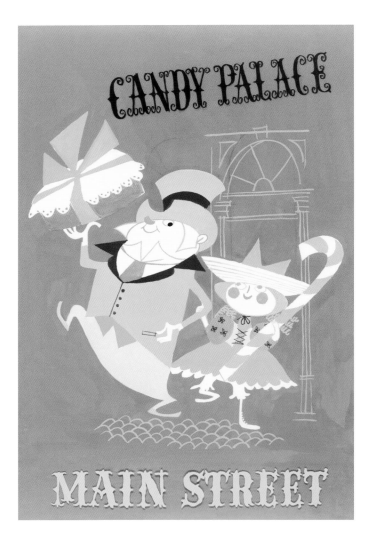

Candy Palace poster concept, Disneyland
Bjorn Aronson, 1953

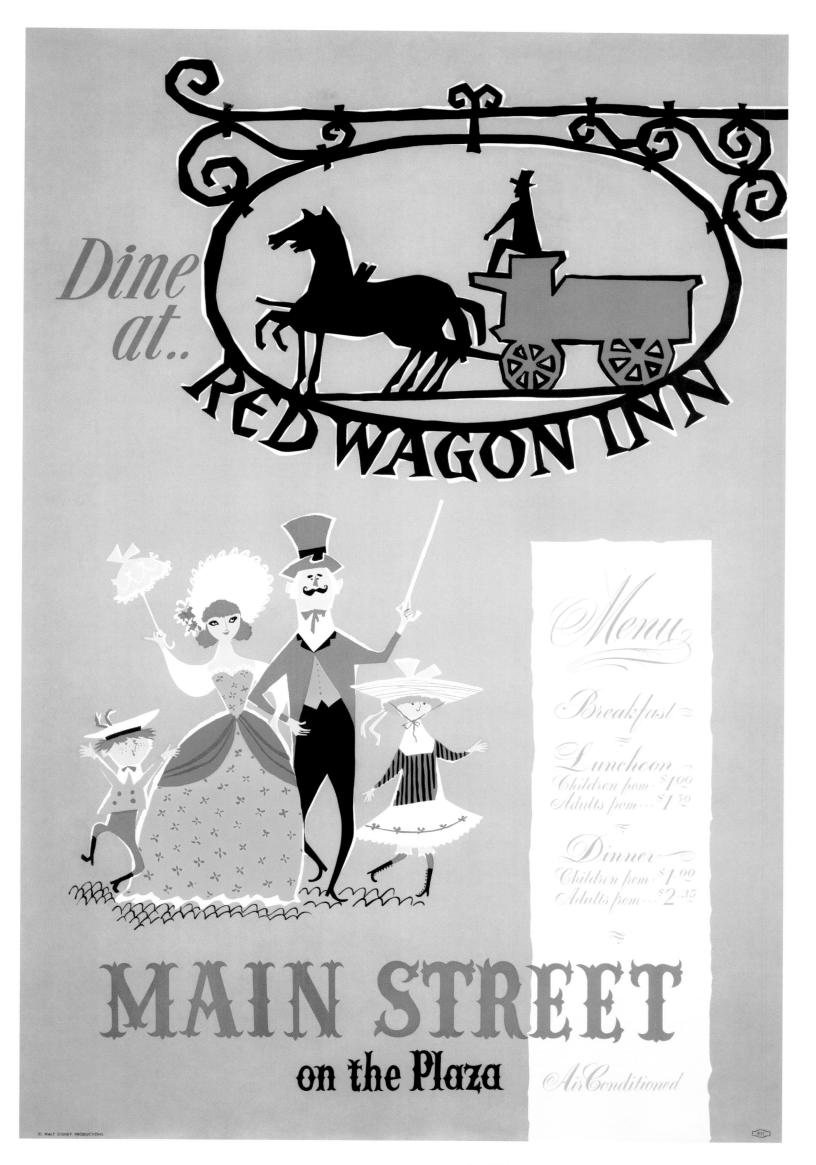

Red Wagon Inn, Disneyland, *Bjorn Aronson, 1955*

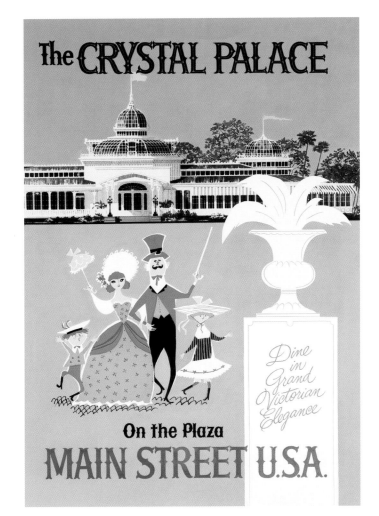

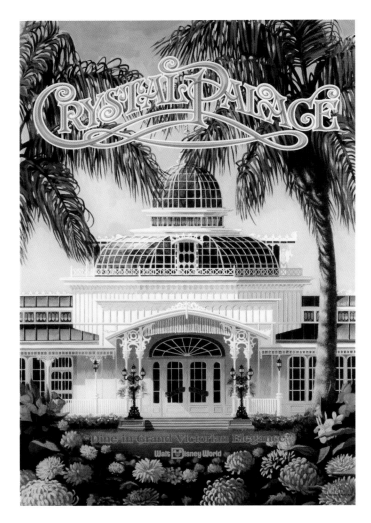

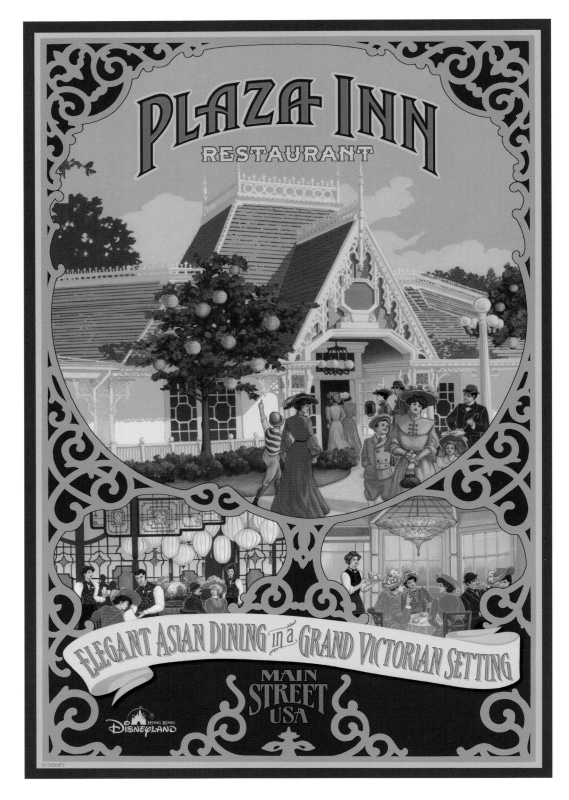

Plaza Inn, Hong Kong Disneyland
Nicole Armitage, Karen Armitage, and Louis Lemoine, 2005

Top: The Crystal Palace, Walt Disney World
Adapted by George Jensen, 1971

The Crystal Palace, Walt Disney World
Julie Svendsen, 1980

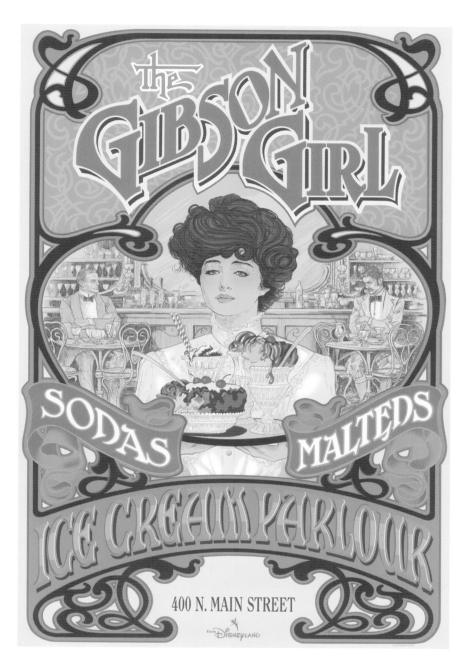

The Gibson Girl Ice Cream Parlour, Disneyland Paris
Jim Michaelson, Eddie Sotto, and Suzanne Rattigan, 1991

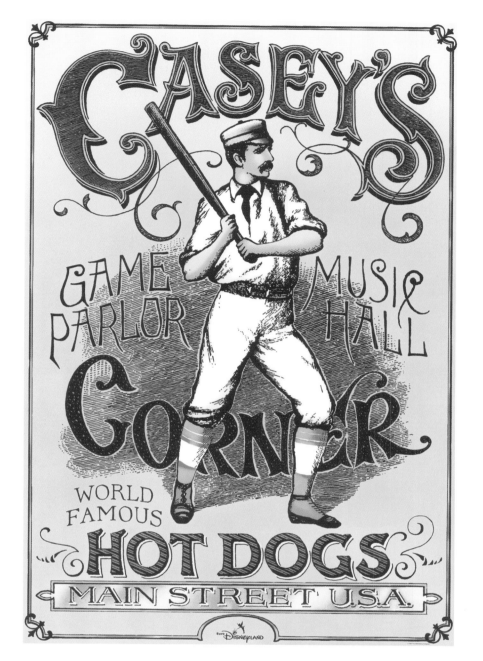

Casey's Corner, Disneyland Paris
Jim Michaelson, Eddie Sotto, and Han Lee, 1991

"I wanted to have some kind of a joke in the Gibson Girl poster similar to what Charles Dana Gibson did in his art. There are two men behind the Gibson Girl waitress, and if you count, there are all these downed sodas as if they sat there for hours and hours glaring at each other like, 'why don't you leave!' 'No! Why don't you leave!' The funny thing is, the waitress is not at all interested in their attempts to win her attention. It's a story we hid inside the poster and is very much inspired by the empowered Gibson Girl."

— Eddie Sotto, show producer

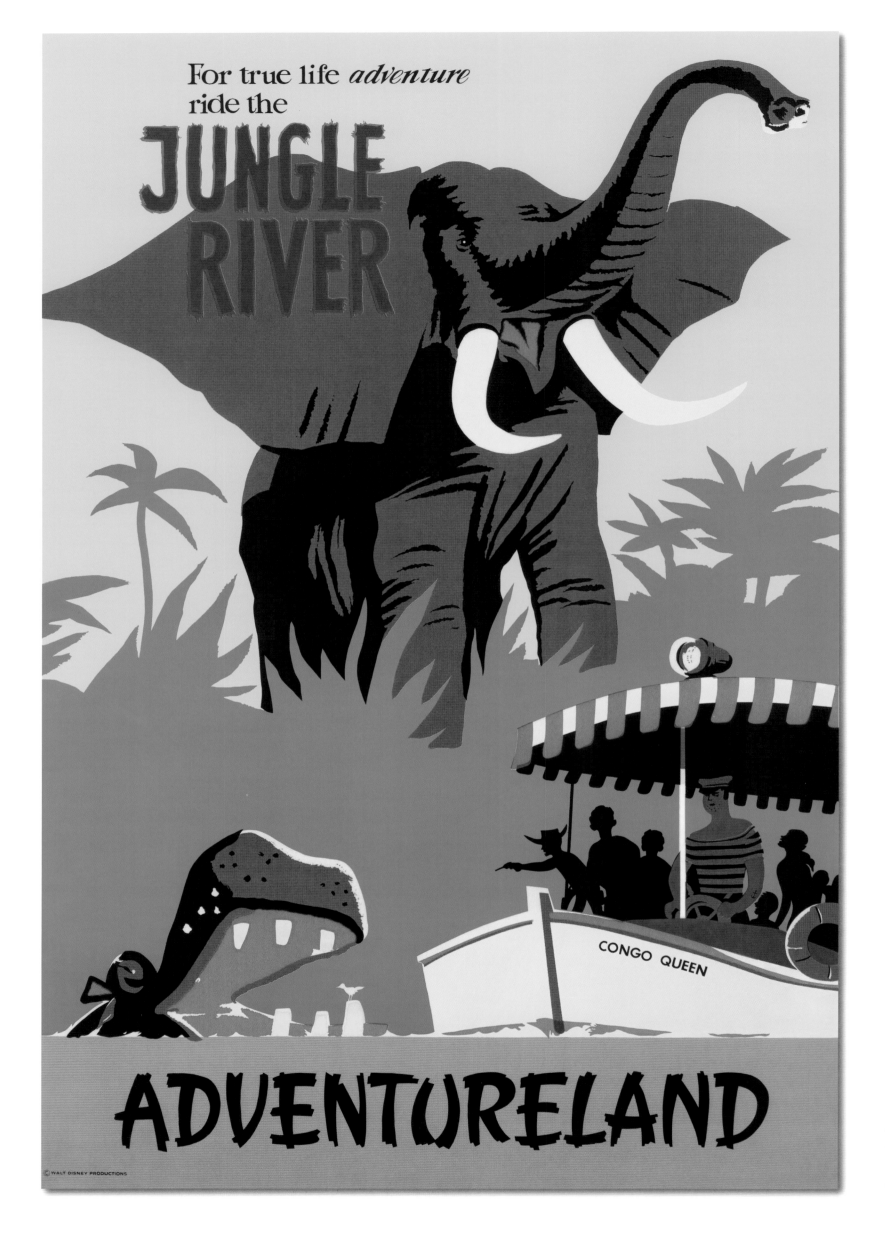

Jungle Cruise, Disneyland and Walt Disney World, *Bjorn Aronson, 1955*

ADVENTURELAND

"Here is adventure. Here is romance. Here is mystery. Tropical rivers—silently flowing into the unknown. The unbelievable splendor of exotic flowers . . . the eerie sound of the jungle . . . with eyes that are always watching. This is Adventureland."

—Walt Disney

Tikis, tree houses, and temples—oh, my! The mystery, intrigue, and excitement of Adventureland are indicated in the following portrayals of true-life adventures. In this land Guests are whisked away from civilization to the remote jungles and exotic locales of Africa, Asia, South America, the South Pacific, and the Caribbean. The posters of Adventureland are bold and lush, and can be considered quite adventurous in design.

Our expedition embarks on the world famous Jungle Cruise, an Opening Day attraction for Disneyland based on Walt Disney's True-Life Adventures series of movies. Bjorn Aronson's 1955 Disneyland poster denotes the original intent of the Jungle Cruise—a realistic and serious boat excursion through treacherous waters. It wasn't until several years later that Imagineer Marc Davis created his humorous vignettes and re-imagined the Jungle Cruise as a tongue-in-cheek journey. In 1976 Jim Michaelson designed a highly detailed and immersive Jungle Cruise poster for Disneyland and Walt Disney World that reflects the romance of the tropic rivers of adventure. This poster was one of the most complicated to screen print, featuring over seventy unique colors.

In the 1960s two new Adventureland attractions opened in Disneyland—the walk-through tour of Swiss Family Treehouse and the first ever Audio-Animatronics musical spectacular, Walt Disney's Enchanted Tiki Room. Paul Hartley's posters for the two experiences are the finest examples of graphic-design work from the period. These intriguing designs made such an impact that when the Swiss Family Treehouse and Enchanted Tiki Room attractions opened in Walt Disney World in 1971 and in Tokyo Disneyland in 1983, the posters maintained similar designs, color palettes, and compositions.

For Disneyland's fortieth anniversary in 1995, the action-packed attraction Indiana Jones™ Adventure: Temple of the Forbidden Eye became the latest and grandest addition to the original Park's Adventureland. To commemorate the opening of the attraction, Indiana Jones™ creator George Lucas personally requested renowned poster artist Drew Struzan to design and paint the Indiana Jones™ Adventure attraction poster (Struzan's vast body of work includes the posters for Lucas's Star Wars™ and Indiana Jones™ movie series). Along with the snakes, spiders, rats, and skulls, Struzan also painted his wife, Dylan, as one of the troop-transport passengers.

Another Adventureland classic, Pirates of the Caribbean, features a band of infamous scallywags, scoundrels, and ne'er-do-well cads, and these characters grace the swashbuckling posters devised for Walt Disney World, Tokyo Disneyland, and Disneyland Paris. (The original Disneyland Pirates of the Caribbean attraction is located in New Orleans Square; the poster is featured in Chapter Four.) These engaging posters introduce Guests to "the wildest crew that ever sailed the Spanish Main" and an attraction bursting with battling galleons, drinking and singing pirates, loads of treasure . . . and more importantly, the voluptuous red head!

Sometimes an attraction, such as Pirates of the Caribbean, may appear in a different land in each Magic Kingdom Park based on circumstances for theme and design. For example, unlike the trains in the other Parks, the steam-powered railroad attraction in Tokyo Disneyland is found in Adventureland above the Jungle Cruise boathouse queue. Instead of a grand circle tour of the Park, the appropriately titled Western River Railroad only has one stop and takes passengers on a scenic route through Adventureland, Westernland, and Critter Country. Likewise, Tokyo Disneyland's Crystal Palace Restaurant is considered part of Adventureland, not Main Street like in Walt Disney World, due to its proximity to the Adventureland area.

Disneyland Paris is unique in that it is the only Magic Kingdom Park not to have a Jungle Cruise. Instead, Disneyland Paris features the elaborate and exclusive Adventure Isle—an exploration attraction with walkways, caverns, and hidden passages. The wonderfully detailed poster features Skull Rock and Captain Hook's Pirate Ship with subtle hints of La Cabane des Robinson and Spyglass Hill in the background.

Out of all the Magic Kingdom Parks, Hong Kong Disneyland has one of the largest Adventurelands ever designed. This is due to its jungle boat ride, Jungle River Cruise, which replaces the archetypical Frontierland Rivers of America found in the other Parks (Hong Kong Disneyland does not have a Frontierland). The statue of Ganesha, the guardian to the sacred Indian elephant bathing pool, plays a crucial role in establishing the mysterious and exciting nature of the Jungle River Cruise in Walt Disney Imagineering executive designer Tim Delaney's digitally created attraction poster from 2005.

Without a doubt, the posters of Adventureland capture the thrilling locales and the diverse attractions to visit and experience.

Jungle Cruise poster concepts, Walt Disney World
Sam McKim, 1971

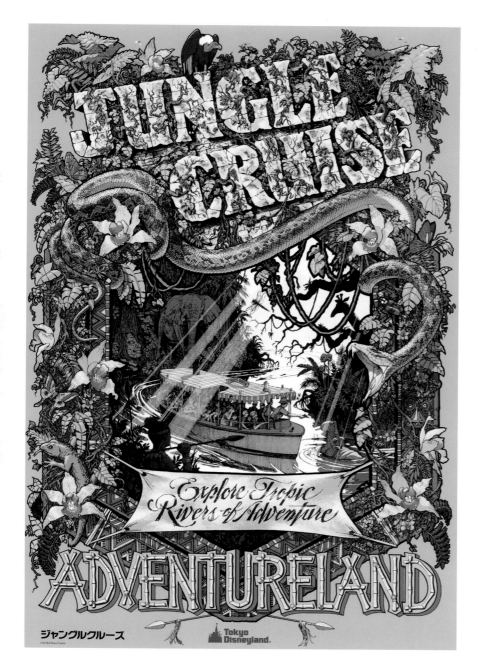

Jungle Cruise, Disneyland, Walt Disney World, and Tokyo Disneyland
Jim Michaelson, Ernie Prinzhorn, and Rudy Lord, 1976

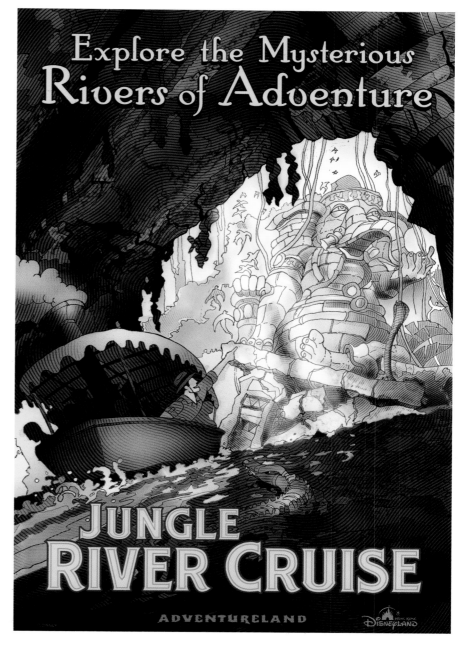

Jungle River Cruise, Hong Kong Disneyland and Disneyland
Tim Delaney, 2005

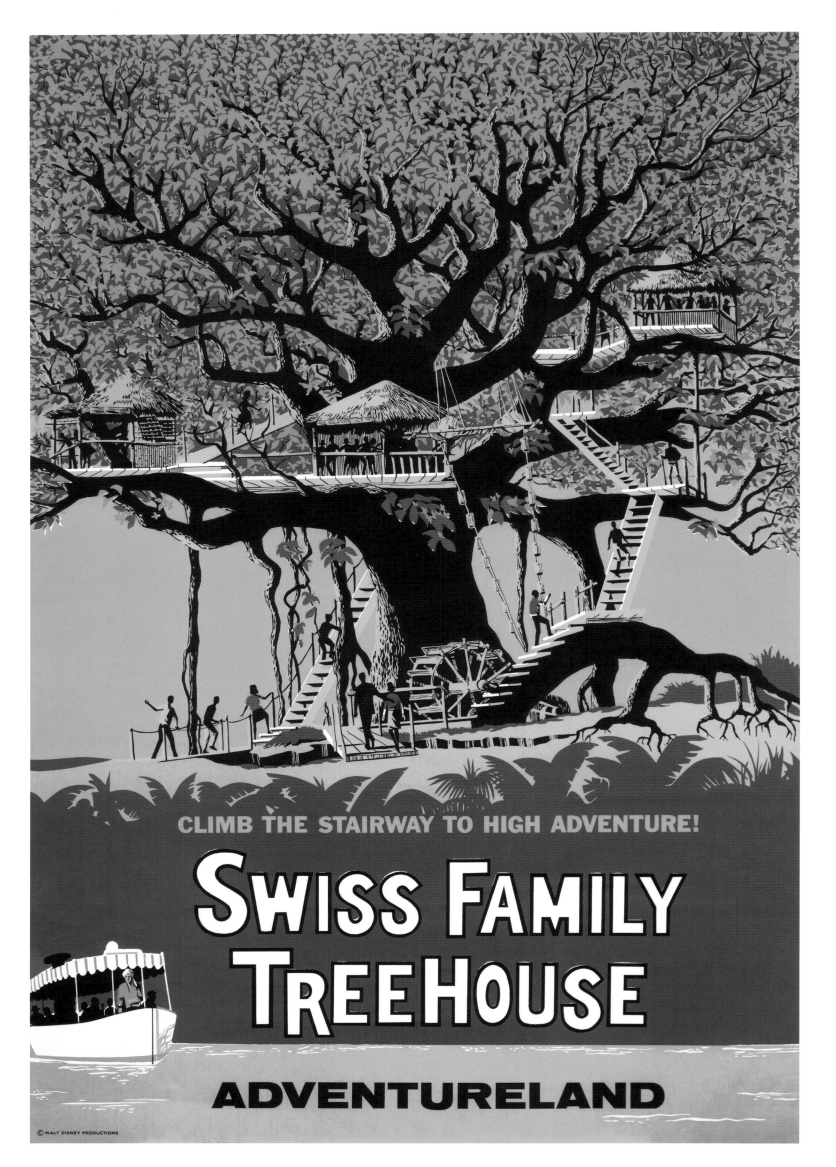

Swiss Family Treehouse, Disneyland and Walt Disney World, *Paul Hartley, 1962*

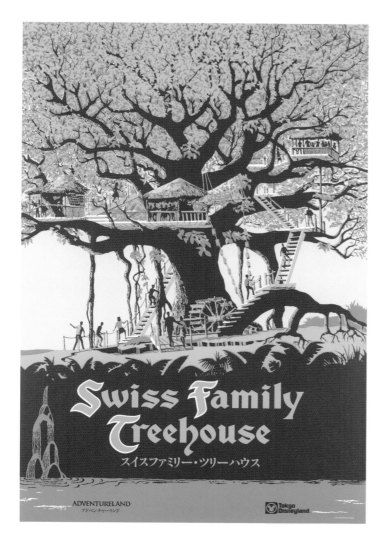

Swiss Family Treehouse, Tokyo Disneyland
Adapted by George Stokes and Mimi Sheean, 1982

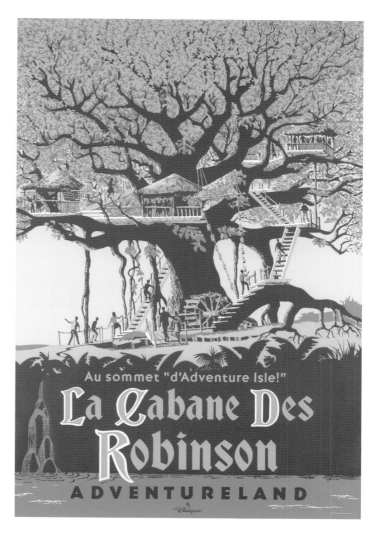

La Cabane des Robinson, Disneyland Paris
Adapted by George Stokes, Mimi Sheean, and Chris Tietz, 1992

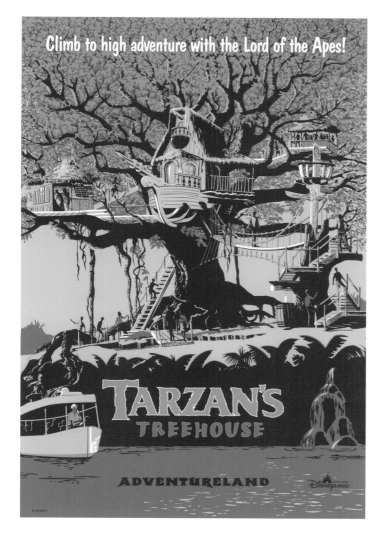

Tarzan's Treehouse, Hong Kong Disneyland
Adapted by Greg Maletic, 2005

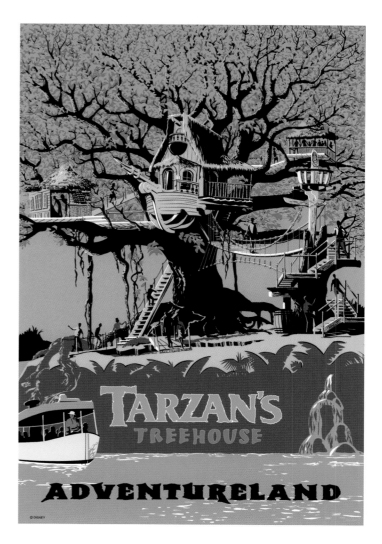

Tarzan's Treehouse, Disneyland
Adapted by Josh Shipley, 2008

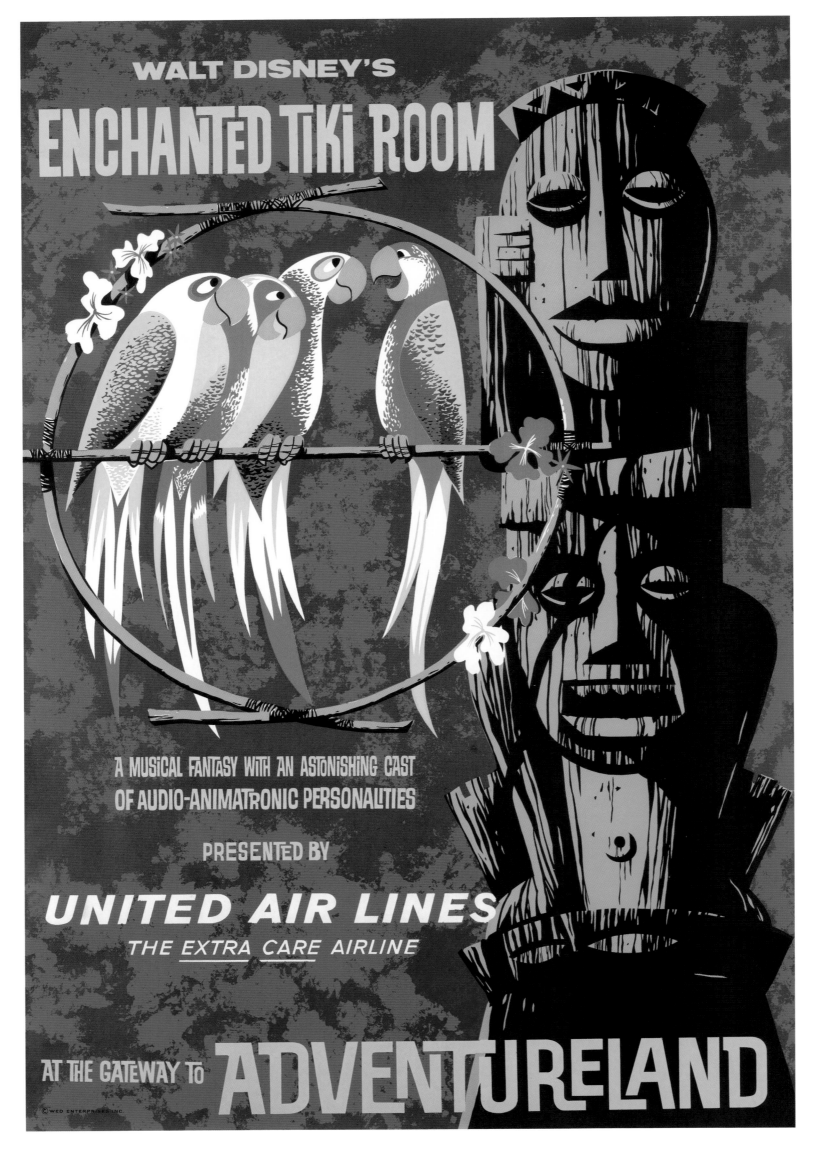

Enchanted Tiki Room, Disneyland, *Paul Hartley, 1963*

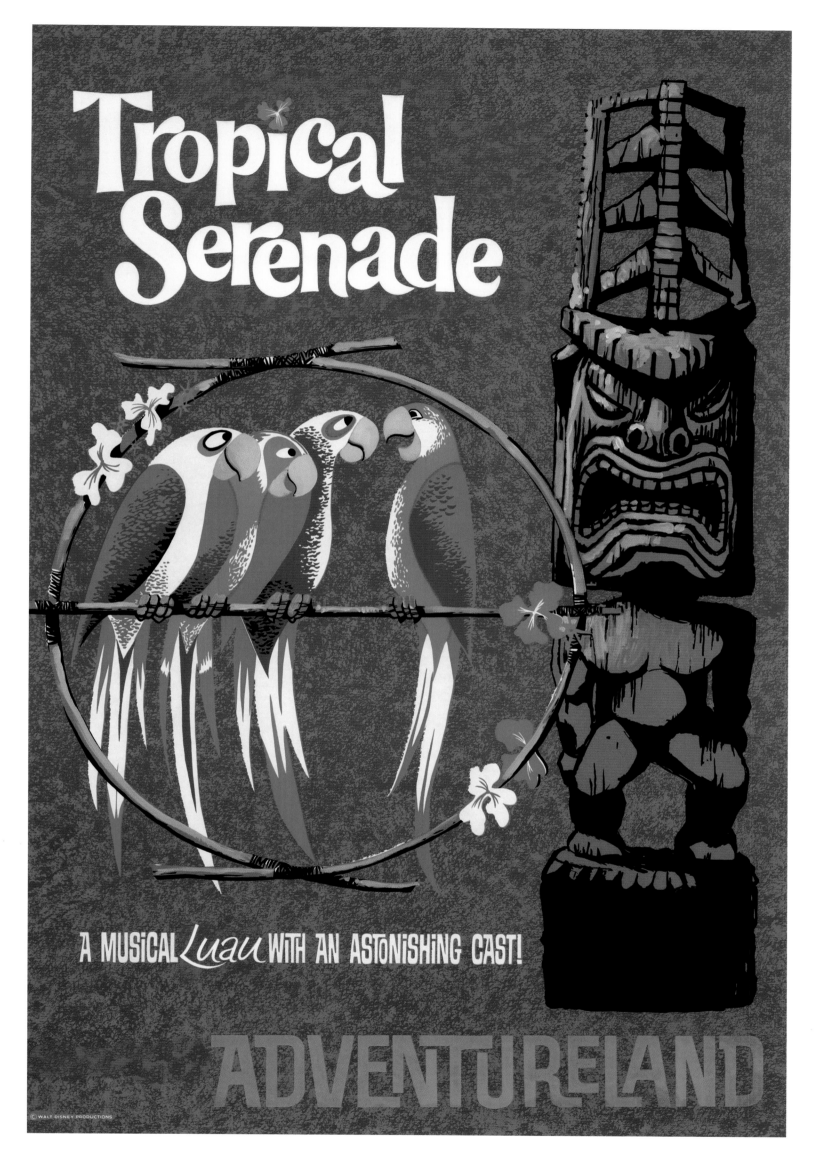

Tropical Serenade, Walt Disney World and Disneyland, *Paul Hartley, 1971*

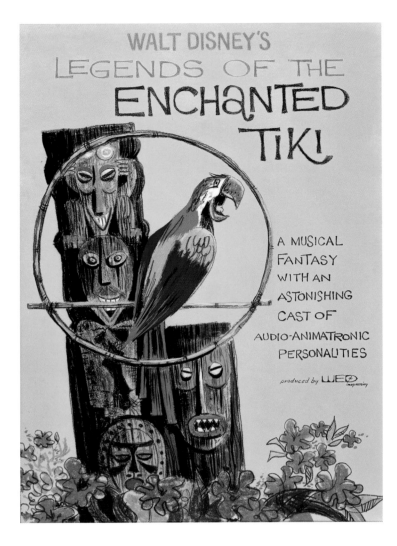

Enchanted Tiki Room poster concept, Disneyland
Paul Hartley, 1963

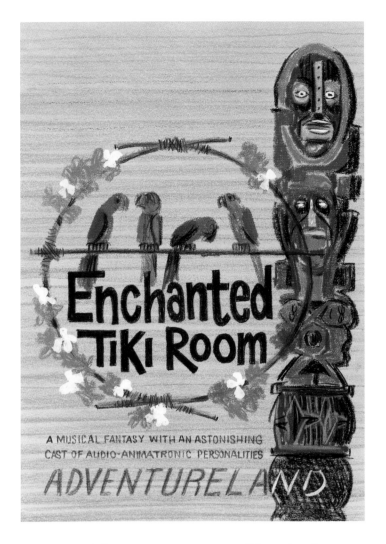

Enchanted Tiki Room poster concept, Disneyland
Paul Hartley, 1963

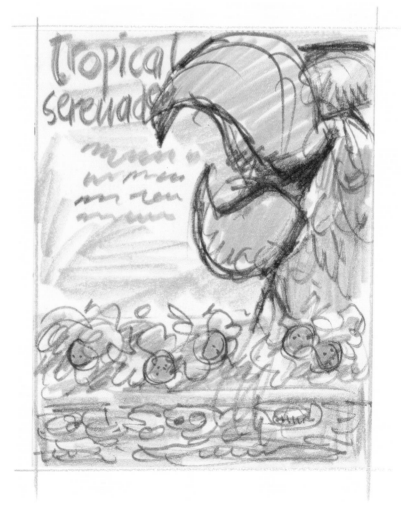

Tropical Serenade poster concept, Walt Disney World
Sam McKim, 1971

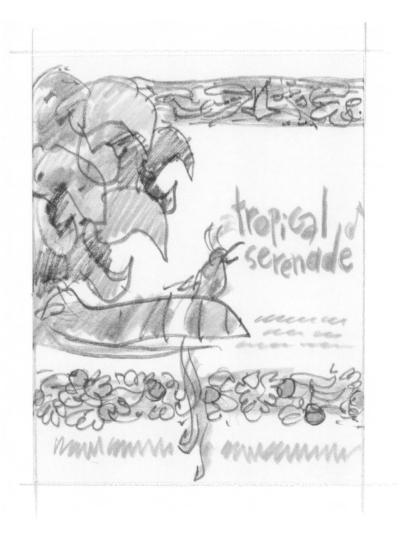

Tropical Serenade poster concept, Walt Disney World
Sam McKim, 1971

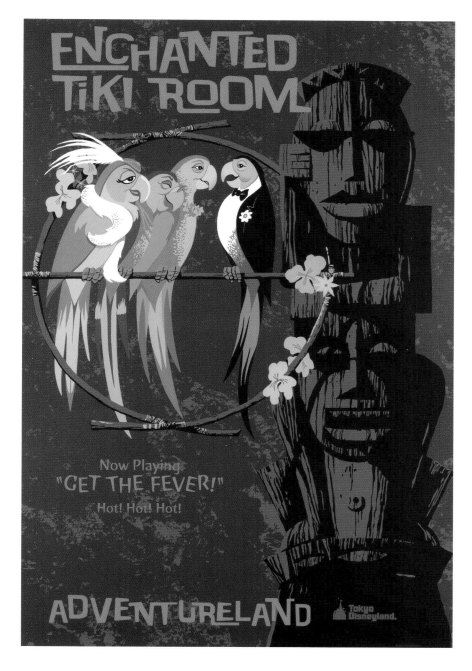

The Enchanted Tiki Room: Now Playing "Get the Fever!"
Tokyo Disneyland
Adapted by unknown artist, 1999

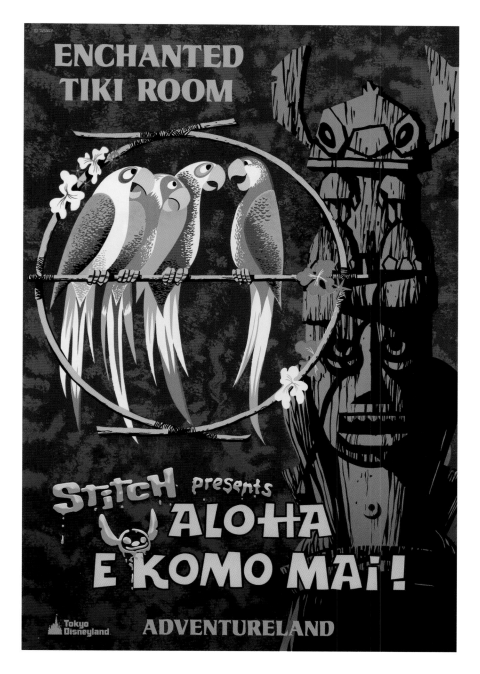

The Enchanted Tiki Room: Stitch Presents "Aloha E Komo Mai!"
Tokyo Disneyland
Adapted by Will Eyerman, 2008

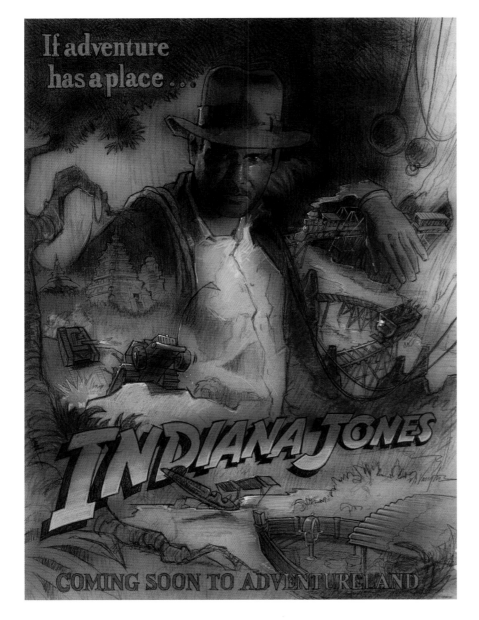

Indiana Jones™ Adventure poster concept, Disneyland
Nina Rae Vaughn, 1989

"When Disney licensed Lucasfilm for the Indiana Jones™ ride, it did not secure the rights to Harrison Ford's likeness. So, when it came to the poster, my take on it was, gee, if I painted Indiana Jones™ and don't put Harrison's likeness on it, I'll look like a fool, like I couldn't do it. So I got his phone number and called him up to ask for his permission. He had just the gentlest Indy voice you ever heard. I told him the situation and his response was, 'If you're painting it then you go right ahead.'"

— Drew Struzan, poster artist

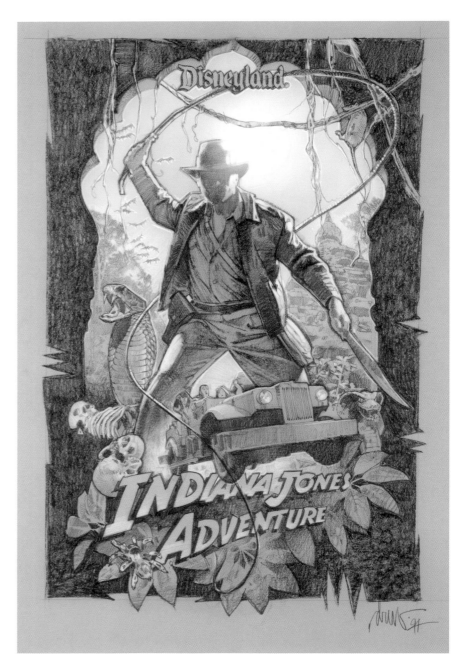

Indiana Jones™ Adventure poster concept, Disneyland
Drew Struzan, 1994

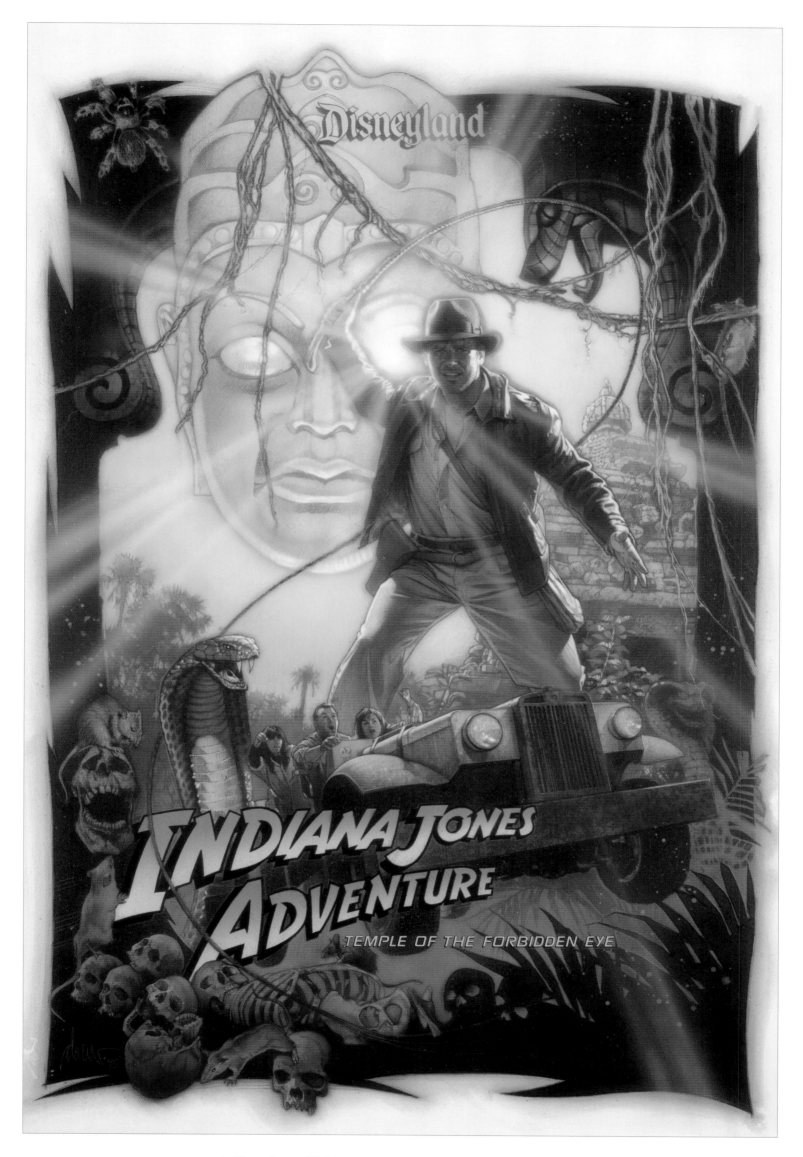

Indiana Jones™ Adventure: Temple of the Forbidden Eye, Disneyland, *Drew Struzan, 1995*

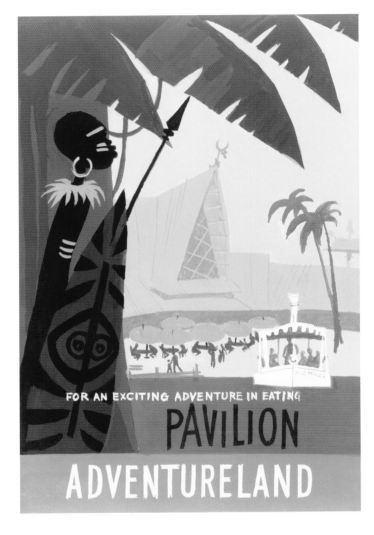

Adventureland Pavilion poster concept, Disneyland
Bjorn Aronson, 1953

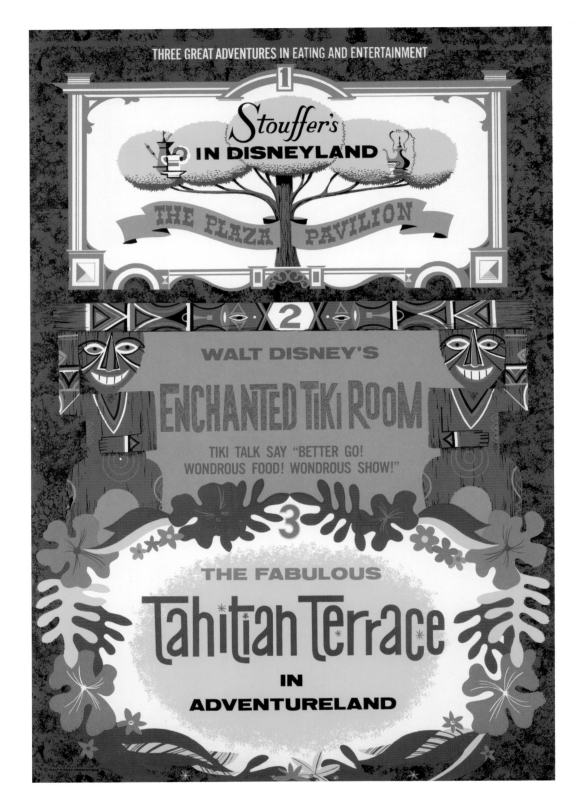

Plaza Pavilion, Enchanted Tiki Room, and Tahitian Terrace, Disneyland
Sam McKim, 1962

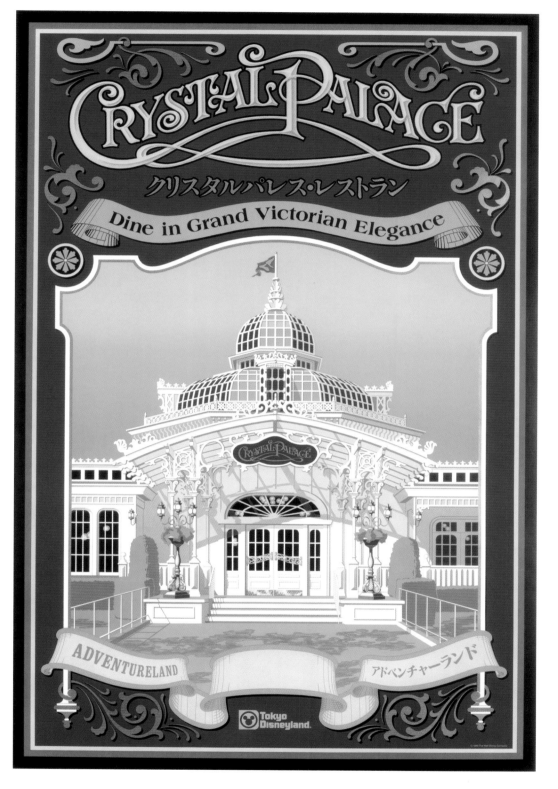

Crystal Palace Restaurant, Tokyo Disneyland
Greg Paul and Mimi Sheean, 1986

Western River Railroad, Tokyo Disneyland
Jim Michaelson, Ernie Prinzhorn, and Rudy Lord, 1983
Adapted by Will Eyerman, 2011

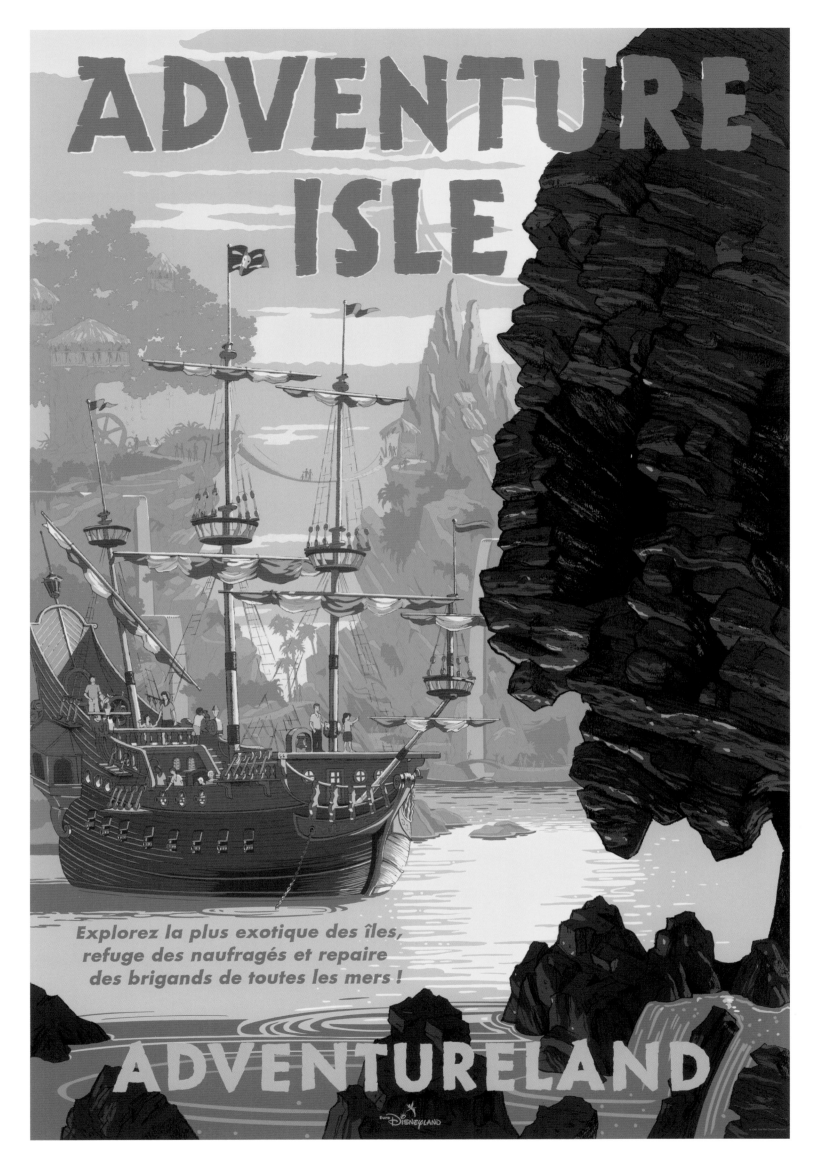

Adventure Isle, Disneyland Paris, *George Stokes, Chris Tietz, and Mimi Sheean, 1991*

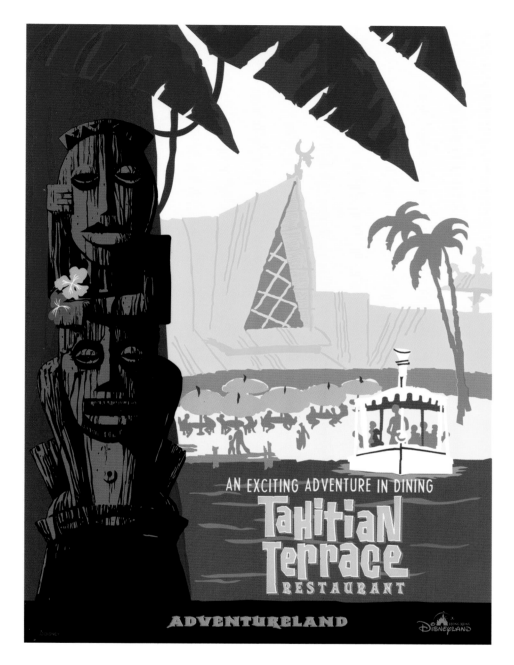

Tahitian Terrace Restaurant, Hong Kong Disneyland
Paul Novacek, 2005

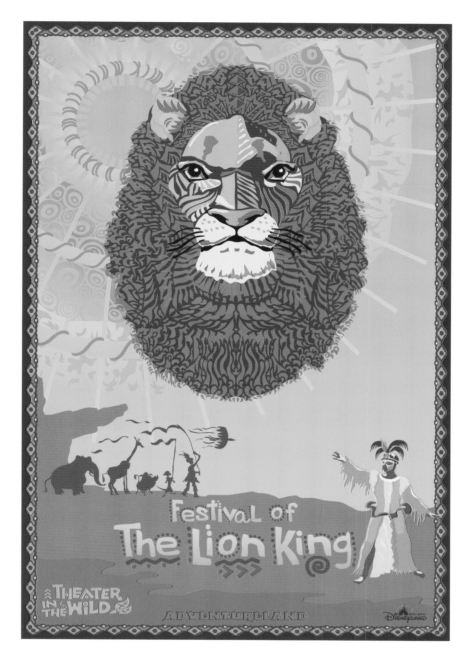

Festival of the Lion King, Hong Kong Disneyland
Paul Novacek, 2005

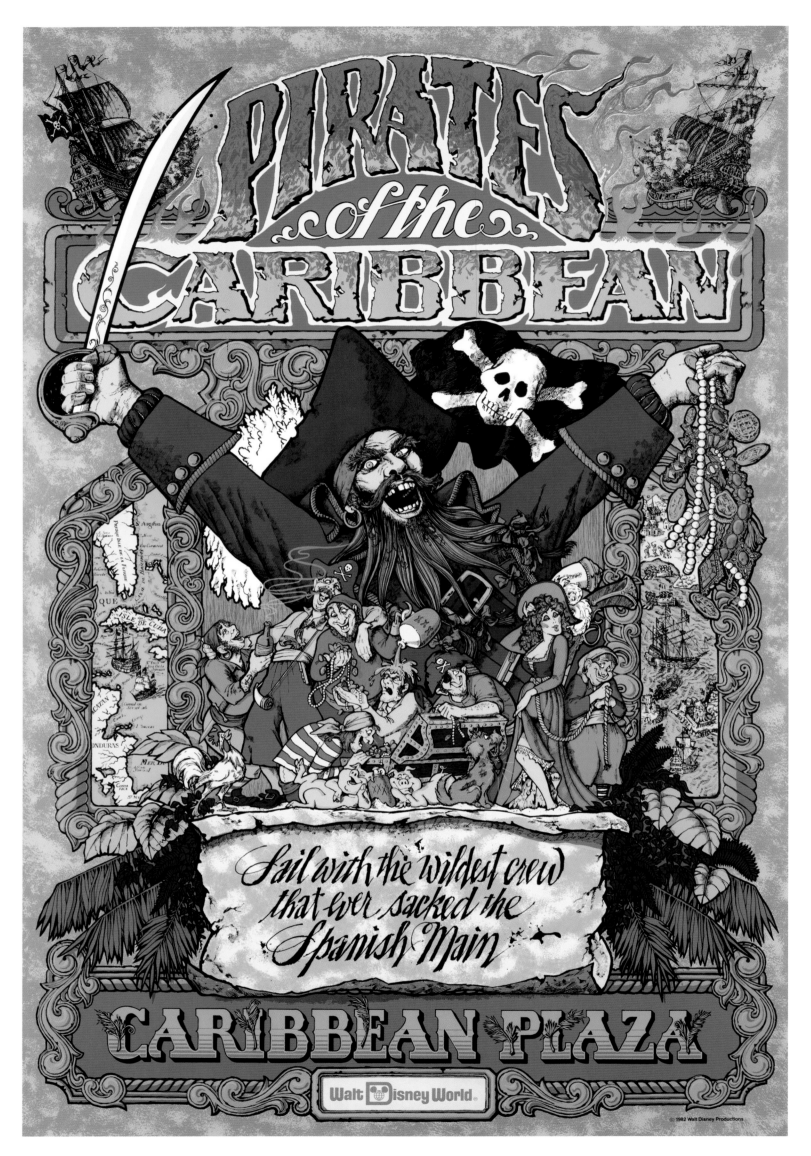

Pirates of the Caribbean, Disneyland, Walt Disney World, and Tokyo Disneyland, *Jim Michaelson, 1982*

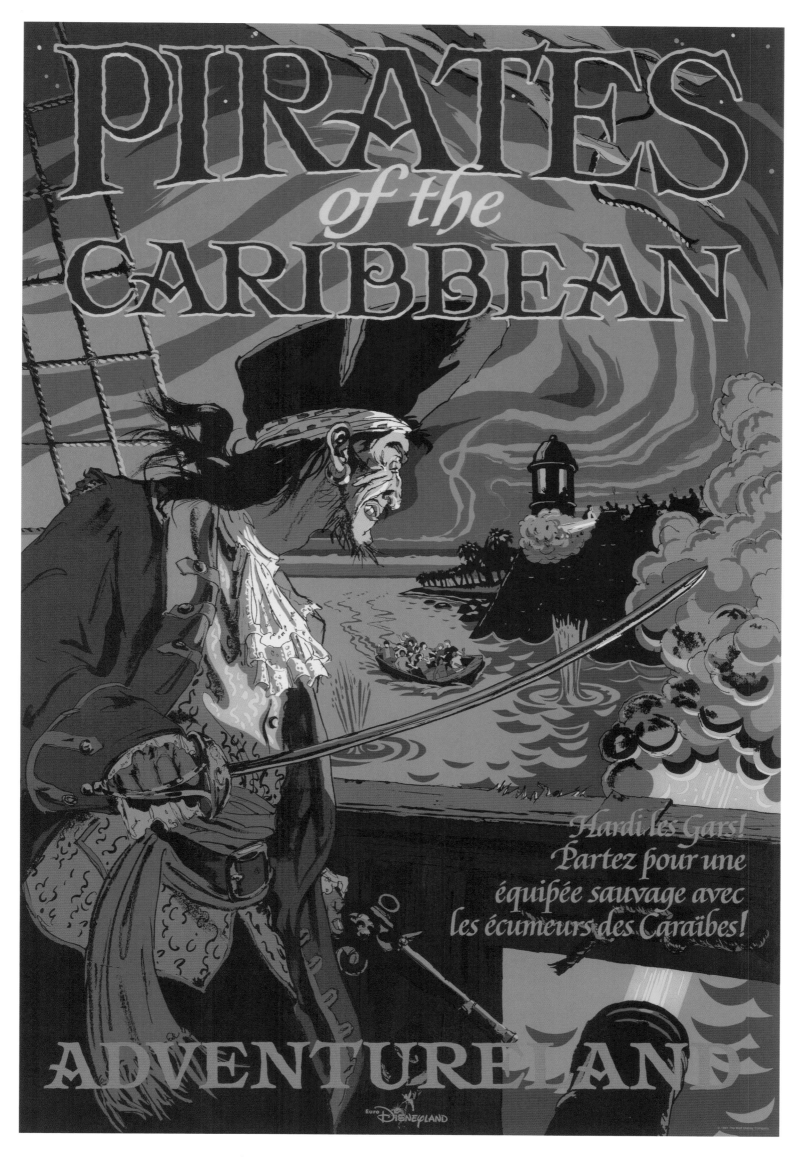

Pirates of the Caribbean, Disneyland Paris and Tokyo Disneyland, *George Stokes, 1991*

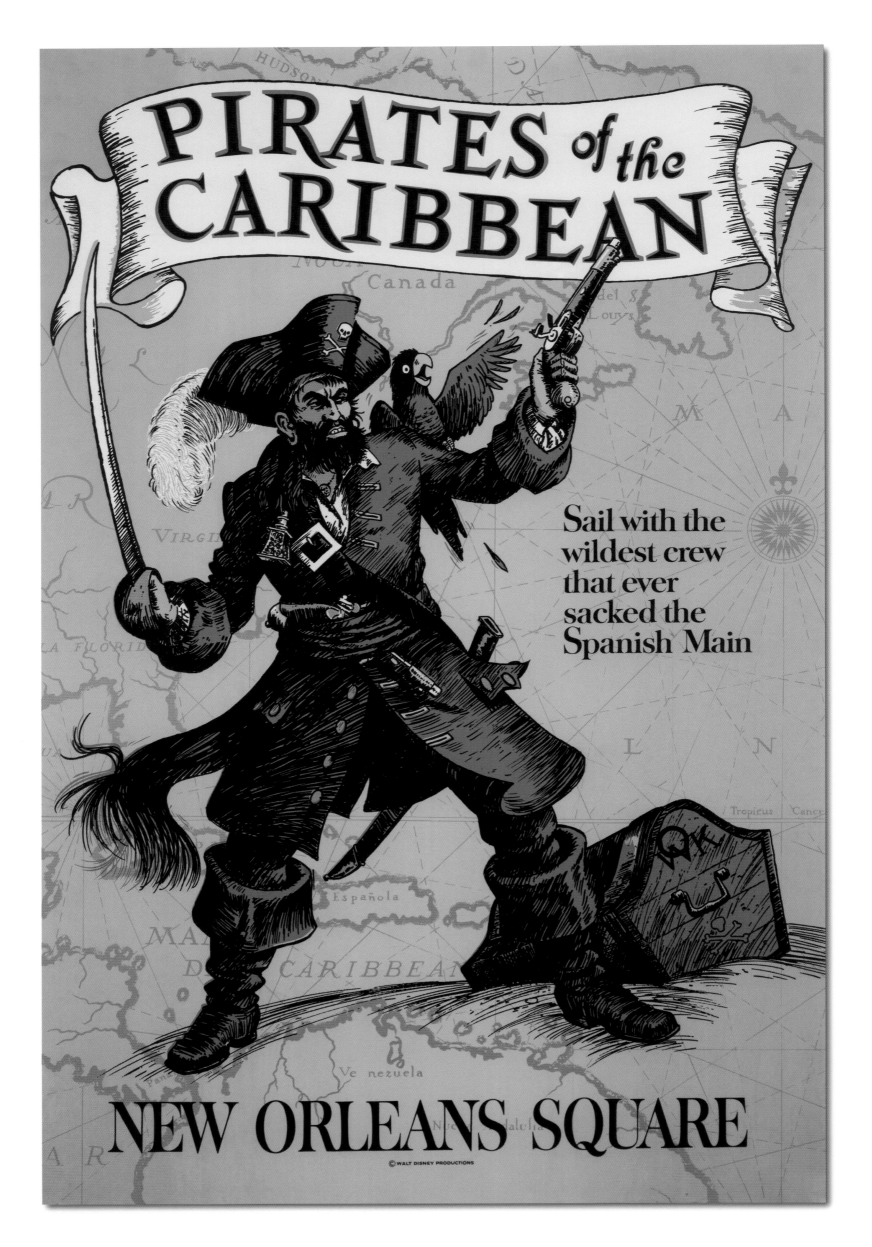

Pirates of the Caribbean, Disneyland, Collin Campbell, 1967

NEW ORLEANS SQUARE AND LIBERTY SQUARE

"From the lacy iron grillwork of its balconies to the sound of a Dixieland jazz band and the sight of the majestic riverboat *Mark Twain* steaming 'round the bend at the foot of Royal Street, New Orleans Square recalls her namesake, the fabled 'Queen of the Delta,' as it was a century ago when cotton was king and the steamboat ruled the Mississippi."

— Walt Disney

L et's take a quick detour through New Orleans Square in Disneyland and Liberty Square in Walt Disney World— two lands with contrasting themes, but similar in that they are both possessed of modest size and haunted houses.

As a complimentary addition to the Mississippi-inspired Rivers of America, New Orleans Square was the first new land to be added to Disneyland after the Park's opening. Although New Orleans Square debuted with no attractions in 1966, two signature Disneyland experiences soon followed: Pirates of the Caribbean in 1967 and the Haunted Mansion in 1969. Collin Campbell's Pirates of the Caribbean poster features a notably warm color palette and parchment-like background map of the Caribbean. The primary pirate figure is actually a self-portrait of Campbell himself—proving Imagineers truly get into their work. Subsequently, the grim grinning poster for the Haunted Mansion is a delightfully devilish design by Ken Chapman and Marc Davis spotlighting the memorable hitchhiking ghosts who are "dying to meet you."

Liberty Square is based on colonial America. As described on the land's gateway plaque, ". . . It is a time when silversmiths put away their tools and march to the drums of a revolution, a time when gentlemen planters leave their farms to become generals, a time when tradesmen leave the safety of home to become heroes. . . ." Exclusive to the opening of Liberty Square in 1971, The Hall of Presidents necessitated a poster featuring an original composition. While most posters from this era were screen prints, The Hall of Presidents was printed using a four-color lithography process.

Whether they're about pirates, ghosts, or presidents, the posters of New Orleans Square and Liberty Square enhance the distinct flavors of the two lands' stories and settings.

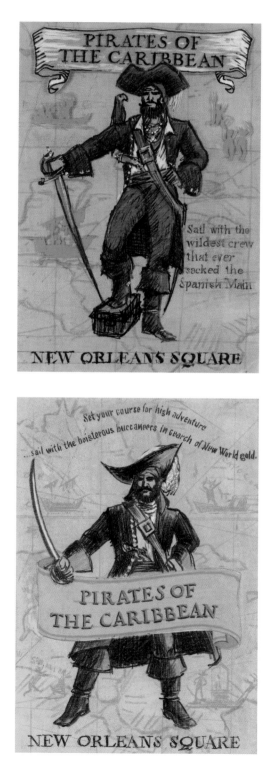

Pirates of the Caribbean poster concepts, Disneyland
Collin Campbell, 1966

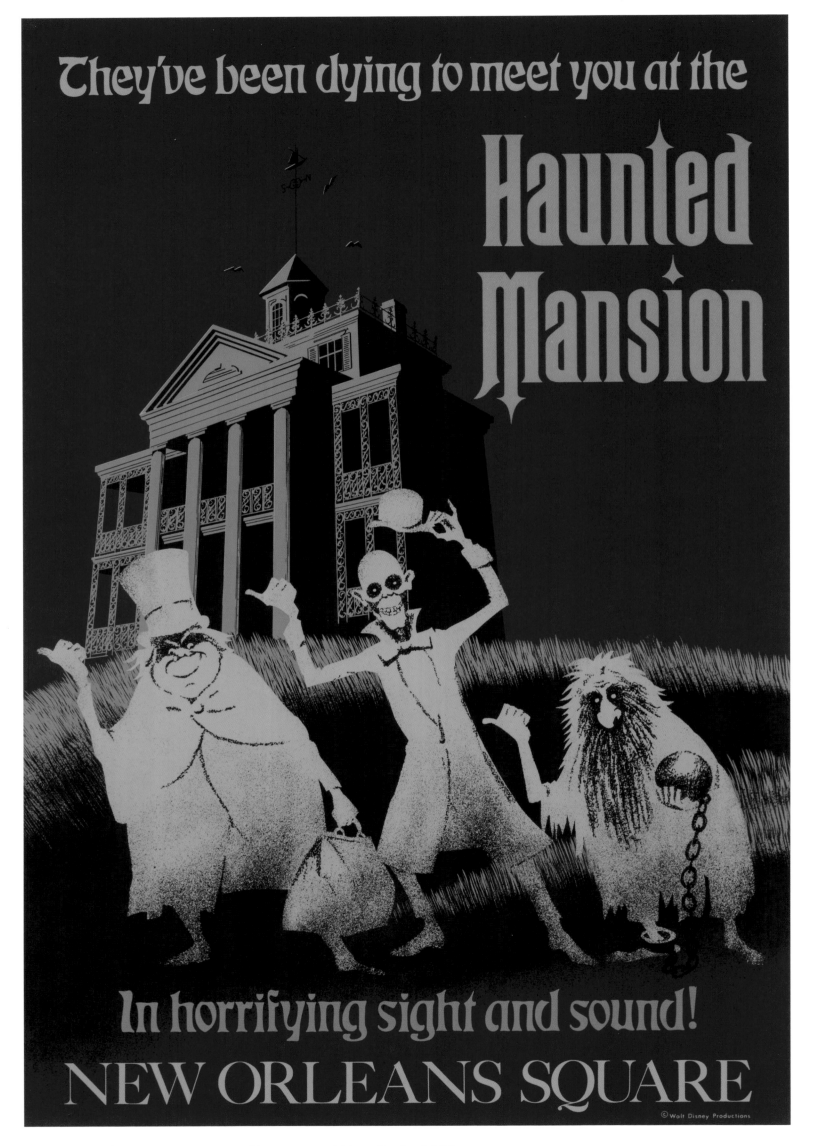

Haunted Mansion, Disneyland, *Ken Chapman and Marc Davis, 1969*

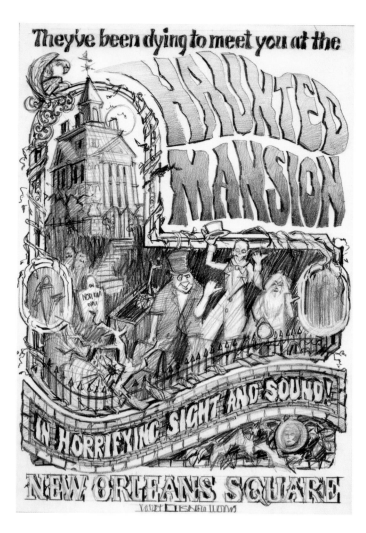

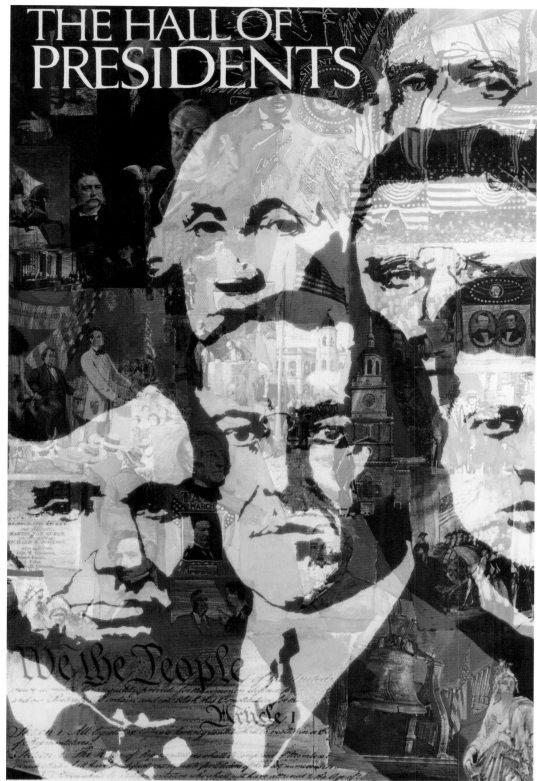

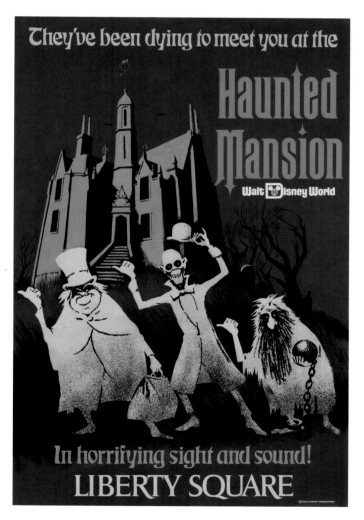

Top: Haunted Mansion poster concept, Disneyland
Jim Michaelson, 1977

The Haunted Mansion, Walt Disney World
Adapted by George Jensen, 1971

The Hall of Presidents, Walt Disney World
John DeCuir Sr., 1971

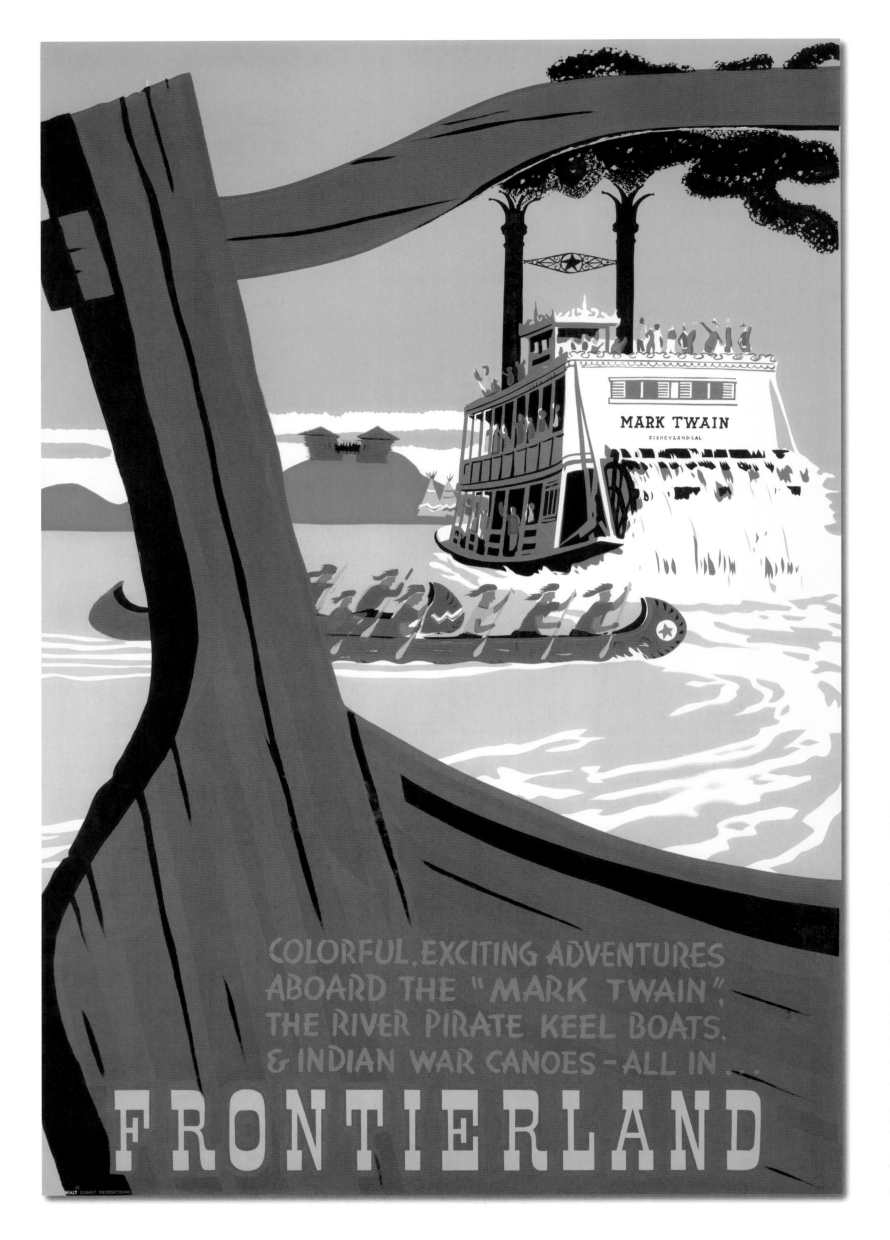

COLORFUL, EXCITING ADVENTURES
ABOARD THE "MARK TWAIN",
THE RIVER PIRATE KEEL BOATS,
& INDIAN WAR CANOES – ALL IN . . .

FRONTIERLAND

Frontierland, Disneyland and Walt Disney World, *Bjorn Aronson, 1955*

FRONTIERLAND

"Here we experience the story of our country's past . . . the colorful drama of Frontier America in the exciting days of the covered wagon and the stagecoach . . . the advent of the railroad . . . and the romantic riverboat. Frontierland is a tribute to the faith, courage, and ingenuity of the pioneers who blazed the trails across America."

— Walt Disney

The attraction posters of Frontierland are authentic tributes to the Old West. Whether projecting rich images of the bustling rivercraft on the majestic Rivers of America, the exhilarating peaks of Big Thunder Mountain, or the mighty "satisfactual" Splash Mountain, these pioneering posters provoke a variety of rootin'-tootin' emotions and excitement.

Our leisurely trip through the wilderness begins with Bjorn Aronson's poster for Disneyland's Frontierland—a wonderful depiction of the many attractions on the Rivers of America, including the *Mark Twain* Riverboat, the Mike Fink Keel Boats, and the Indian War Canoes (known today as Davy Crockett's Explorer Canoes). Here, and in several of the other Rivers of America-based posters, Tom Sawyer Island serves as an appropriate backdrop and point of destination. Other early Frontierland posters feature Slue Foot Sue's dance hall girls from "The Golden Horseshoe Revue," the delicious Mexican food of Casa de Fritos, and the lively Stage Coach, Mine Train, and Mule Pack attractions.

Walt Disney World is home to two iconic Frontierland attractions: Big Thunder Mountain Railroad and Splash Mountain (the latter of which is located in Critter Country at Disneyland and Tokyo Disneyland). The posters for these two "E" ticket experiences provoke a variety of emotions. Exciting, thrilling, intimidating—not to mention fun—are some of the words that come to mind when viewing these highly detailed masterpieces.

In the Country Bear Jamboree everybody's favorite foot-stomping bears celebrate some of the most memorable country songs with a one-of-a-kind hillbilly hoedown. In Westernland, the Tokyo Disneyland equivalent of Frontierland, the Country Bear Theater plays three different seasonal shows—the original

Country Bear Jamboree, the winter Jingle Bell Jamboree, and the summer Vacation Jamboree. Walt Disney Imagineering principal concept designer Larry Nikolai, who illustrated the characters in the posters for Jingle Bell Jamboree and Vacation Jamboree, recalls, "Back before computers it was all cut and paste. I would make a copy of my drawing, cut the characters out and mess around with the layout, then make another copy and start the process all over again. There was a lot of refining once we reached the direction we all liked. Then the screen print shop laid transparencies to trace over my final painting and break down the colors to screen print."

When Disneyland opened in the 1950s the Western genre was at the height of its popularity. So to help portray the ideals of Frontierland at the international Parks, such as Disneyland Paris, Imagineers looked to a different source for their posters. "We wanted the posters for Frontierland in Disneyland Paris to look like they were printed in the town during that era," says former Walt Disney Imagineering graphics designer Leticia Lelevier. "Posters like The Lucky Nugget Saloon, Cowboy Cookout Barbecue, and Phantom Manor look like engraved prints with limited color palettes. There was a lot of flavor because, in Europe, they had this romance of the American West from their French films. So that was the feeling we wanted to communicate."

From the lazy rivers and lively saloons to the majestic mountain range, Frontierland blazes a trail of exciting and authentic posters.

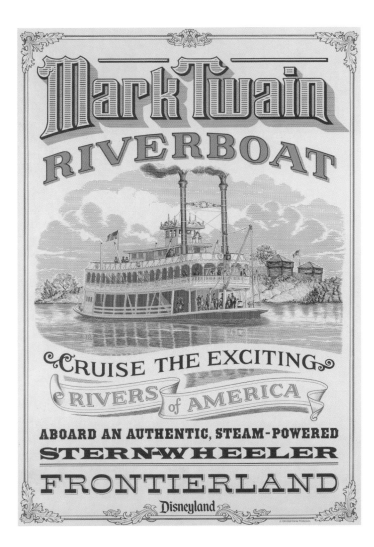

Mark Twain Riverboat, Disneyland and Tokyo Disneyland
Debbie Lord, 1983

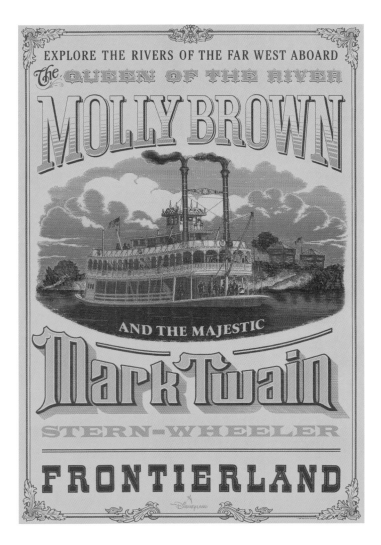

Molly Brown and Mark Twain, Disneyland Paris
Jeff Burke, Leticia Lelevier, and Debbie Lord, 1990

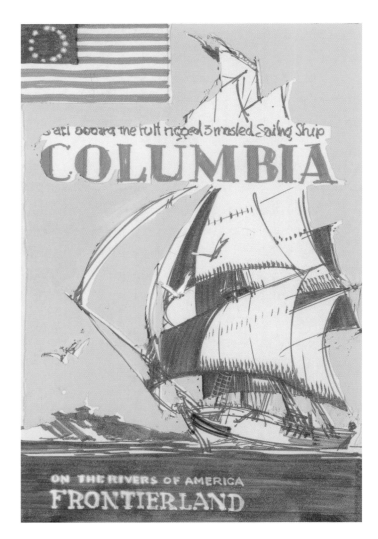

Sailing Ship Columbia poster concept, Disneyland
Unknown artist, 1958

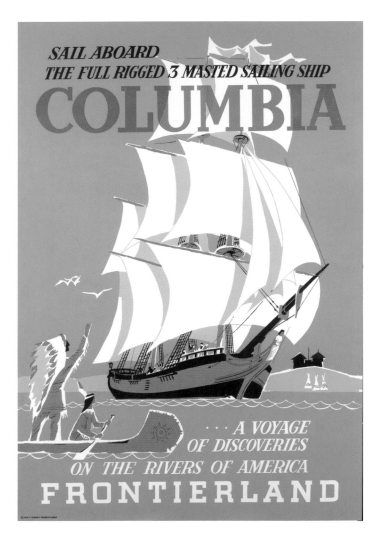

Sailing Ship Columbia, Disneyland
Bjorn Aronson, 1958

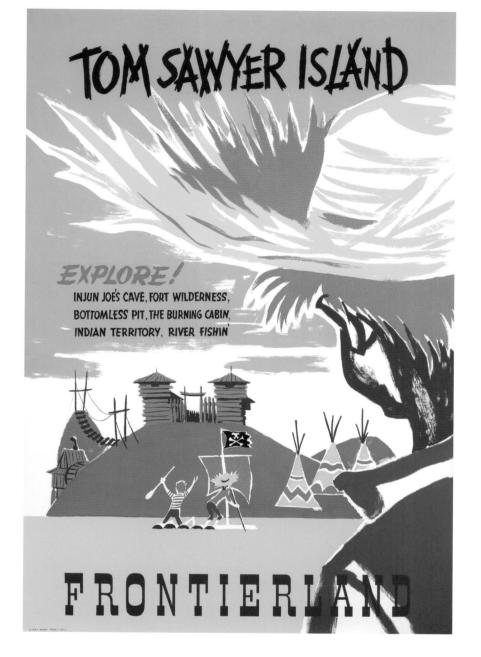

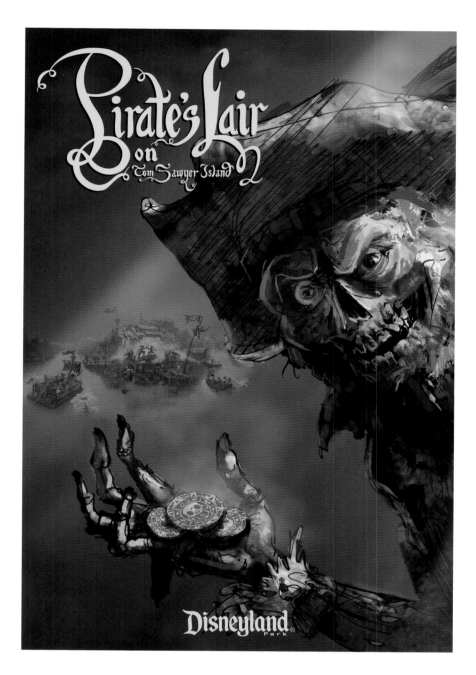

Tom Sawyer Island, Disneyland
Bjorn Aronson, 1956

Pirate's Lair on Tom Sawyer Island, Disneyland
Danny Handke, Chris Runco, Wesley Keil, and Chris Merritt, 2007

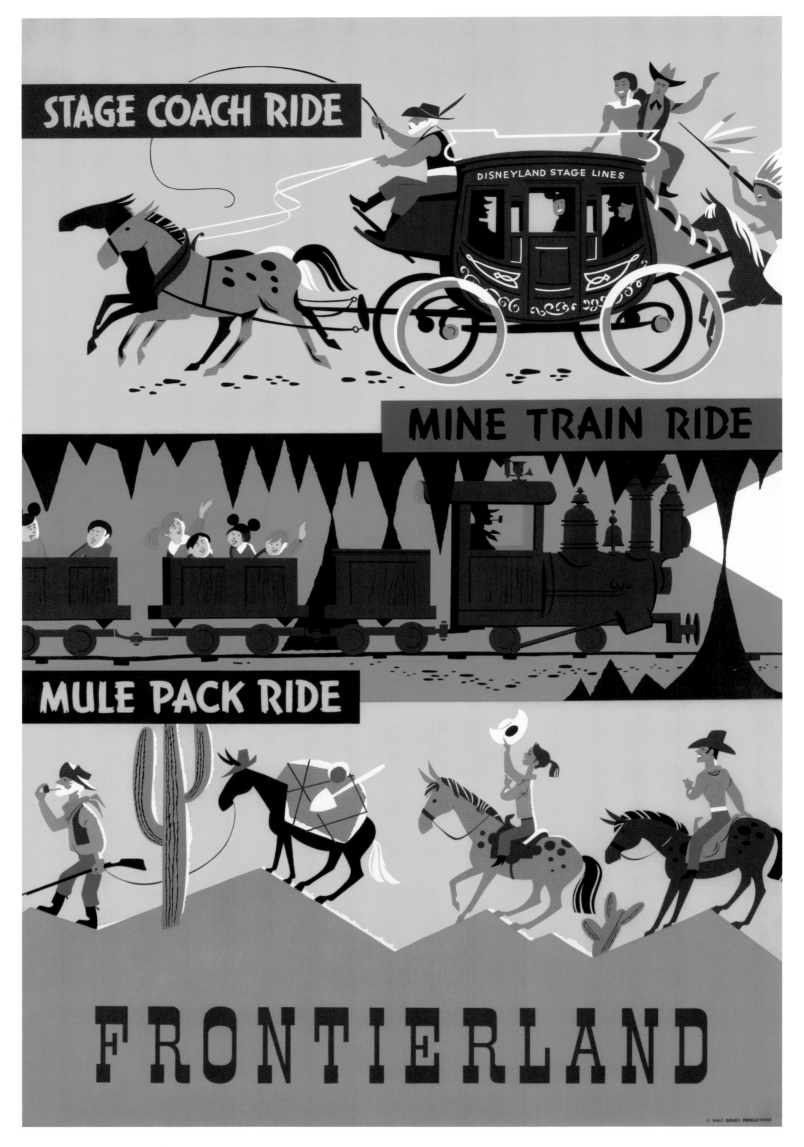

Stage Coach, Mine Train, and Mule Pack, Disneyland, *Bjorn Aronson, 1956*

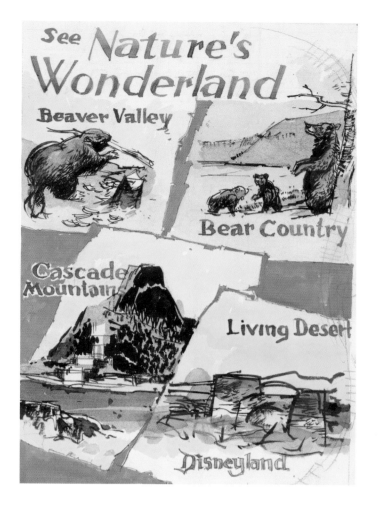

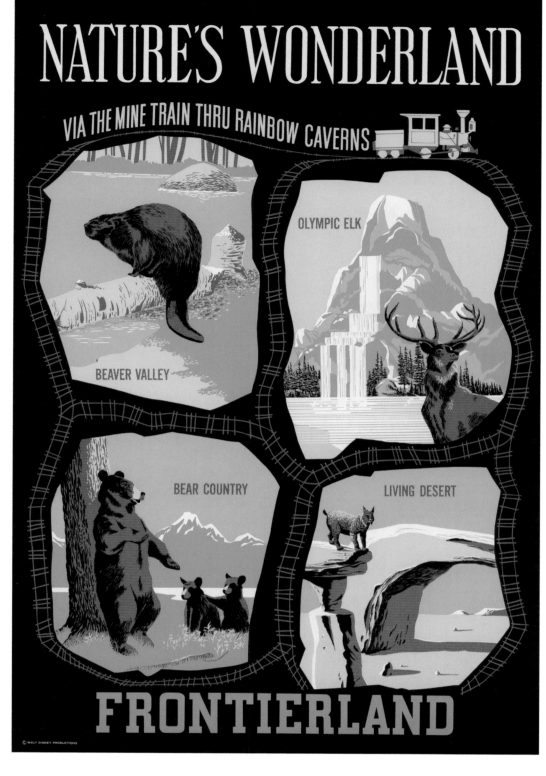

Mine Train Thru Nature's Wonderland, Disneyland
Unknown artist, 1960

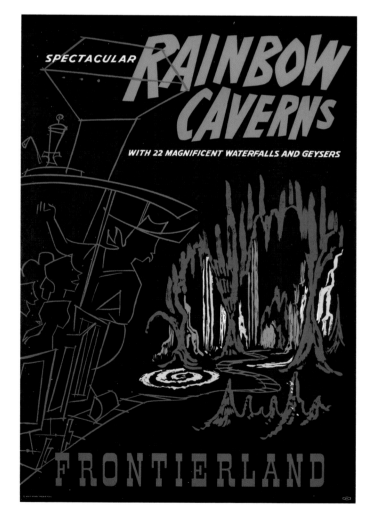

Top: Mine Train Thru Nature's Wonderland poster concept, Disneyland
Herb Ryman, 1960

Rainbow Caverns, Disneyland
Bjorn Aronson, 1956

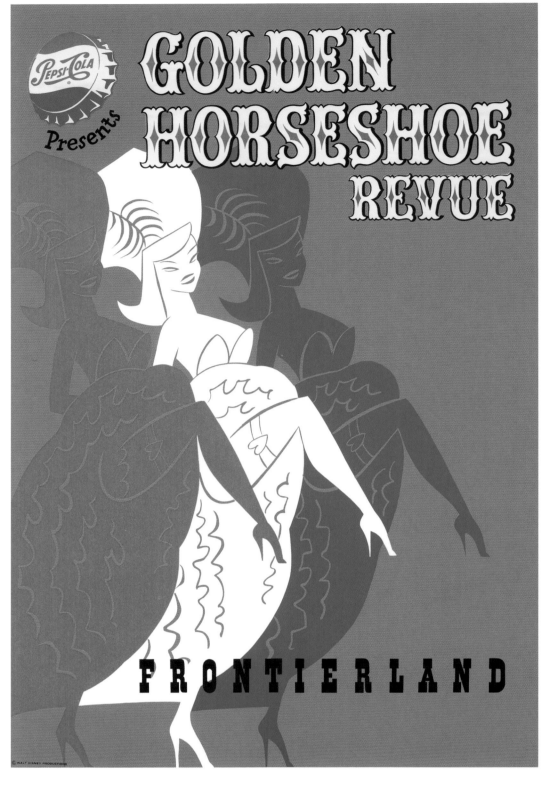

"The Golden Horseshoe Revue," Disneyland
Bjorn Aronson, 1955

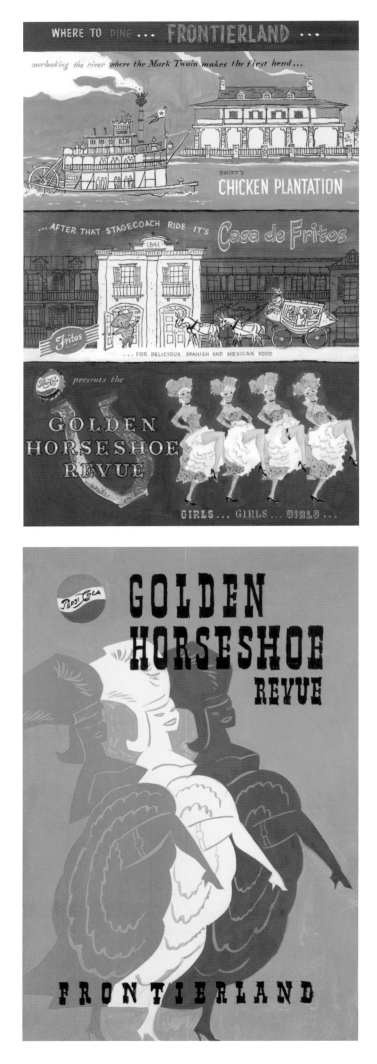

Top: Chicken Plantation, Casa de Fritos, and "The Golden Horseshoe Revue"
poster concept, Disneyland
Sam McKim, 1956

"The Golden Horseshoe Revue" poster concept, Disneyland
Bjorn Aronson, 1955

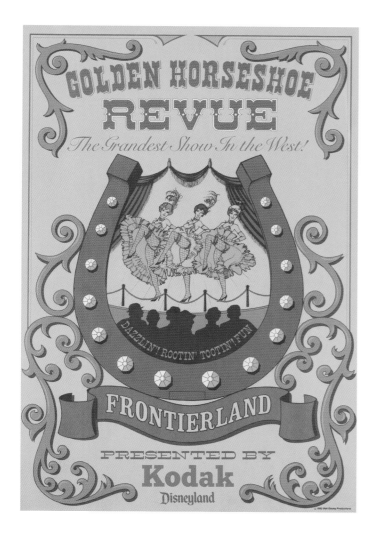

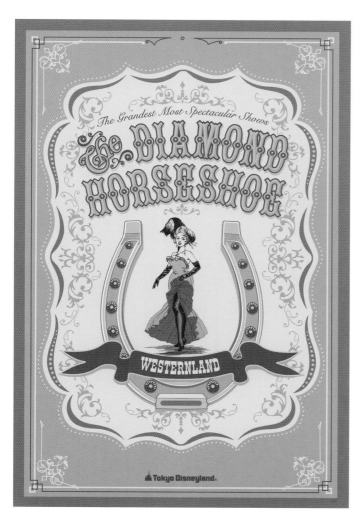

"The Diamond Horseshoe Revue," Walt Disney World
Adapted by unknown artist, 1971

Top: "The Golden Horseshoe Revue," Disneyland and Tokyo Disneyland
Patty Meyers and Collin Campbell, 1983

The Diamond Horseshoe, Tokyo Disneyland
Masahiro Tsukakoshi, 2001

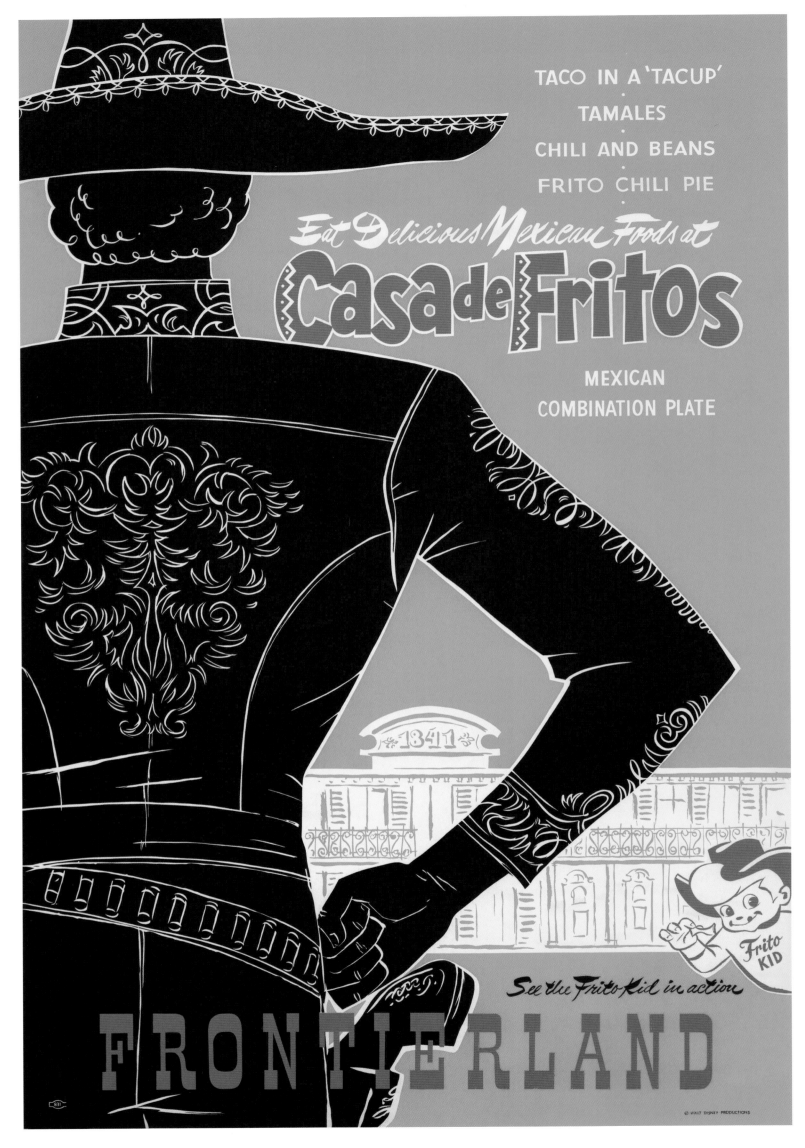

Casa de Fritos, Disneyland, *Bjorn Aronson, 1955*

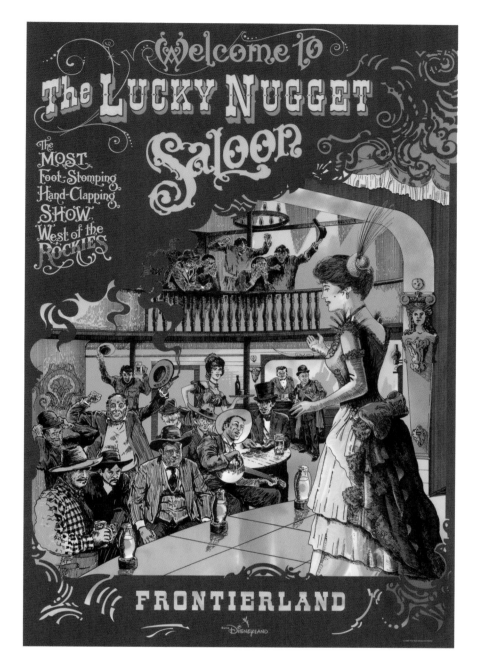

The Lucky Nugget Saloon, Disneyland Paris
Fernando Tenedora and Leticia Lelevier, 1992

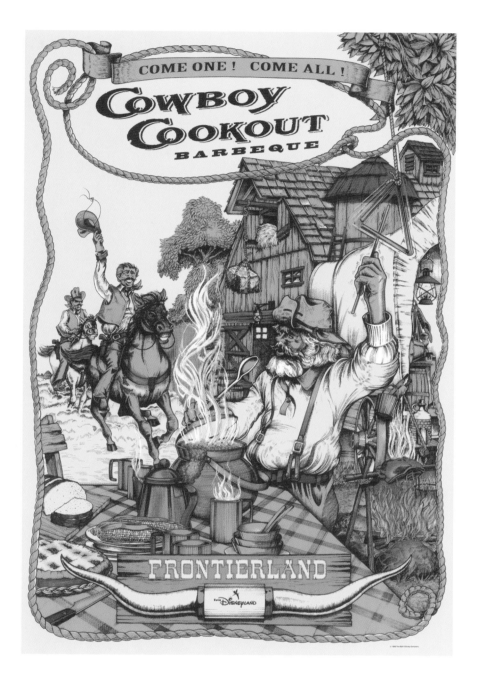

Cowboy Cookout Barbecue, Disneyland Paris
Leticia Lelevier, Fred Bodie, and Will Eyerman, 1992

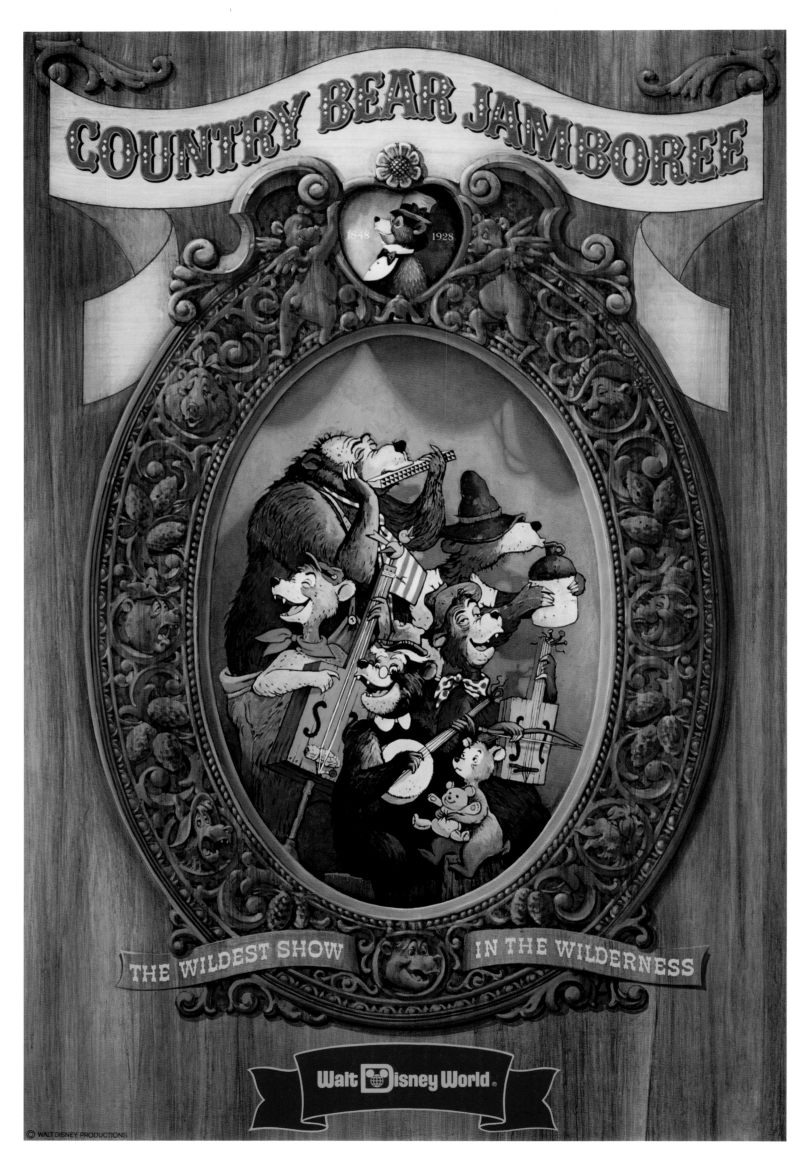

Country Bear Jamboree, Walt Disney World, Disneyland, and Tokyo Disneyland, *Jim Michaelson, Marc Davis, and Eddie Martinez, 1978*

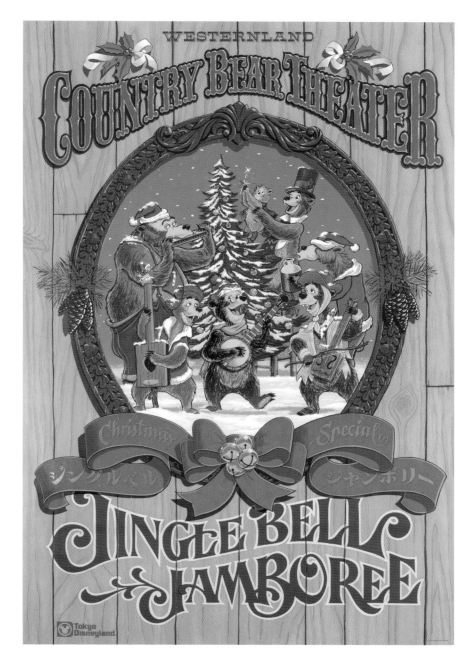

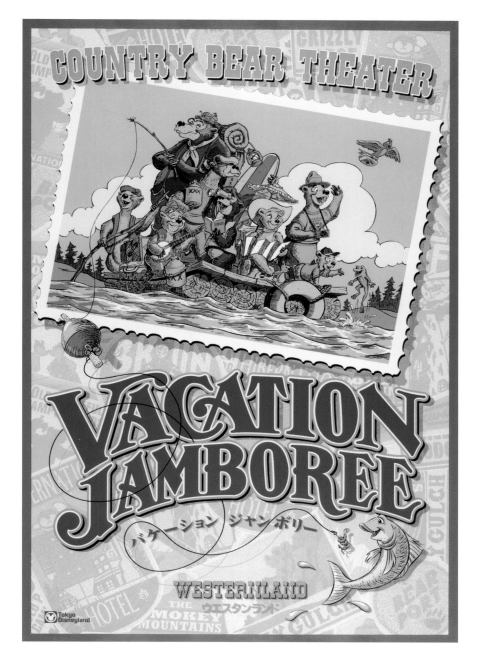

Country Bear Jingle Bell Jamboree, Tokyo Disneyland
Larry Nikolai and Michael Warzocha, 1991

Country Bear Vacation Jamboree, Tokyo Disneyland
Larry Nikolai and Will Eyerman, 1994

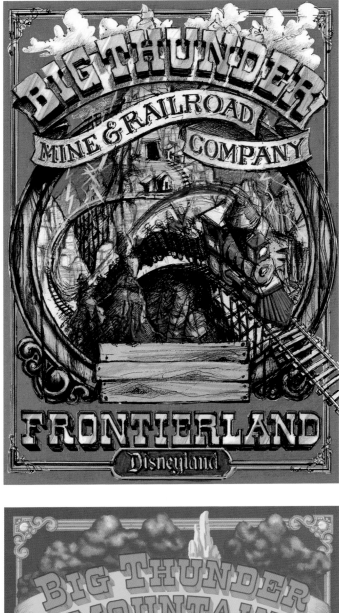

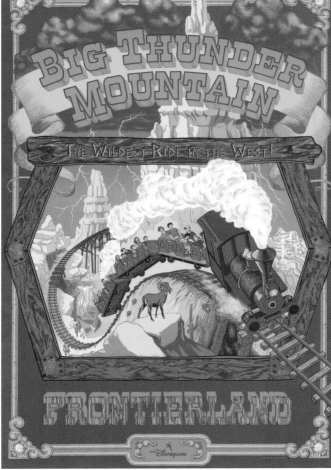

"Jim Michaelson did the original Big Thunder Mountain poster that was used for both Disneyland and Walt Disney World. I had to redo the poster because the Big Thunder story was different for Tokyo and Paris. I used a new color palette to capture the romance of the West. Back then we didn't use airbrushes because of the screens. So I used a toothbrush for the steam."

— Leticia Lelevier, former Walt Disney Imagineering graphic designer

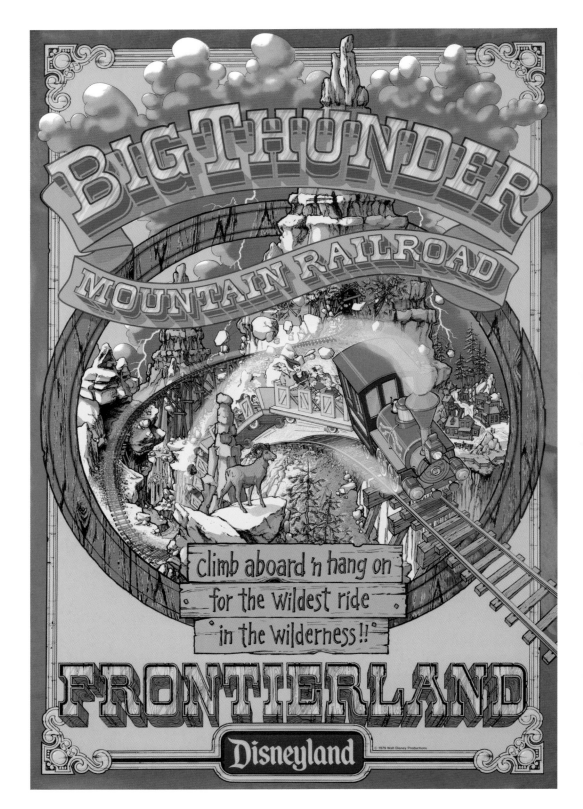

Top: Big Thunder Mountain Railroad poster concept
Disneyland and Walt Disney World
Jim Michaelson, 1977

Big Thunder Mountain, Disneyland Paris and Tokyo Disneyland
Adapted by Leticia Lelevier and Greg Paul, 1987

Big Thunder Mountain Railroad, Disneyland and Walt Disney World
Jim Michaelson, Rudy Lord, and Greg Paul, 1979

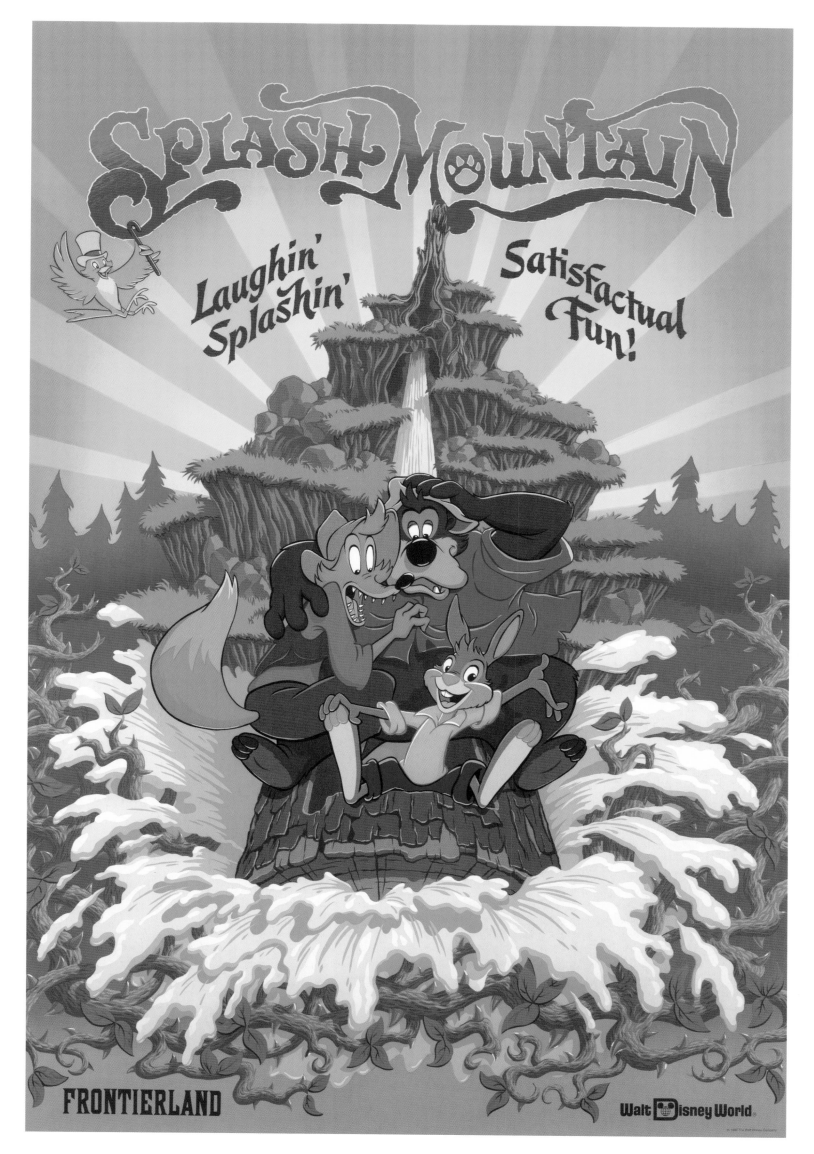

Splash Mountain, Disneyland, Walt Disney World, and Tokyo Disneyland, *Larry Nikolai, 1992*

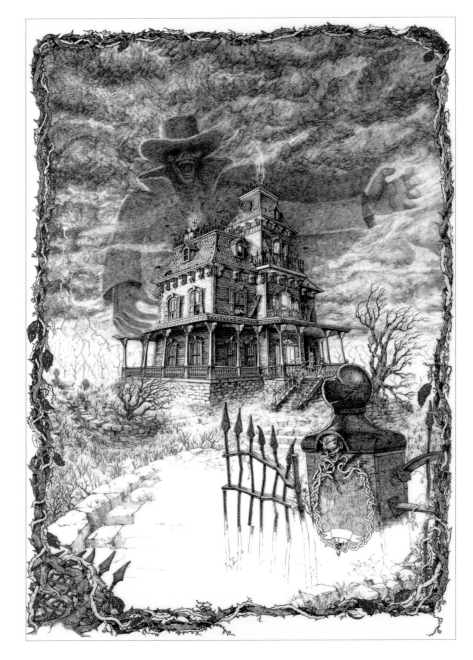

Phantom Manor poster line artwork, Disneyland Paris
Maggie Parr, 1990

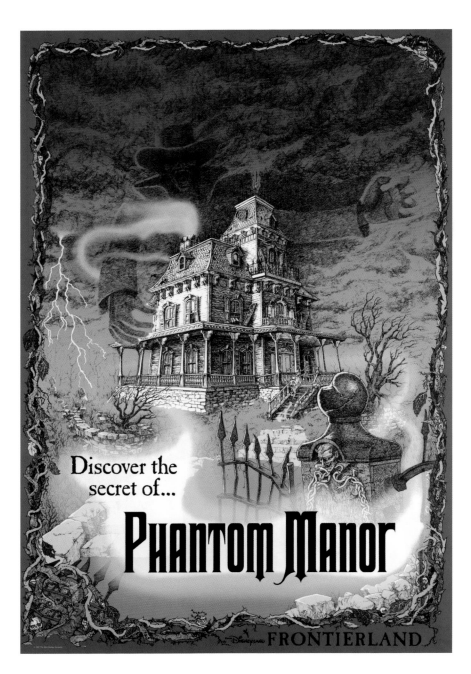

Phantom Manor, Disneyland Paris
Maggie Parr and Leticia Lelevier, 1991

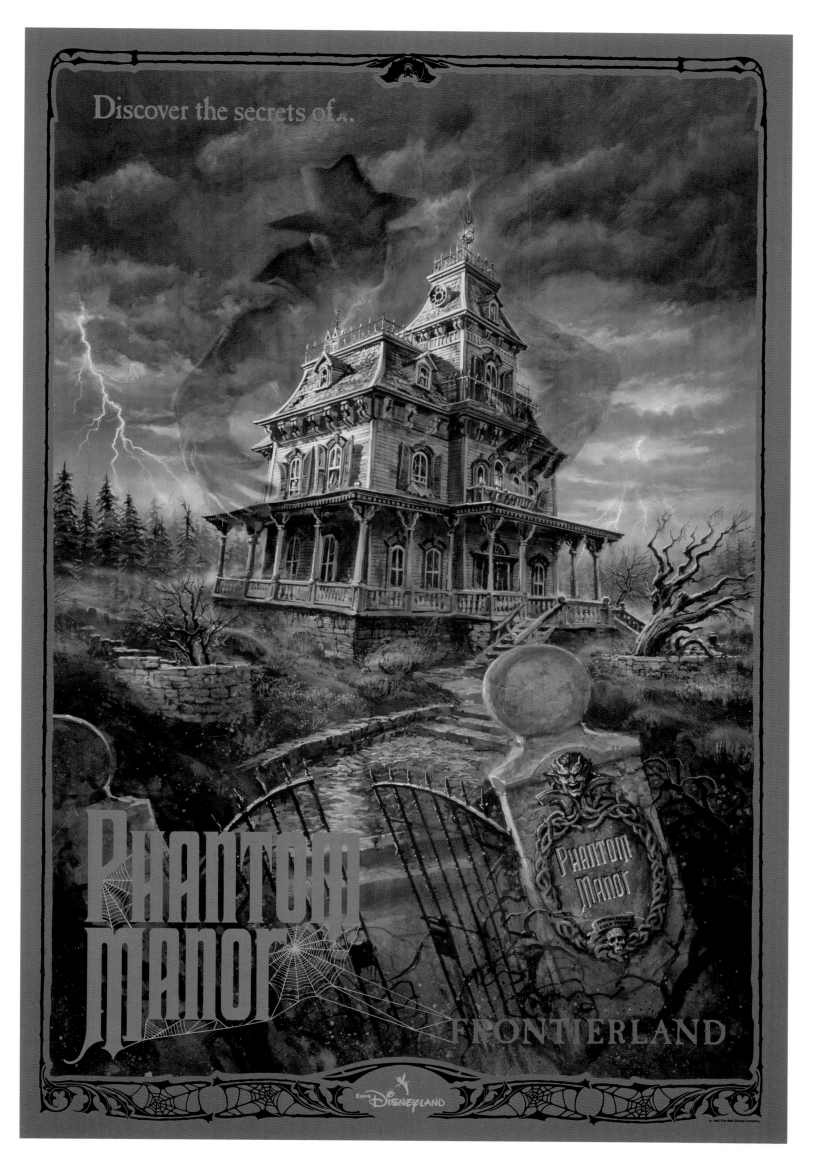

Phantom Manor, Disneyland Paris, *Dan Goozee, 1992*

Alice in Wonderland, Disneyland, *Sam McKim, 1958*

Fantasyland

"Here is the world of imagination, hopes, and dreams. In this timeless land of enchantment, the age of chivalry, magic, and make-believe are reborn—and fairy tales come true. Fantasyland is dedicated to the young-in-heart, to those who believe that when you wish upon a star, your dreams come true."

—Walt Disney

Welcome to Fantasyland—home to beloved Disney storybook characters, magnificent castles, a thrilling bobsled run, and "the happiest cruise that ever sailed 'round the world." The posters of "the Happiest Kingdom of Them All" have real character—they capture the imagination of children of all ages with their familiar faces, bold colors, and a sense of wonder and fantasy.

Taglines are a staple in the attraction poster gallery, and especially for the Fantasyland classics in Disneyland. These simple teasers give Guests a small taste of their larger roles in the story, whether they're "soaring over moonlit London to Never Land aboard a pirate galleon" on Peter Pan's Flight, "spinning into the fun-filled world of Wonderland" during the Mad Tea Party, or "wishing upon a star and reliving a fantastic adventure" on Pinocchio's Daring Journey.

Matterhorn Bobsleds was part of the first major Disneyland expansion in 1959. Although the other two new attractions of the expansion, Submarine Voyage and Disneyland Monorail, belonged to Tomorrowland, the Disneyland guide booklets from the 1960s alternately listed the Matterhorn Bobsleds under both Fantasyland and Tomorrowland. It wasn't until a decade later that the Matterhorn Bobsleds permanently settled into the Fantasyland realm. Although the concept poster suggested Tomorrowland, the final Matterhorn poster design listed Fantasyland as its home.

In the 1970s and 1980s several Fantasyland posters were designed to be adaptable for Disneyland, Walt Disney World, and Tokyo Disneyland. These flexible posters included Peter Pan's Flight, Snow White's Scary Adventures, Mad Tea Party, Dumbo the Flying Elephant, Pinocchio's Daring Journey, and "it's a small world." Some Fantasyland posters, such as 20,000 Leagues Under the Sea in Walt Disney World and Haunted Mansion in Tokyo Disneyland, were altered posters from other Magic Kingdom Parks' lands.

However, not all the posters in this period were multipurpose, such as the ones promoting the new additions to Tokyo Disneyland in the 1980s. The macabre poster for Cinderella Castle Mystery Tour shows the villains, ghouls, and gigantic dragon one will encounter deep within Cinderella Castle—including the Horned King from *The Black Cauldron* (one of the few attractions to feature elements from this 1985 animated feature film). Imagineering legend X Atencio's wonderful sense of character design is evident in the poster for The Mickey Mouse Revue, an attraction brought over from Walt Disney World to Tokyo Disneyland in 1983. Although Atencio is better known for writing the scripts and the song lyrics for Pirates of the Caribbean and Haunted Mansion, he was also a talented artist who began his forty-seven-year Disney career in Feature Animation.

Attraction posters are tools to not only excite Guests, but to educate them as well. Such is the case for Hong Kong Disneyland, where posters are used to inform an audience unfamiliar with the Disney experience. While the posters for "it's a small world" in other Magic Kingdom Parks are simple and stylized, the poster for Hong Kong Disneyland literally shows Guests riding boats in the attraction. Something as simple as this will help the Guests better understand what they will be experiencing.

Nearby Fantasyland at Tokyo Disneyland is another fanciful land—Toontown. The poster for Toontown captures the whimsical nature and unique style of its setting, as well as the memorable characters that inhabit it.

From flying elephants to mad tea parties, the posters of Fantasyland capture the fun and imagination for the young and young-at-heart.

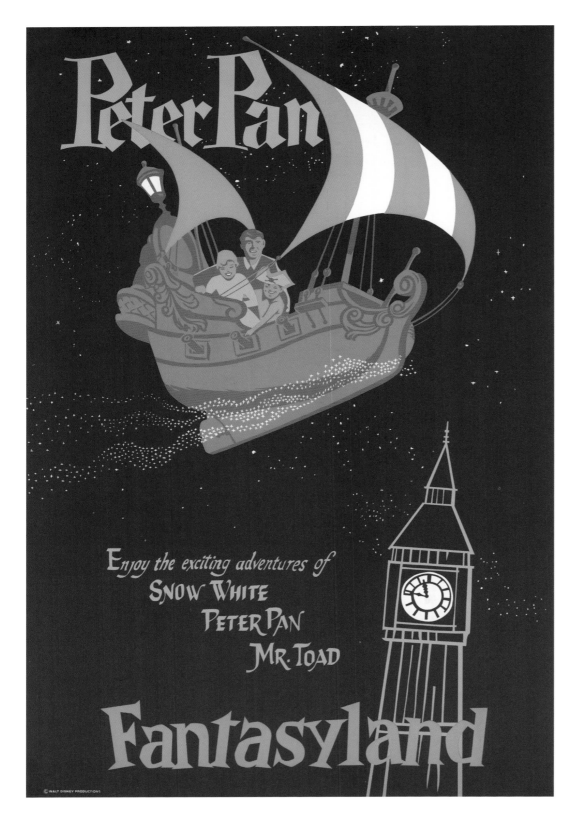

Peter Pan's Flight, Disneyland and Walt Disney World
Bjorn Aronson, 1955

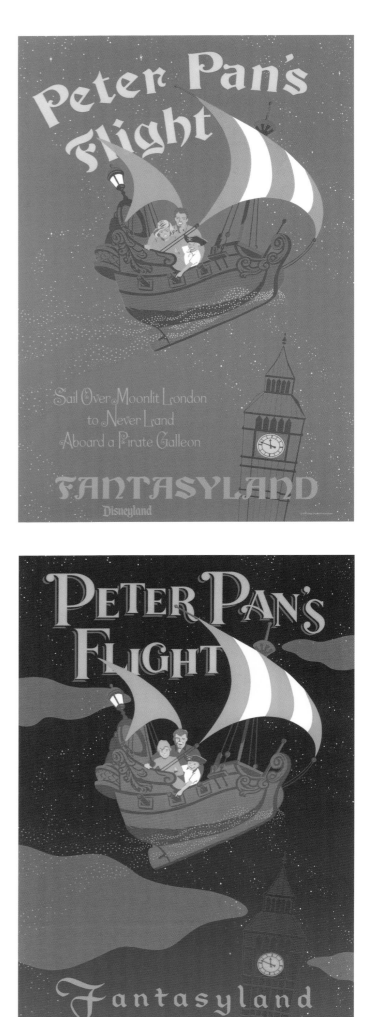

Top: Peter Pan's Flight, Disneyland and Tokyo Disneyland
Adapted by Leticia Lelevier, 1983

Peter Pan's Flight, Disneyland Paris
Adapted by Steve Cargile, 1990

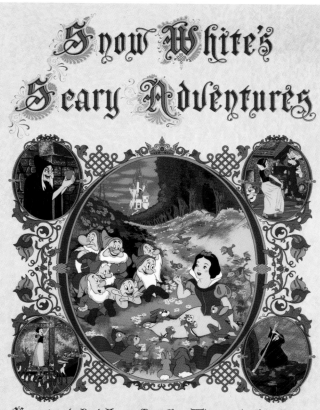

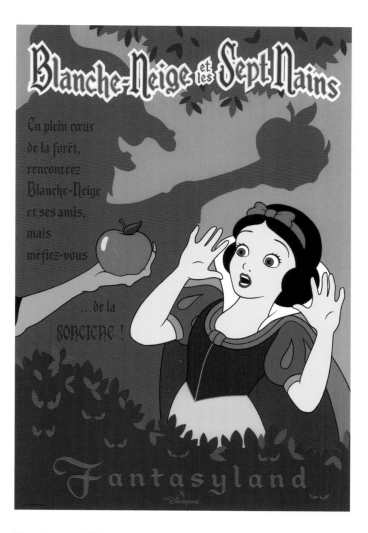

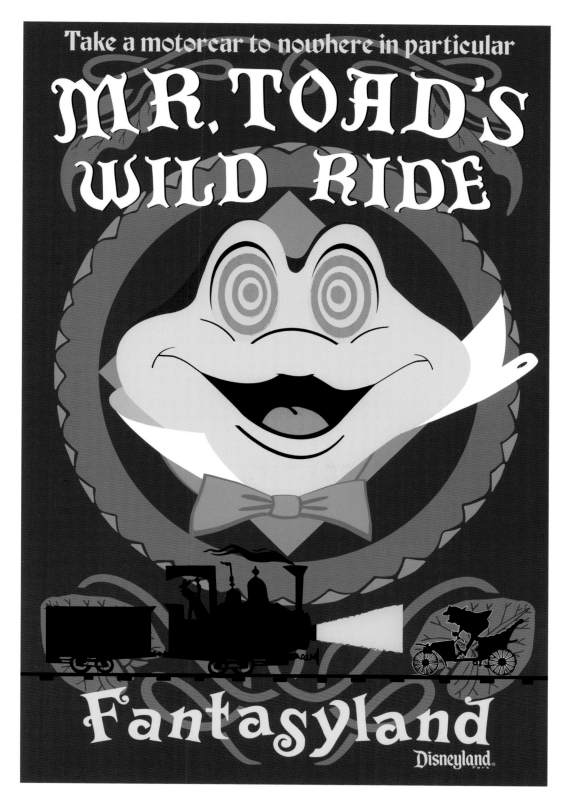

Mr. Toad's Wild Ride, Disneyland
Danny Handke, 2008

Top: Snow White's Scary Adventures, Disneyland,
Walt Disney World, and Tokyo Disneyland
Leticia Lelevier, 1983

Blanche-Neige et les Sept Nains, Disneyland Paris
Steve Cargile, Tom Morris, and Tracy Trinast, 1991

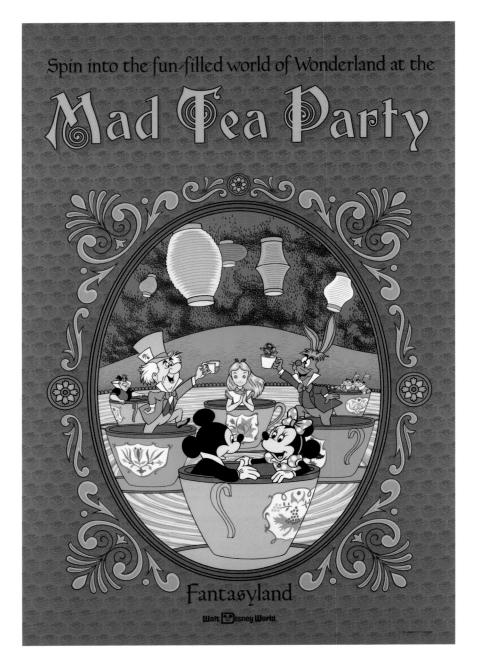

Mad Tea Party, Disneyland, Walt Disney World, and Tokyo Disneyland
John Drury and Greg Paul, 1985

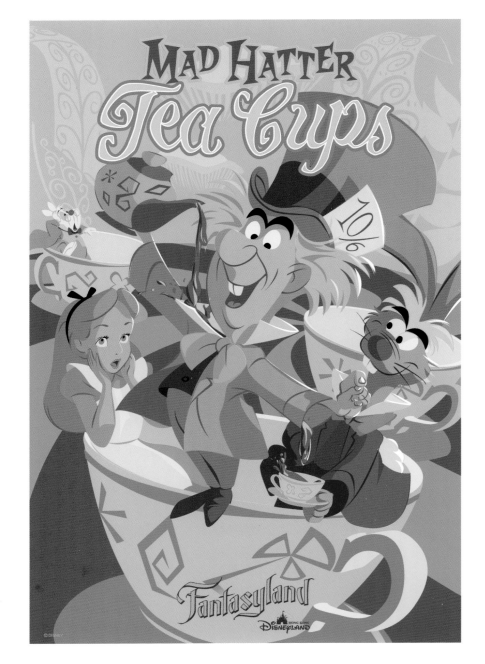

Mad Hatter Tea Cups, Hong Kong Disneyland
Greg Maletic, 2005

"In the Mad Hatter Tea Cups poster [for Hong Kong Disneyland] I had originally drawn the White Rabbit's arms up in the air, presumably in some expression of delight and excitement. The Legal department had one objection—the White Rabbit's hands were not inside the ride vehicle, which was considered unsafe behavior. I pointed out that the Mad Hatter was actually standing on the edge of the cup, completely outside the ride vehicle, pouring hot tea down his sleeve. Compared to that, I thought the White Rabbit's behavior was pretty innocuous. 'Well, he's mad,' was the response. And that was that—the White Rabbit's arms went back in the ride vehicle!"

— Greg Maletic, *graphic designer*

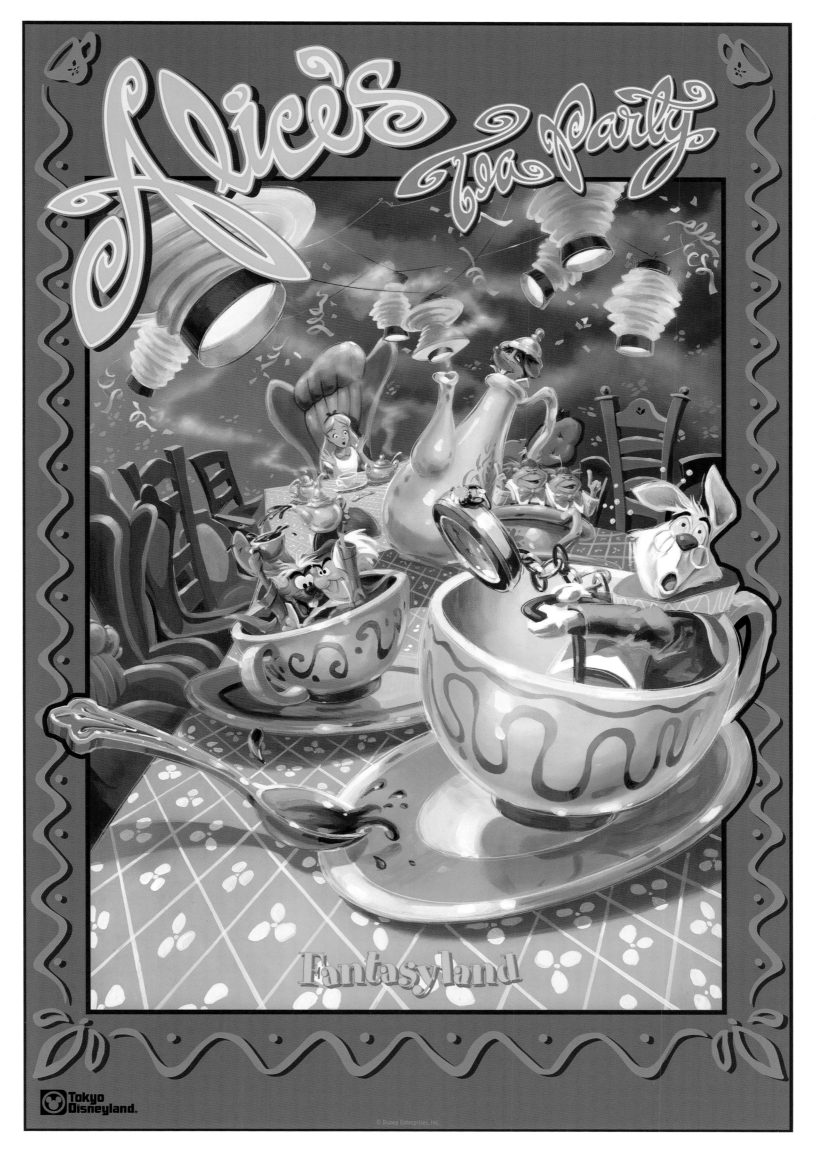

Alice's Tea Party, Tokyo Disneyland, *Christopher Smith, 1998*

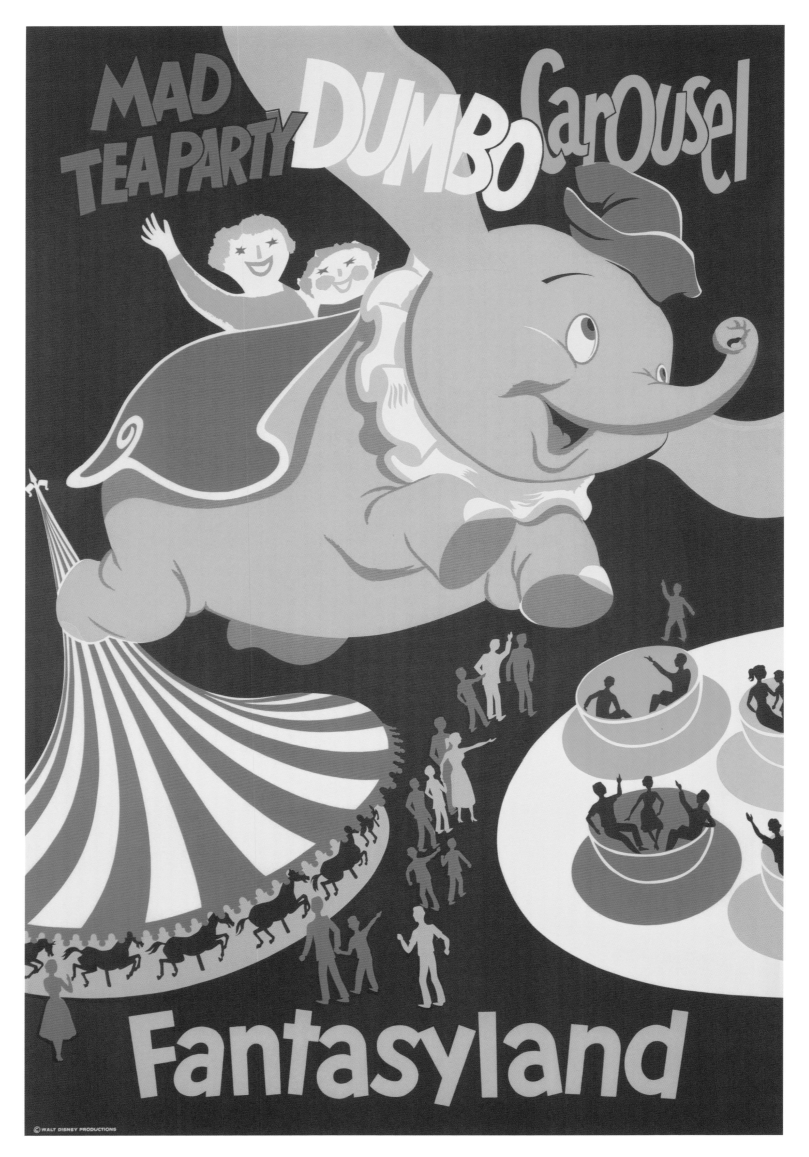

Dumbo, Mad Tea Party, and Carousel, Disneyland and Walt Disney World, *Bjorn Aronson, 1955*

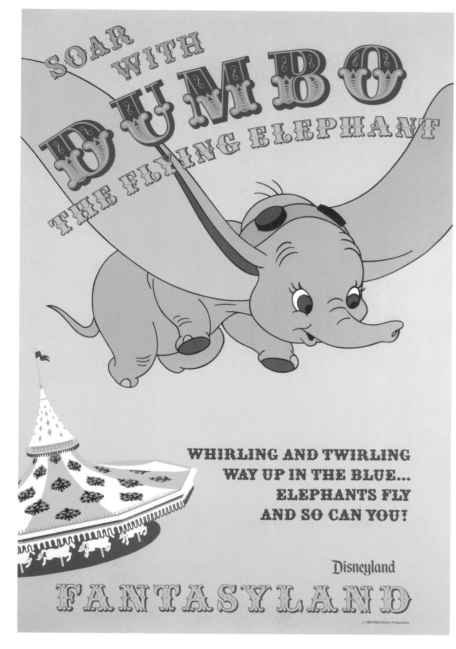

Dumbo the Flying Elephant, Disneyland and Tokyo Disneyland
Leticia Lelevier, 1983

Dumbo the Flying Elephant, Hong Kong Disneyland
Greg Maletic, 2005

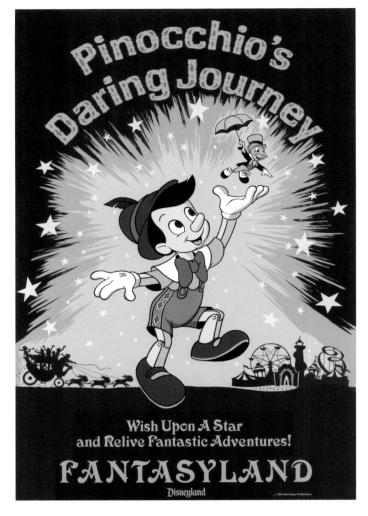

Pinocchio's Daring Journey, Disneyland and Tokyo Disneyland
Bill Justice, 1983

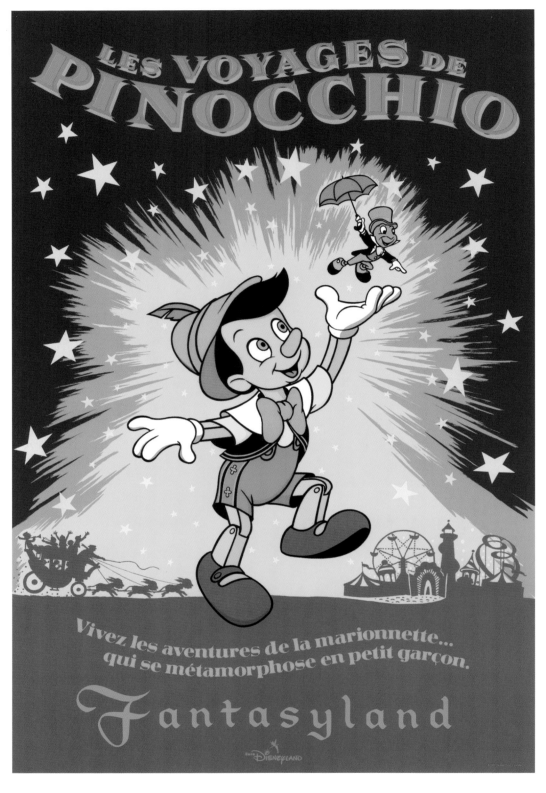

Les Voyages de Pinocchio, Disneyland Paris
Adapted by Steve Cargile and Tracy Trinast, 1992

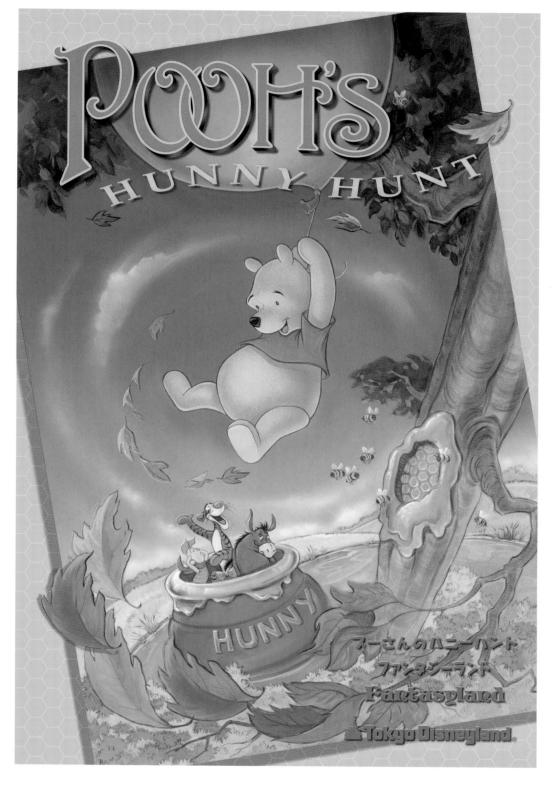

Pooh's Hunny Hunt, Tokyo Disneyland
Nina Rae Vaughn and Vince Petersen, 2000

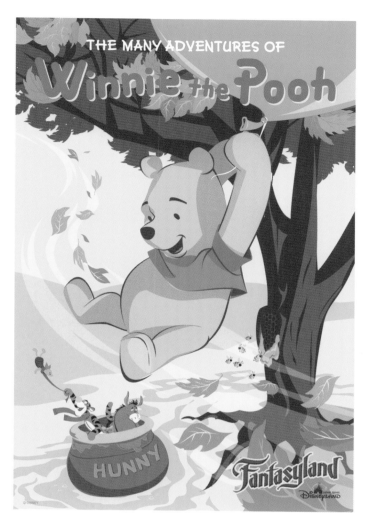

The Many Adventures of Winnie the Pooh
Hong Kong Disneyland and Disneyland
Greg Maletic, 2005

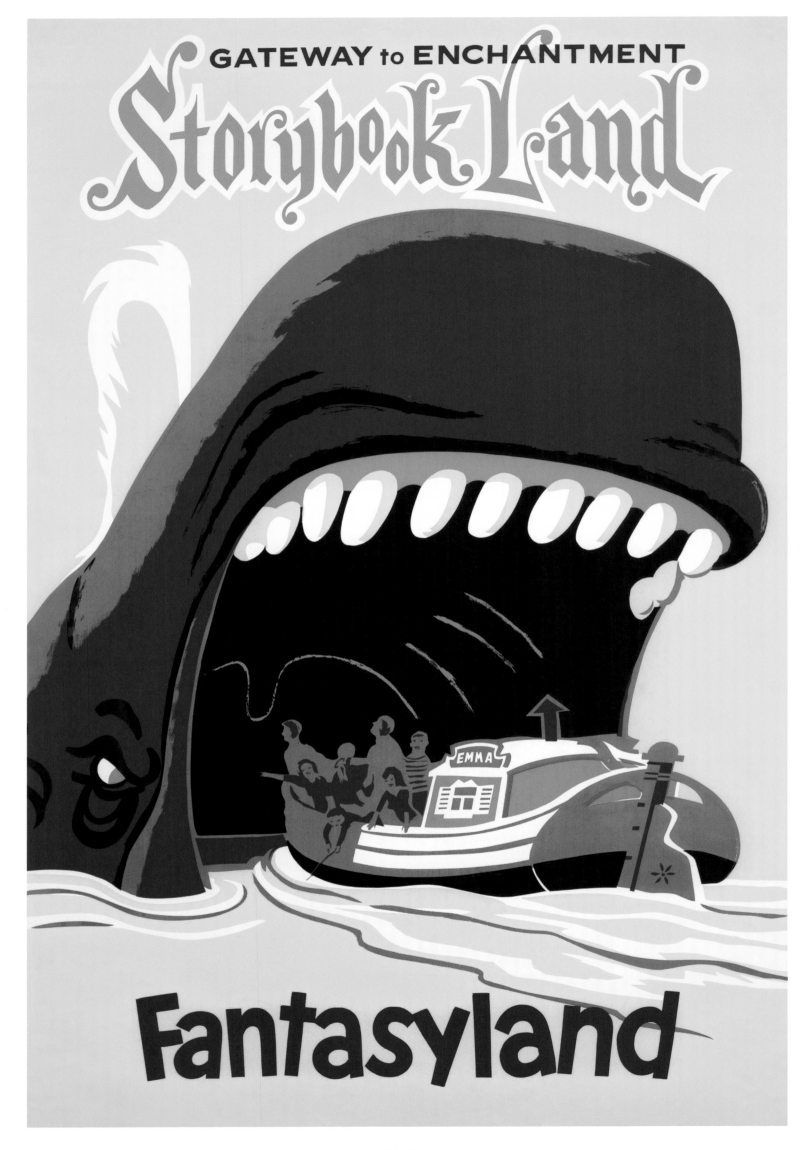

Storybook Land Canal Boats, Disneyland, *Bjorn Aronson, 1955*

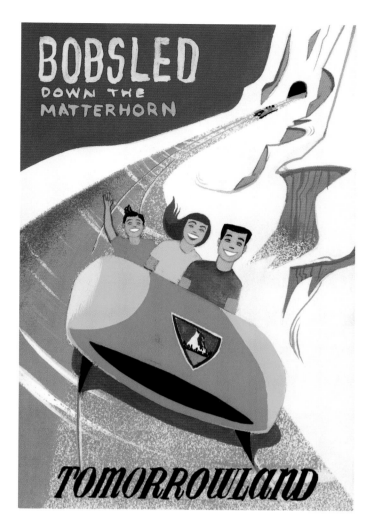

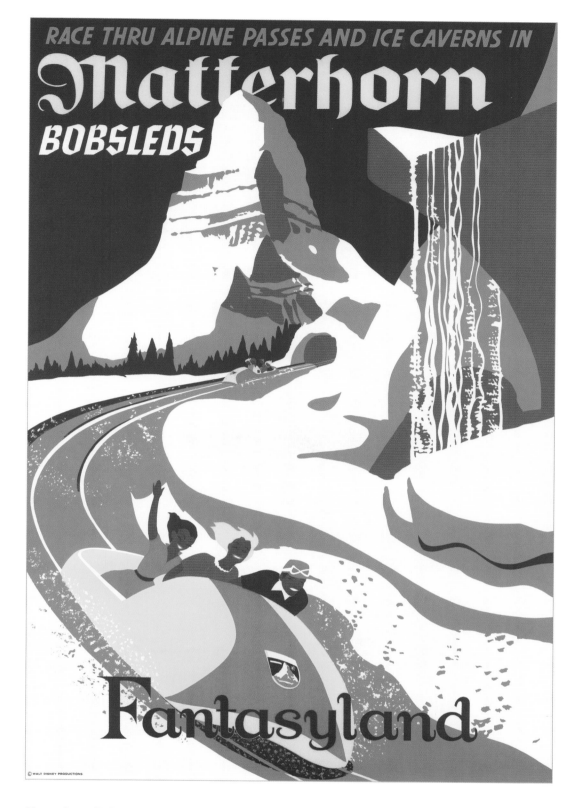

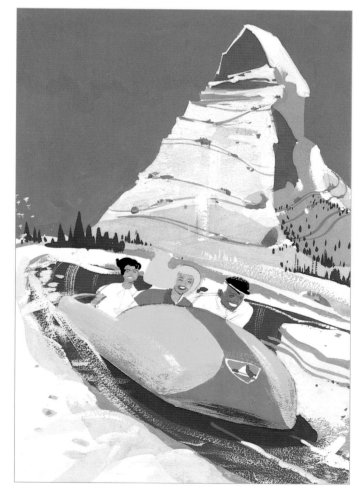

Matterhorn Bobsleds poster concepts, Disneyland
Paul Hartley, 1959

Matterhorn Bobsleds, Disneyland
Paul Hartley, 1959

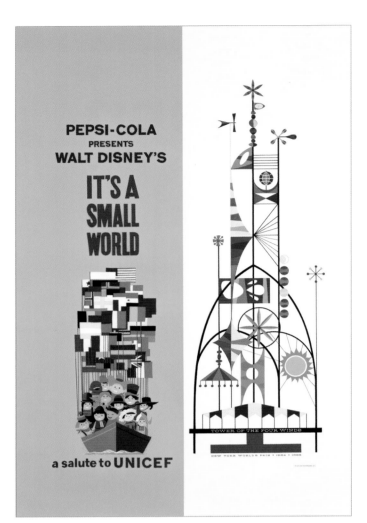

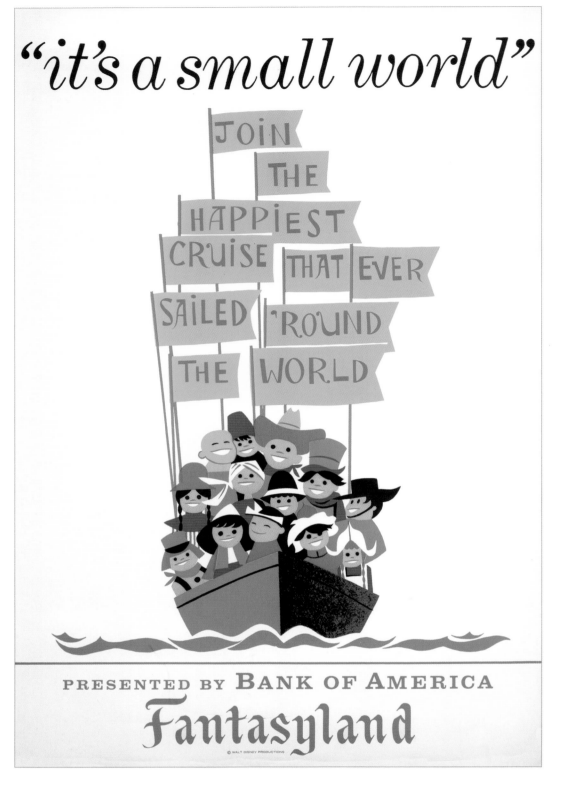

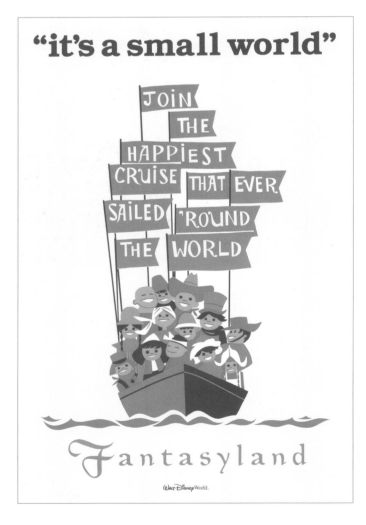

"it's a small world," Disneyland and Walt Disney World
Paul Hartley, 1966

Top: "it's a small world," 1964–65 New York World's Fair
Paul Hartley, 1963

"it's a small world," Disneyland, Walt Disney World, and Tokyo Disneyland
Adapted by Leticia Lelevier, 1983

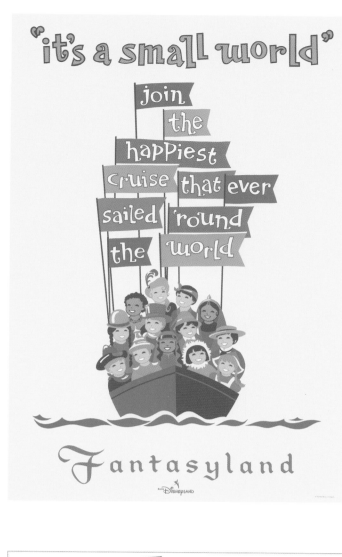

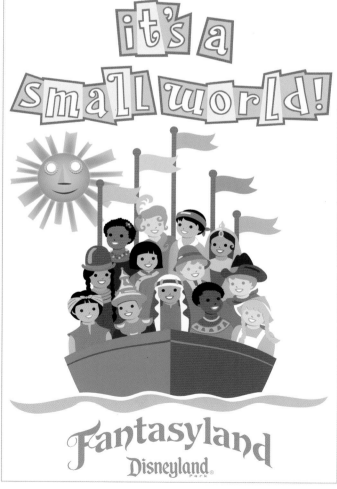

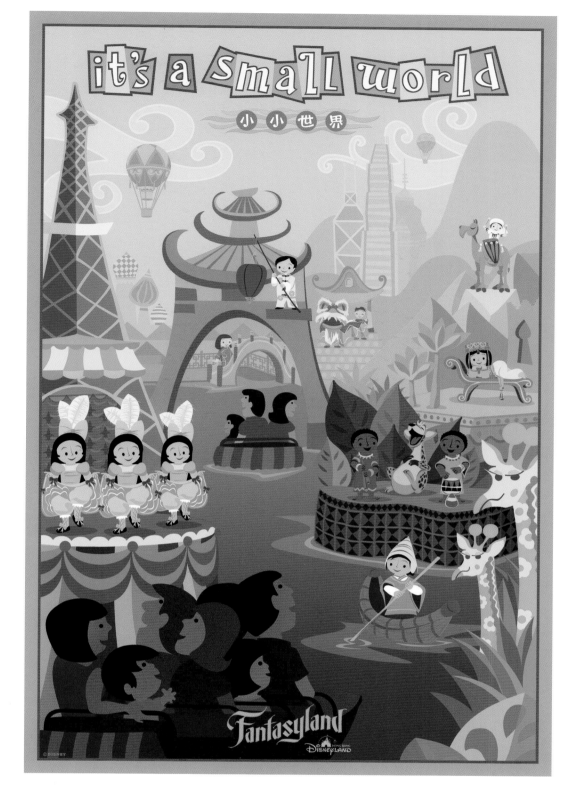

"it's a small world," Hong Kong Disneyland
Will Eyerman and Greg Maletic, 2008

Top: "it's a small world," Disneyland, Walt Disney World, and Disneyland Paris
Adapted by Steve Cargile and Tracy Trinast, 1992

"it's a small world," Disneyland
Danny Handke and Eileen Xie, 2009

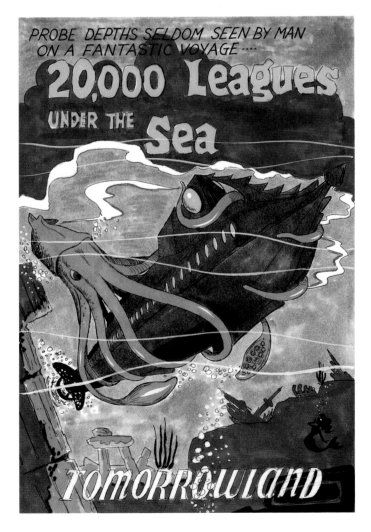

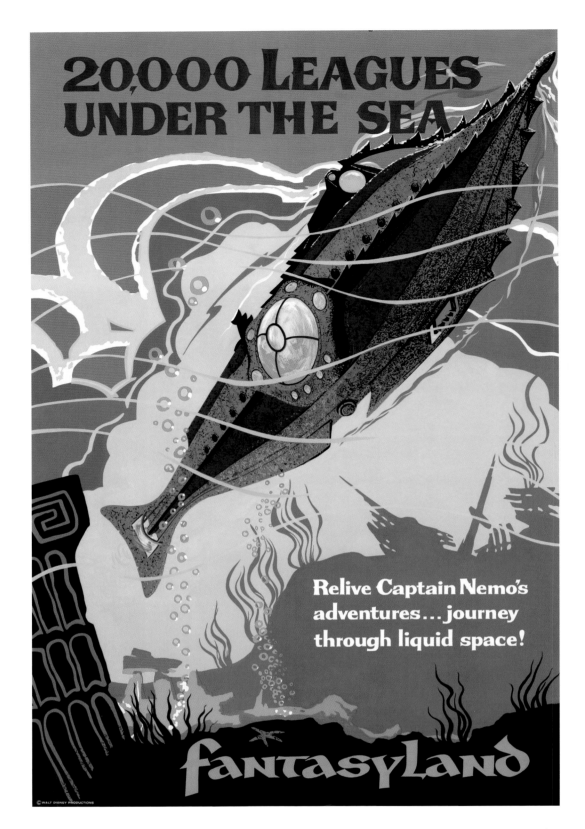

20,000 Leagues Under the Sea, Walt Disney World
Adapted by Richard Hebner, 1971

Top: 20,000 Leagues Under the Sea poster concept, Walt Disney World
Jim Michaelson, 1976

20,000 Leagues Under the Sea poster concept, Walt Disney World
Unknown artist, 1971

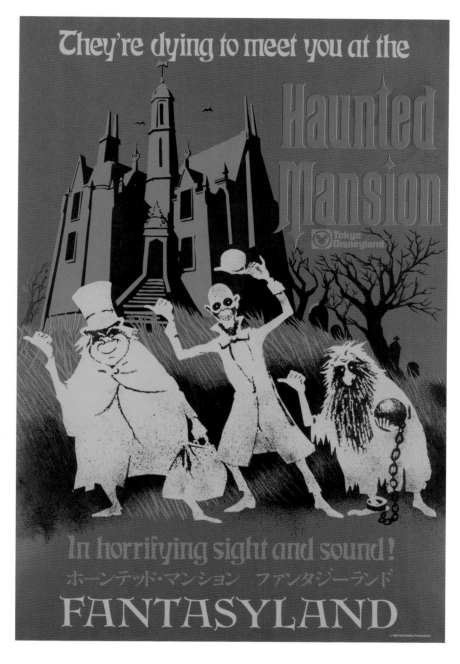

Haunted Mansion, Tokyo Disneyland
Ken Chapman and Marc Davis, 1983

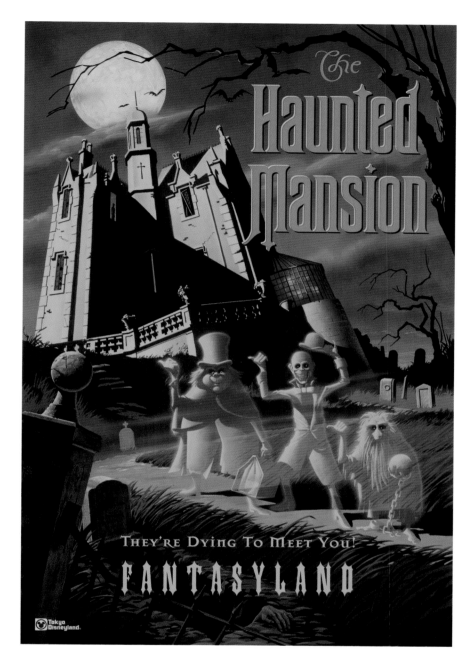

Haunted Mansion, Tokyo Disneyland
George Stokes and Debbie Lord, 1998

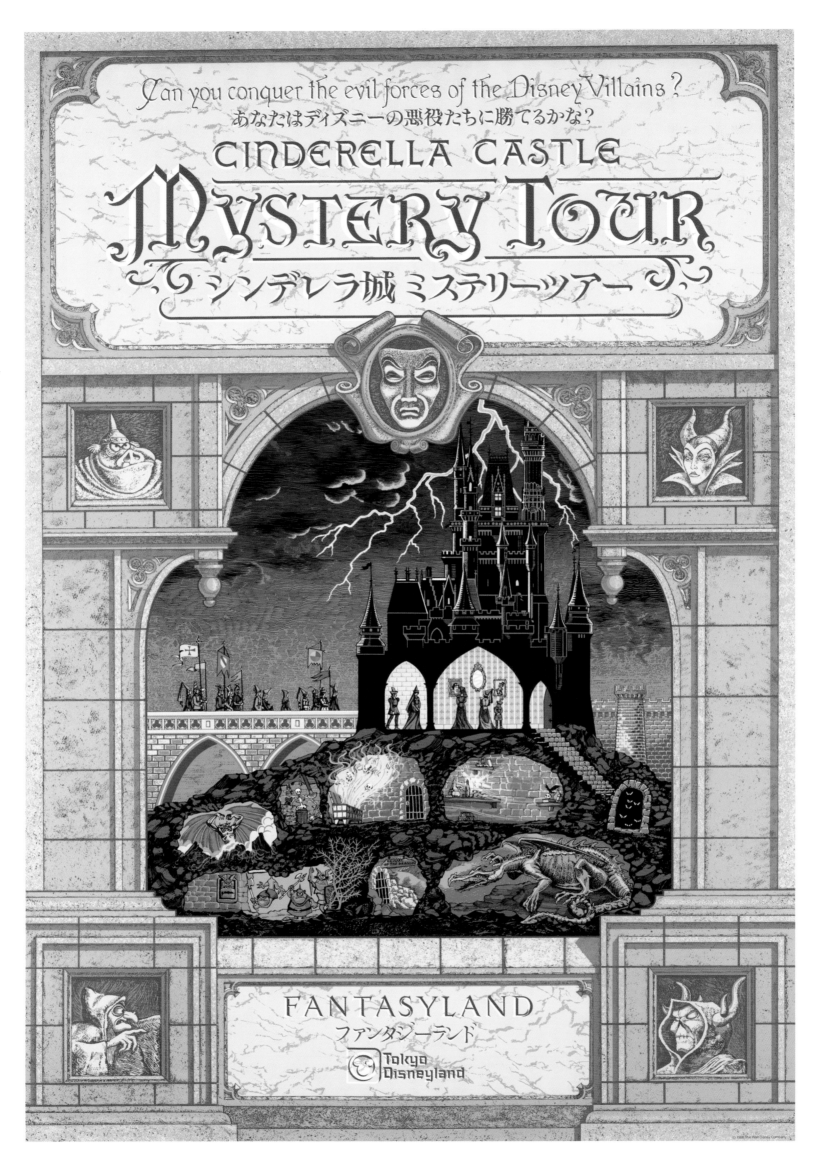

Cinderella Castle Mystery Tour, Tokyo Disneyland, *John Drury and Greg Paul, 1986*

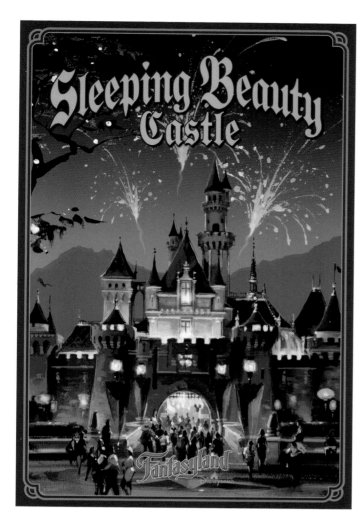

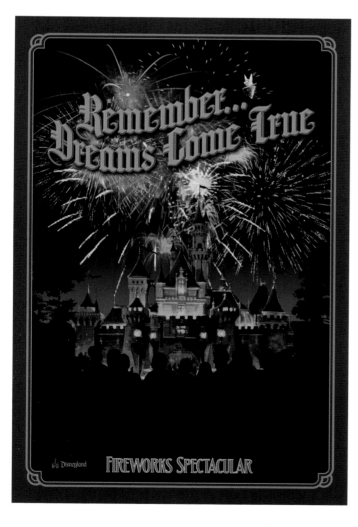

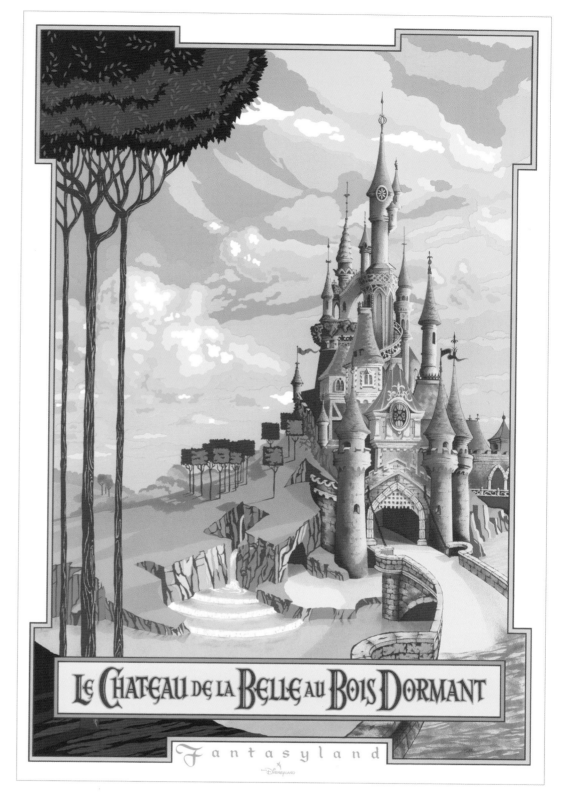

Le Château de la Belle au Bois Dormant, Disneyland Paris
Tracy Trinast and Tom Morris, 1992

Top: Sleeping Beauty Castle, Hong Kong Disneyland
Christopher Smith and Louis Lemoine, 2005

"Remember . . . Dreams Come True" Fireworks Spectacular, Disneyland
Louis Lemoine, 2007

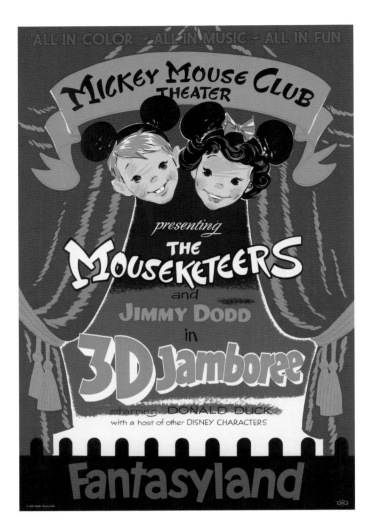

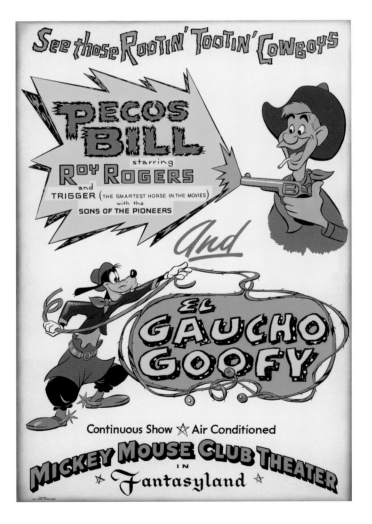

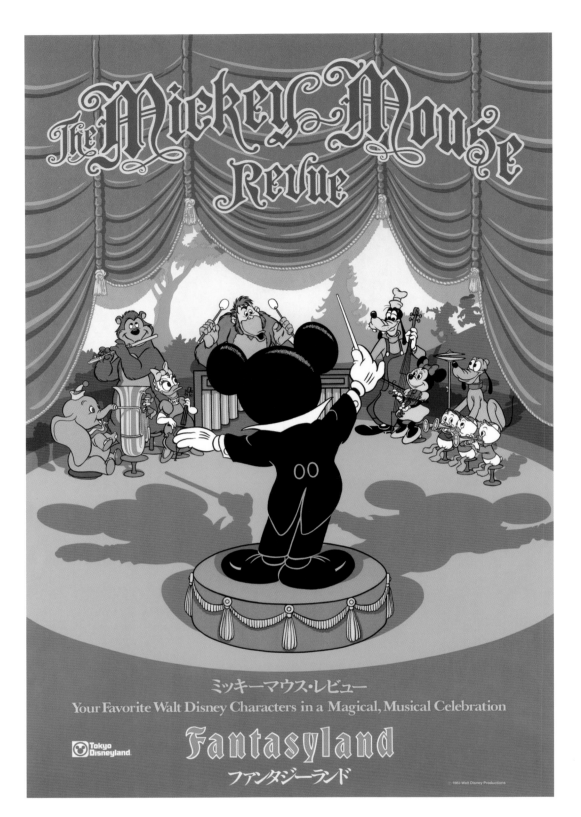

The **Mickey Mouse Revue,** Tokyo Disneyland
X Atencio and Leticia Lelevier, 1983

Top: Mickey Mouse Club Theater—3D Jamboree, Disneyland
Unknown artist, 1955

Mickey Mouse Club Theater—Pecos Bill and El Gaucho Goofy, Disneyland
Unknown artist, 1955

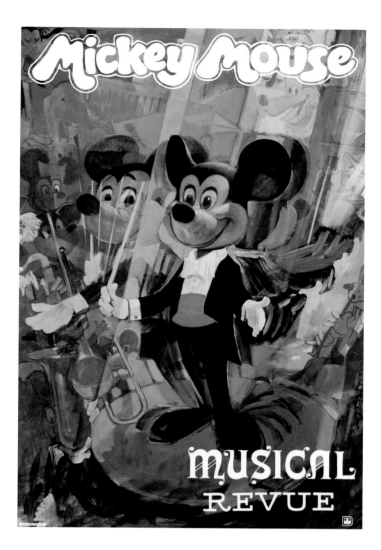

The Mickey Mouse Revue, Walt Disney World
John DeCuir Sr. and David Negron, 1971

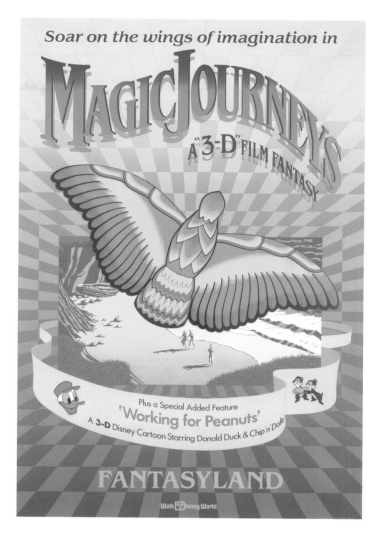

Magic Journeys, Walt Disney World
Greg Paul, Norm Inouye, and Mimi Sheean, 1987

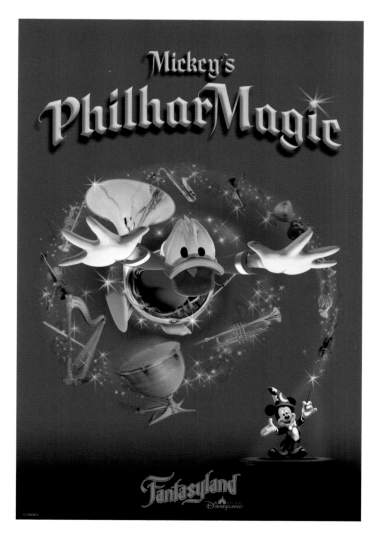

Mickey's PhilharMagic
Walt Disney World, Hong Kong Disneyland, and Tokyo Disneyland
George Scribner, 2005

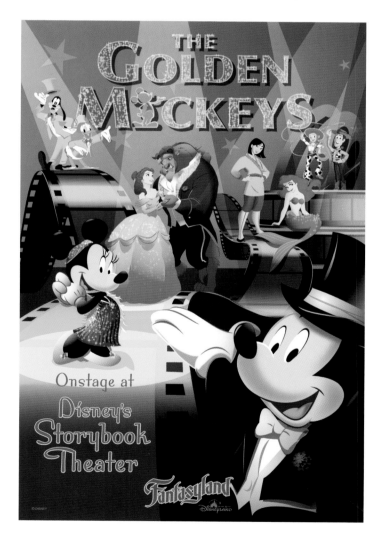

Disney's Storybook Theater—"The Golden Mickeys"
Hong Kong Disneyland
Greg Maletic, 2005

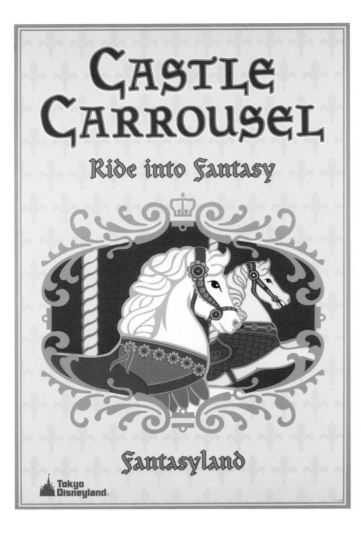

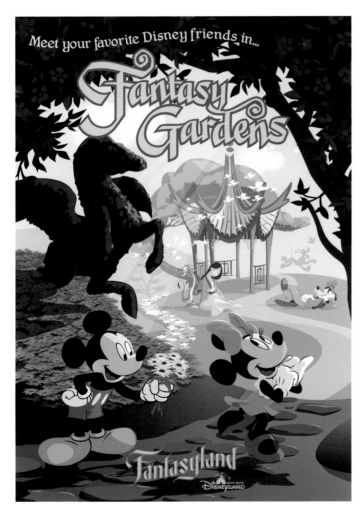

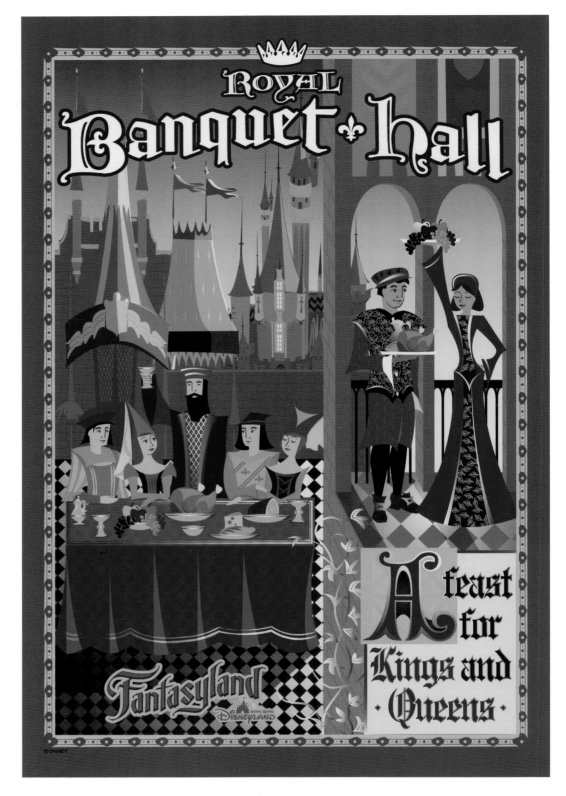

Royal Banquet Hall, Hong Kong Disneyland
Greg Maletic, 2005

Top: Castle Carrousel, Tokyo Disneyland
Leticia Lelevier, 2001

Fantasy Gardens, Hong Kong Disneyland
Greg Maletic, 2005

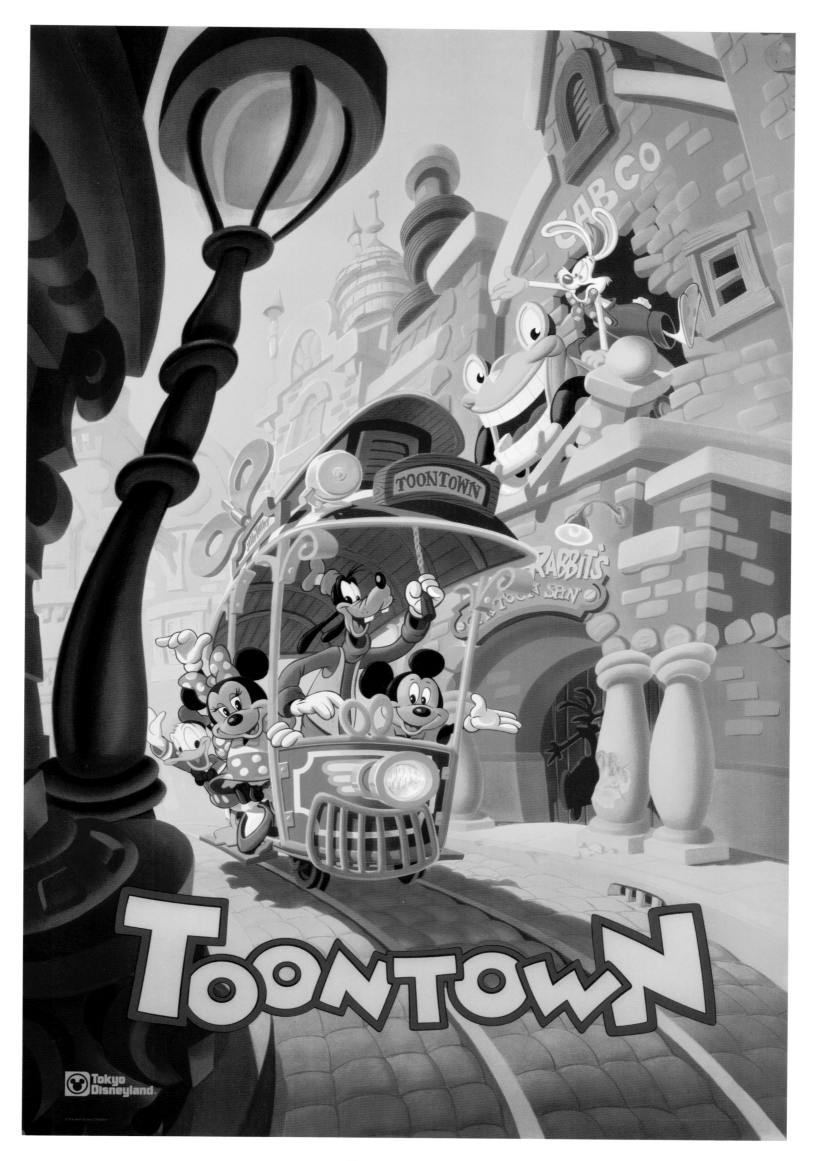

Toontown, Tokyo Disneyland, *Marcelo Vignali and Andrea Hom, 1995*

The Future
That Never
Was...
Is Finally
Here!

TOMORROWLAND

Walt Disney World

New Tomorrowland, Walt Disney World, *George Stokes and Anne Tryba, 1995*

90

CHAPTER SEVEN
TOMORROWLAND

"A vista into a world of wondrous ideas, signifying man's achievements . . . a step into the future, with predictions of constructive things to come. Tomorrow offers new frontiers in science, adventure, and ideals: the atomic age . . . the challenge of outer space . . . and the hope for a peaceful and unified world."

— Walt Disney

Inspired by visions of the future, Tomorrowland is where one can blast off in a rocket ship, submerge undersea aboard a submarine, or "ride tomorrow's transportation today." It's a land that's always on the move—with innovative ideas, both practical and imagined, constantly shaping new attractions and experiences for Guests to enjoy.

Tomorrowland has a rather robust and eclectic gallery of posters due to the ever-evolving nature of the land. The 1950s Tomorrowland posters for Disneyland are simple with bold elements—for example, the giant squid from 20,000 Leagues Under the Sea or the Moonliner rocket ship in Rocket to the Moon. The Disneyland posters from the 1960s are stylized and abstract; the atomic scheme of the Adventure Thru Inner Space poster and the stage design of the Carousel of Progress poster both exhibit these qualities.

From the 1970s through the 1990s, the Tomorrowland posters become more imaginative than ever—with designs for Space Mountain and Star Tours taking on an artistic approach to further illustrate the fantastic nature of the land. Today, the past inspires the future, which is evident in the retro designs of the posters for Autopia, Finding Nemo Submarine Voyage, and Disneyland Monorail Mark VII.

For example, the original 1959 Disneyland Monorail attraction poster was used as inspiration for the layout of the Mark VII poster. Because the original poster may appear dated for the Tomorrowland of today, the updated poster's design features a digital paint approach to enhance the sleek, elegant, and modern look of the Mark VII monorails.

Some attractions, such as Space Mountain, continue to have many incarnations of posters through the years, while several obscure attractions, like Space Station X-1, have each had one consistent design. These posters are not only time capsules of the various phases of Tomorrowland but gorgeous works of art celebrating "a great big beautiful tomorrow."

Science fiction reigns supreme in Tomorrowland, as is evident in the illustrative and aesthetically pleasing posters for Disneyland Paris. The posters for Videopolis, Orbitron—Machines Volantes, and Space Mountain—De la Terre à la Lune all look as if they belong in the science fantasy novels of Jules Verne.

Speaking of science fantasy, the universal theme of Tomorrowland allows for some familiar faces. Guests join Buzz Lightyear in an intergalactic battle with the Evil Emperor Zurg in Buzz Lightyear Astro Blasters, an attraction found at all Magic Kingdom Parks. In Hong Kong Disneyland, Guests have an interactive conversation with everybody's favorite alien experiment, Stitch, in Stitch Encounter. And at Tokyo Disneyland, Guests play the flashlight hide-and-go-seek game with Mike and Sulley in Monsters, Inc. Ride & Go Seek! Whether it's science fact or science fantasy, there is real "character" to Tomorrowland.

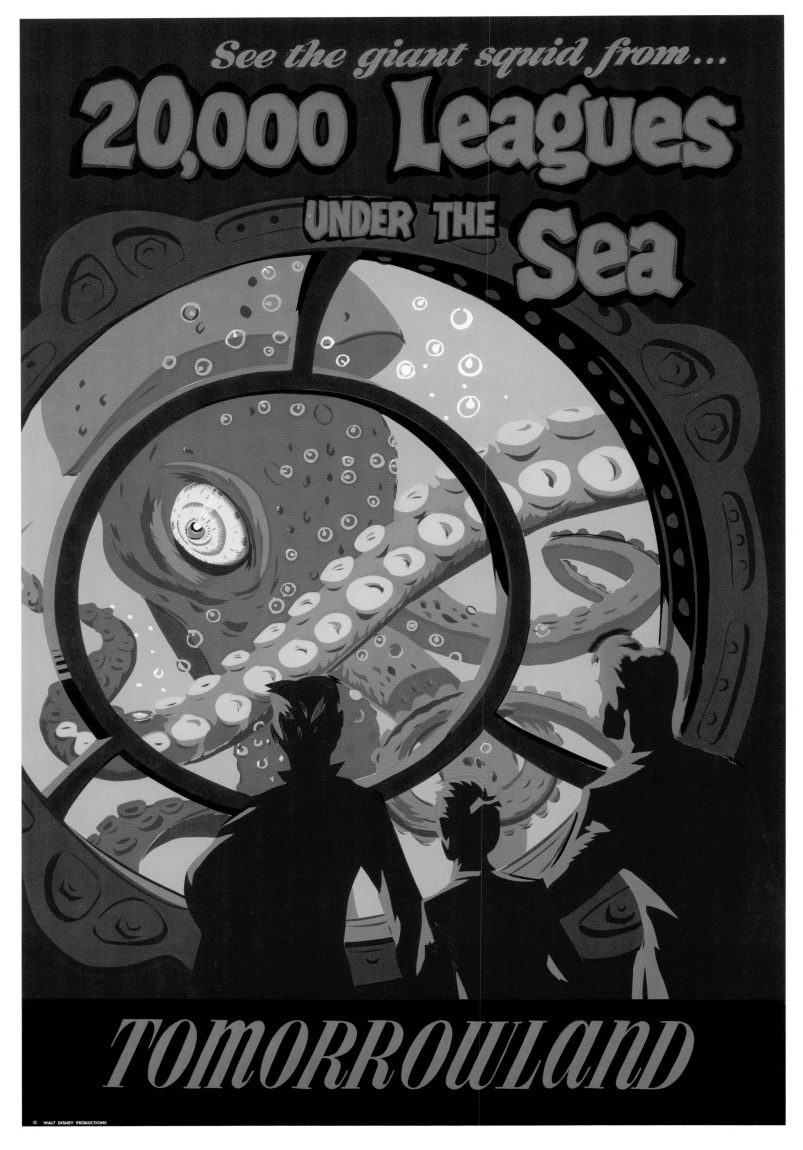

20,000 Leagues Under the Sea, Disneyland, *Bjorn Aronson, 1955*

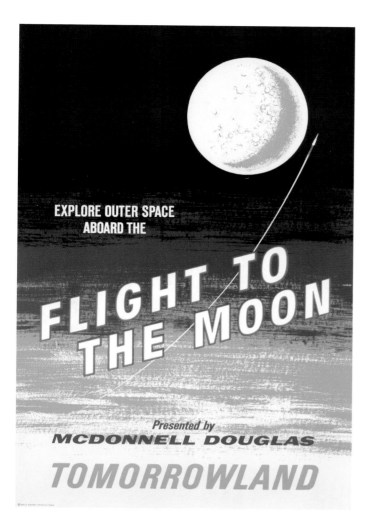

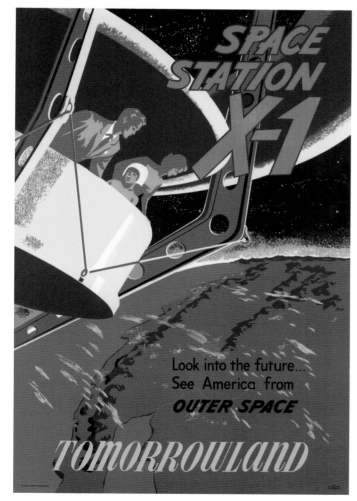

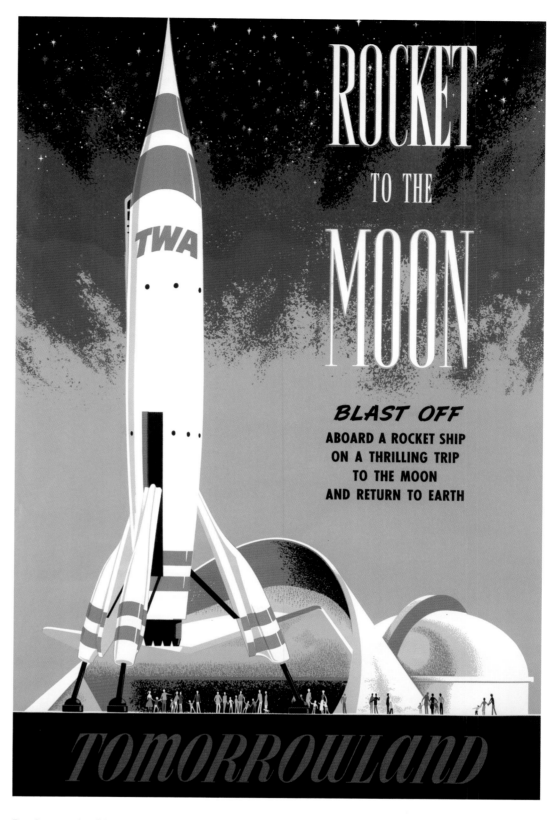

Rocket to the Moon, Disneyland
Bjorn Aronson, 1955

Top: Flight to the Moon, Disneyland and Walt Disney World
Ken Chapman, 1967

Space Station X-1, Disneyland
Bjorn Aronson, 1955

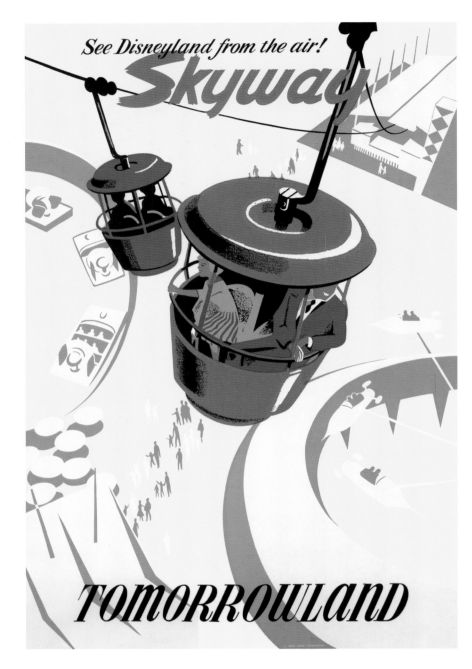

Skyway, Disneyland and Walt Disney World
Bjorn Aronson, 1956

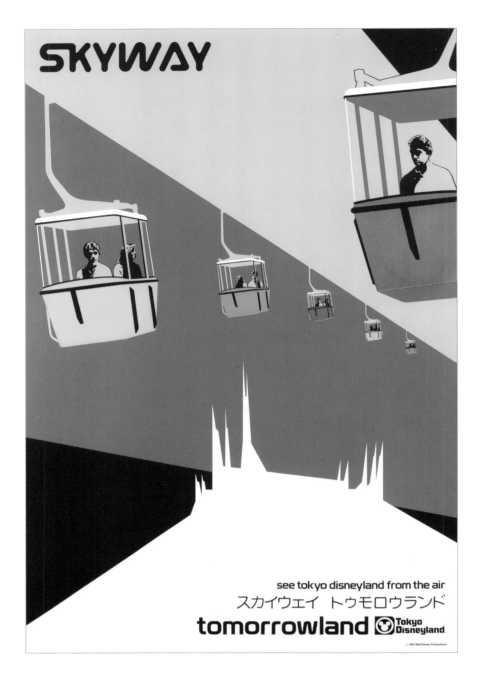

Skyway, Tokyo Disneyland
Rudy Lord, 1983

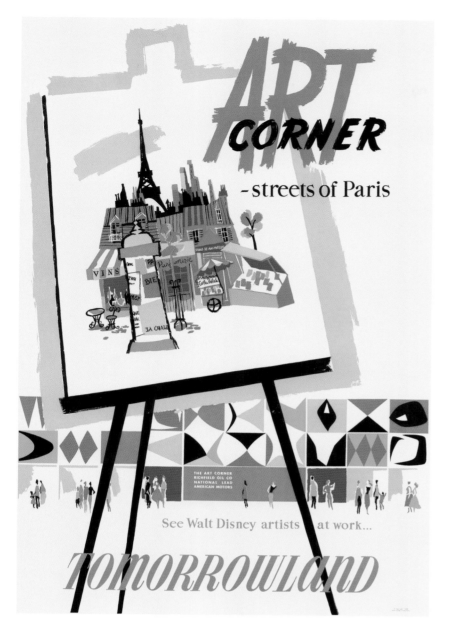

Art Corner, Disneyland
Bjorn Aronson, 1956

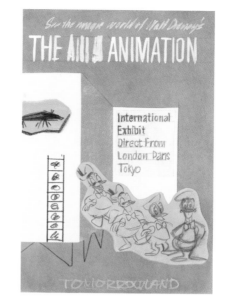

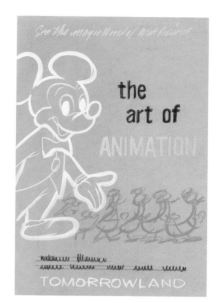

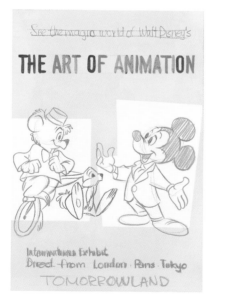

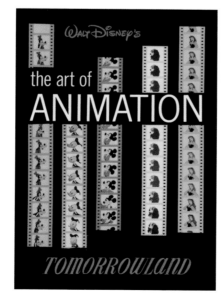

Above and top right: Art of Animation poster concepts, Disneyland
Paul Hartley, 1960

Bottom right: Art of Animation, Disneyland
Paul Hartley, 1960

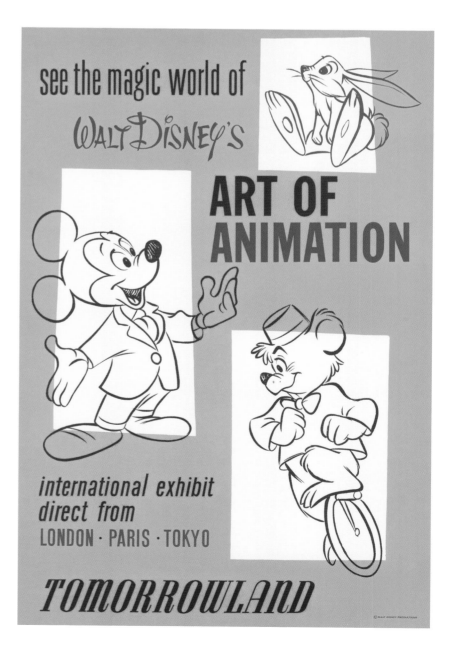

"John Hench asked me to design the Flying Saucers poster. One day Walt saw the sketchiness of my poster and asked, 'Is that it? That's the drawing?' I responded, 'That's my style.' Walt replied, 'Oh OK,' then told me to go with it. Walt appreciated creativity as long as it was appropriate for the project. For example, he loved Mary Blair's untraditional style of art. Not many people know I did this poster, but I'm very happy with how it turned out."

— Rolly Crump, designer and Disney Legend

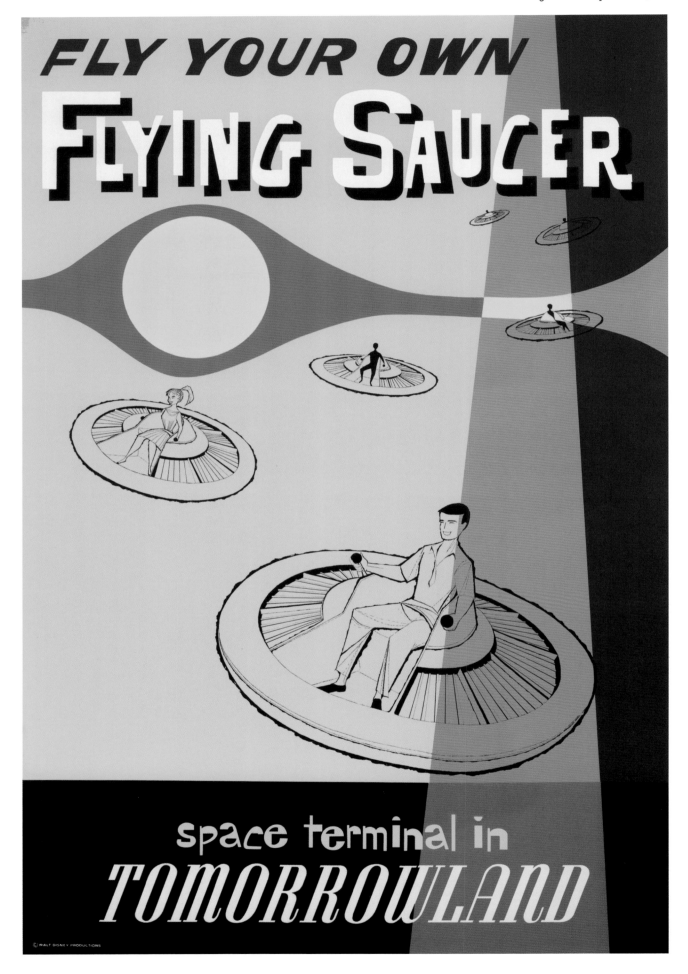

Flying Saucers, Disneyland, *Rolly Crump, 1961*

Adventure Thru Inner Space, Disneyland, *John Drury, 1967*

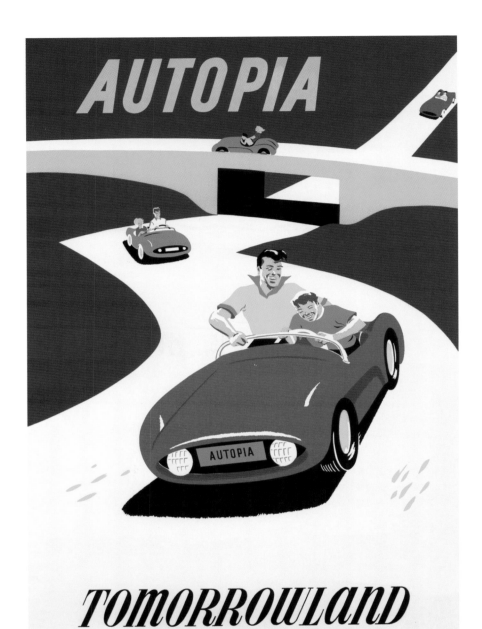

Autopia, Disneyland
Bjorn Aronson, 1955

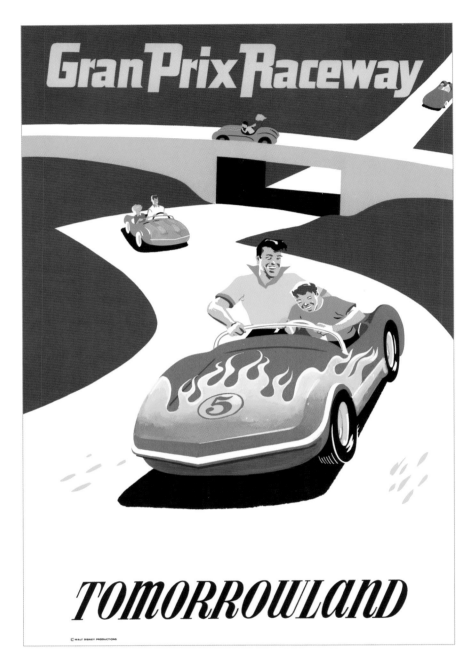

Grand Prix Raceway, Walt Disney World
Adapted by Richard Hebner, 1971

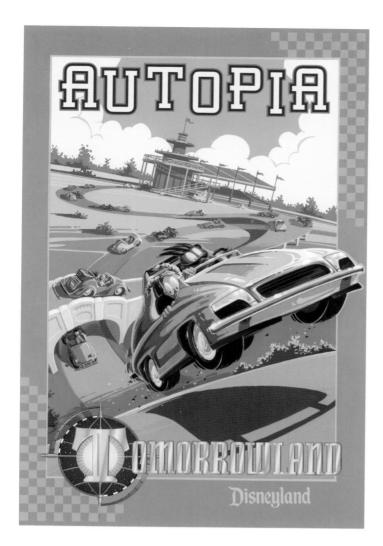

Autopia, Disneyland
Christopher Smith, 2000

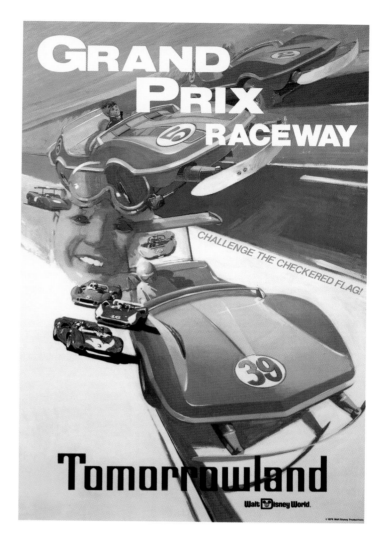

Grand Prix Raceway, Walt Disney World
Richard Hebner, 1978

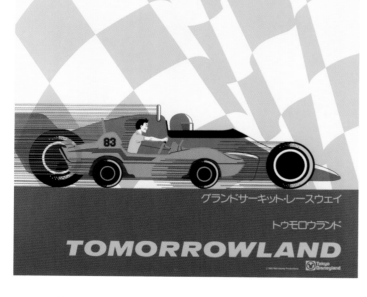

Grand Circuit Raceway, Tokyo Disneyland
John Drury, 1983

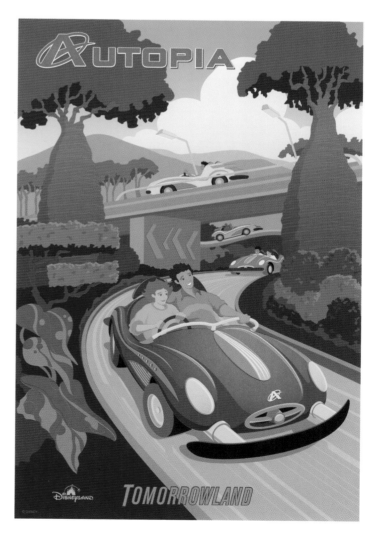

Autopia, Hong Kong Disneyland
Tim Delaney, Craig Tadaki, and Louis Lemoine, 2006

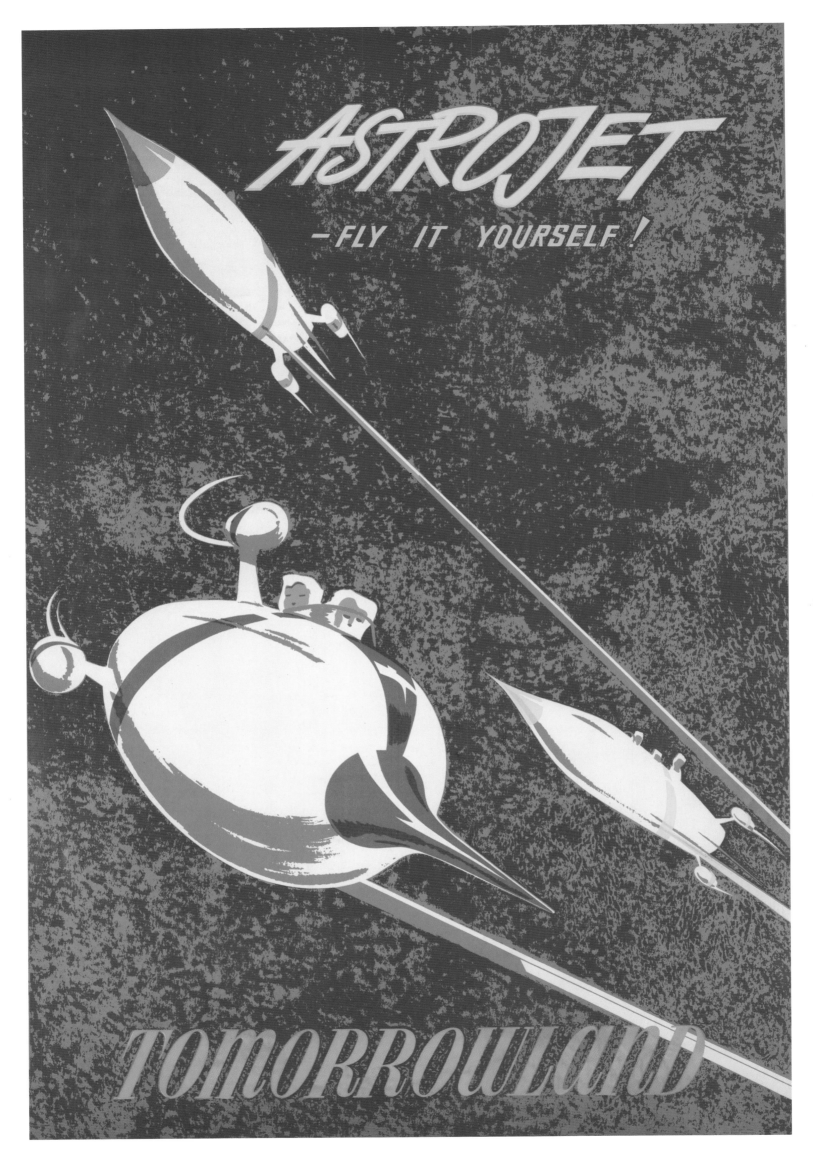

Astro-Jets, Disneyland, *Bjorn Aronson, 1956*

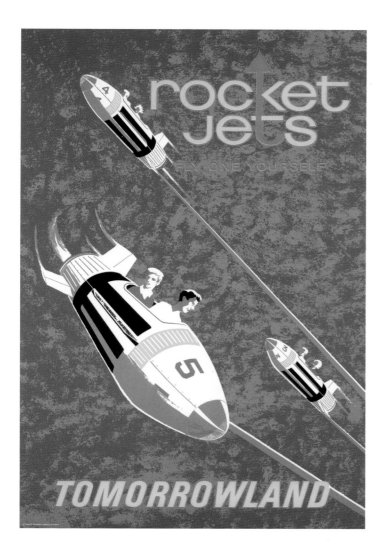

Rocket Jets, Disneyland
Ken Chapman, 1967

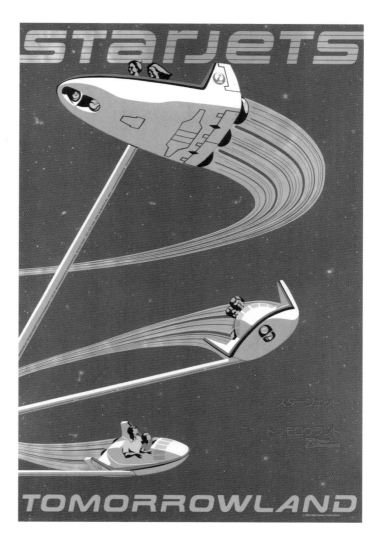

StarJets, Tokyo Disneyland
Mimi Sheean, 1983

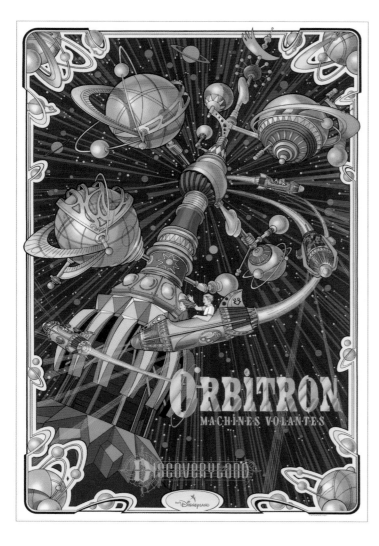

Orbitron—Machines Volantes, Disneyland Paris
Tim Delaney and Jim Michaelson, 1991

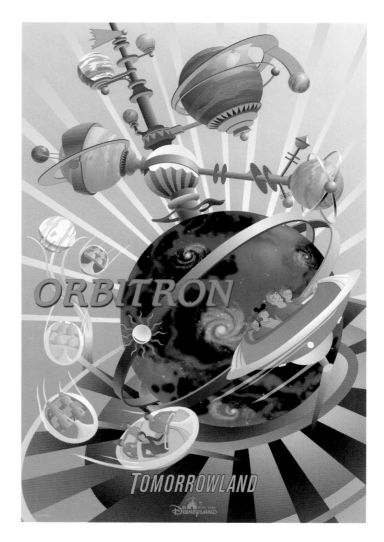

Orbitron, Hong Kong Disneyland
Tim Delaney and Paul Novacek, 2005

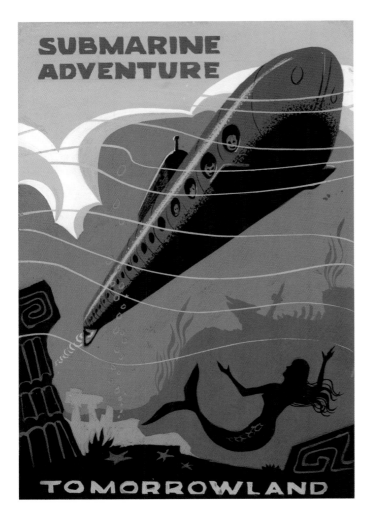

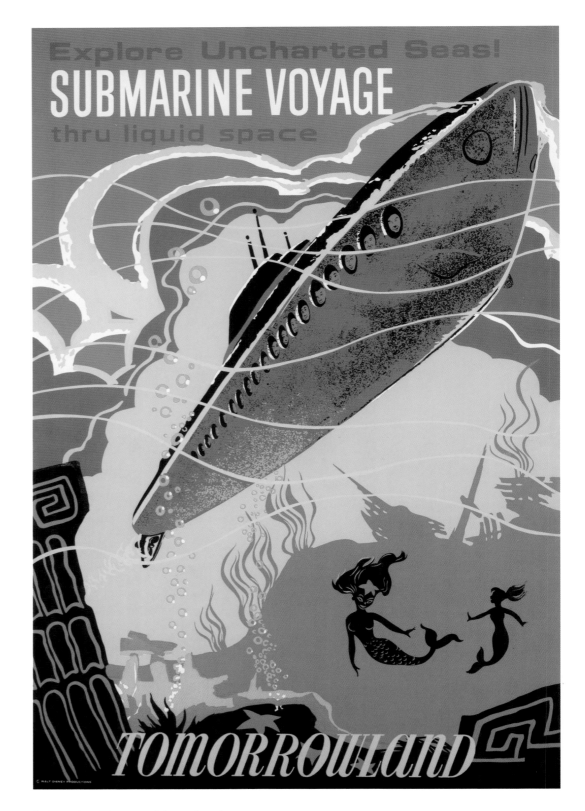

Submarine Voyage, Disneyland
Sam McKim, 1959

Submarine Voyage poster concepts, Disneyland
Unknown artist, 1959

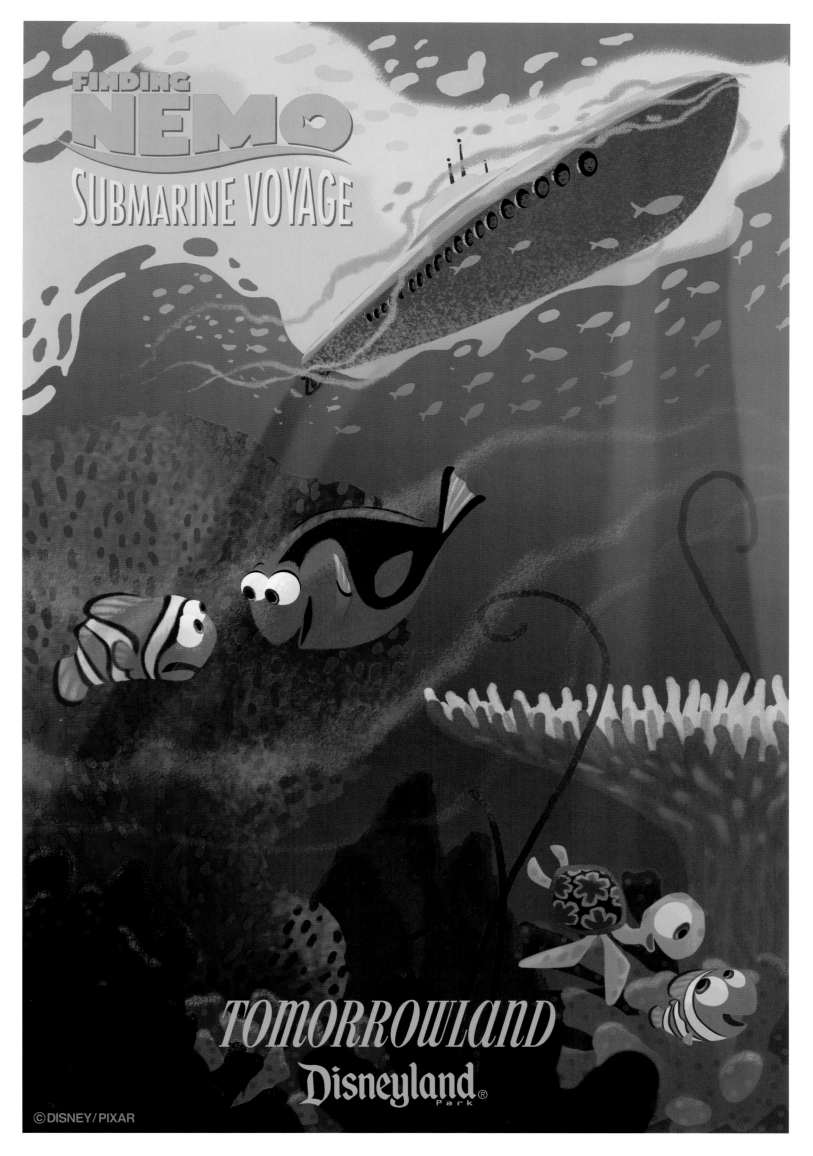

Finding Nemo Submarine Voyage, Disneyland, *Ralph Eggleston, 2007*

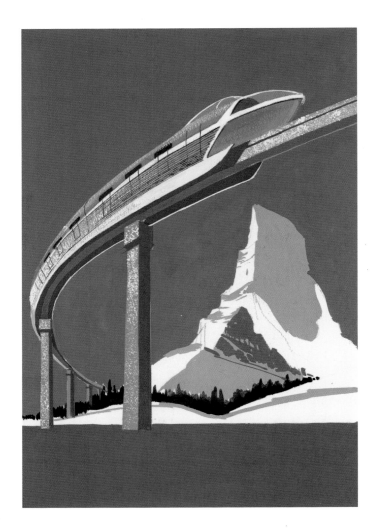

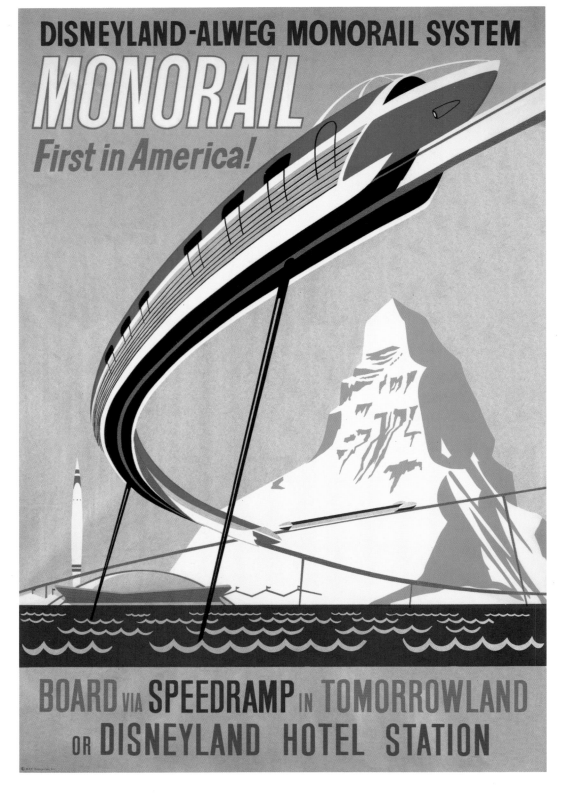

Disneyland Monorail, Disneyland
Paul Hartley, 1961

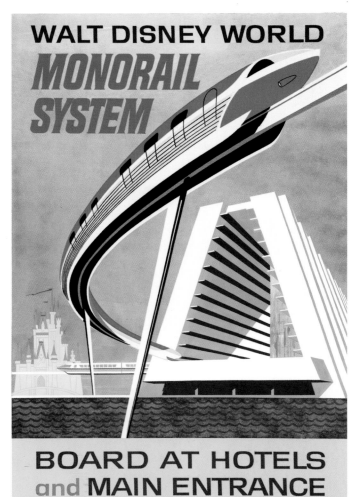

Top: Disneyland Monorail poster concept, Disneyland
Unknown artist, 1959

Walt Disney World Monorail System, Walt Disney World Resort
Adapted by Collin Campbell, 1971

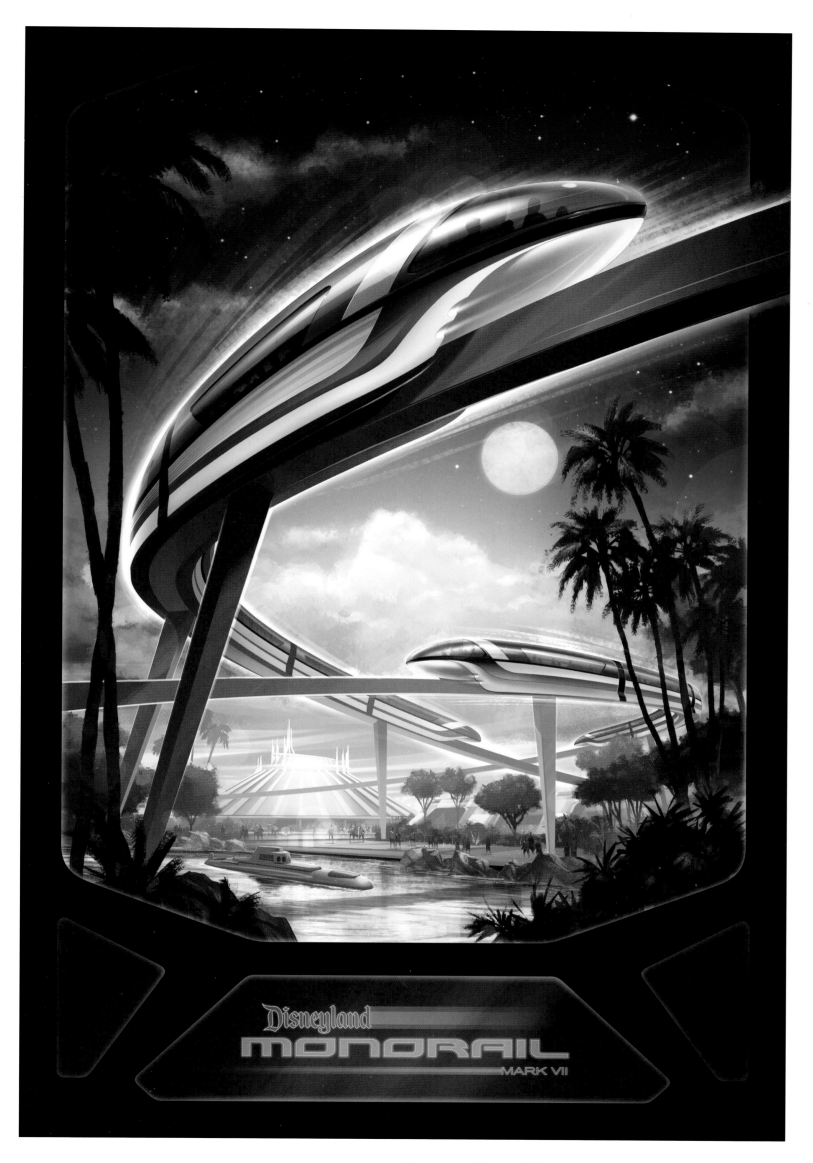

Disneyland Monorail Mark VII, Disneyland, *Scot Drake, 2008*

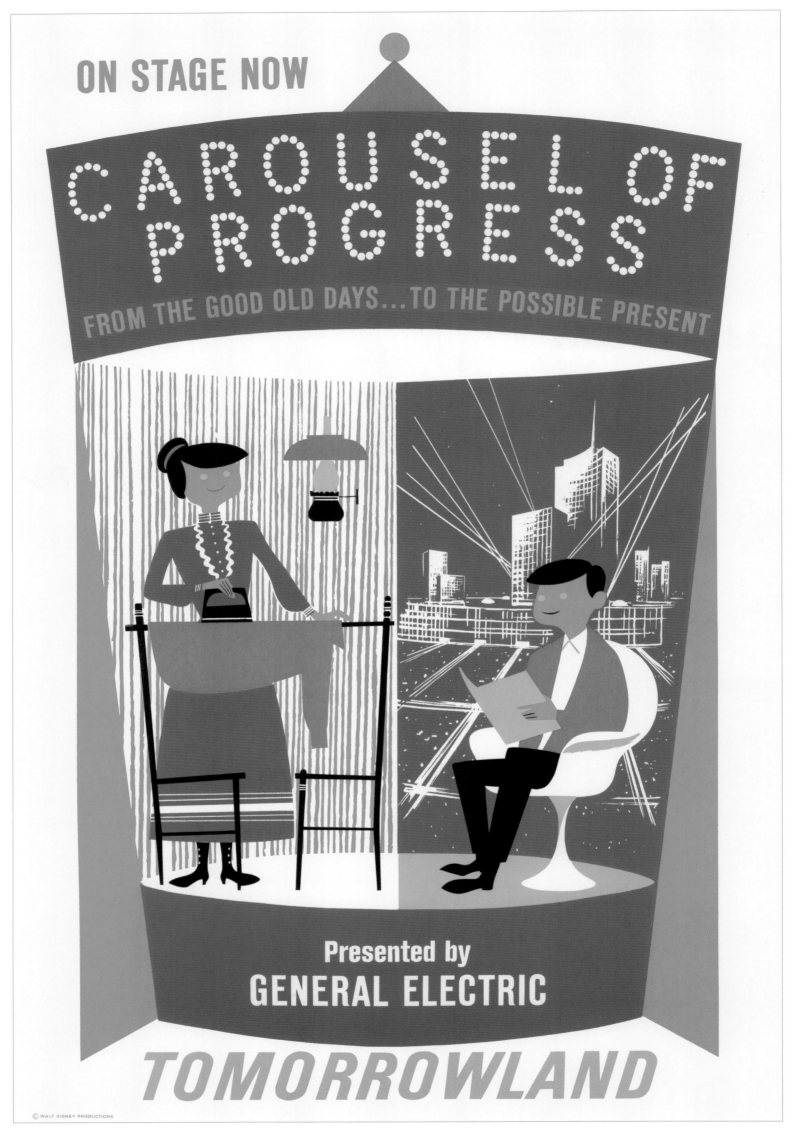

Carousel of Progress, Disneyland, *Ken Chapman, 1967*

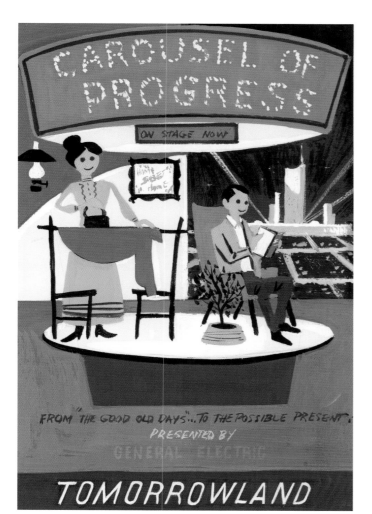

Carousel of Progress poster concepts, Disneyland
Ken Chapman, 1967

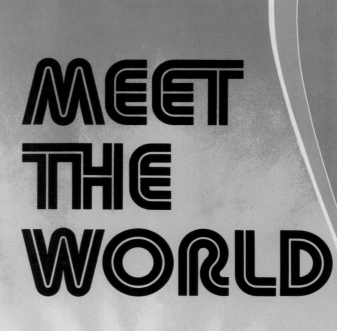

Meet the World, Tokyo Disneyland
Leticia Lelevier and Mimi Sheean, 1991

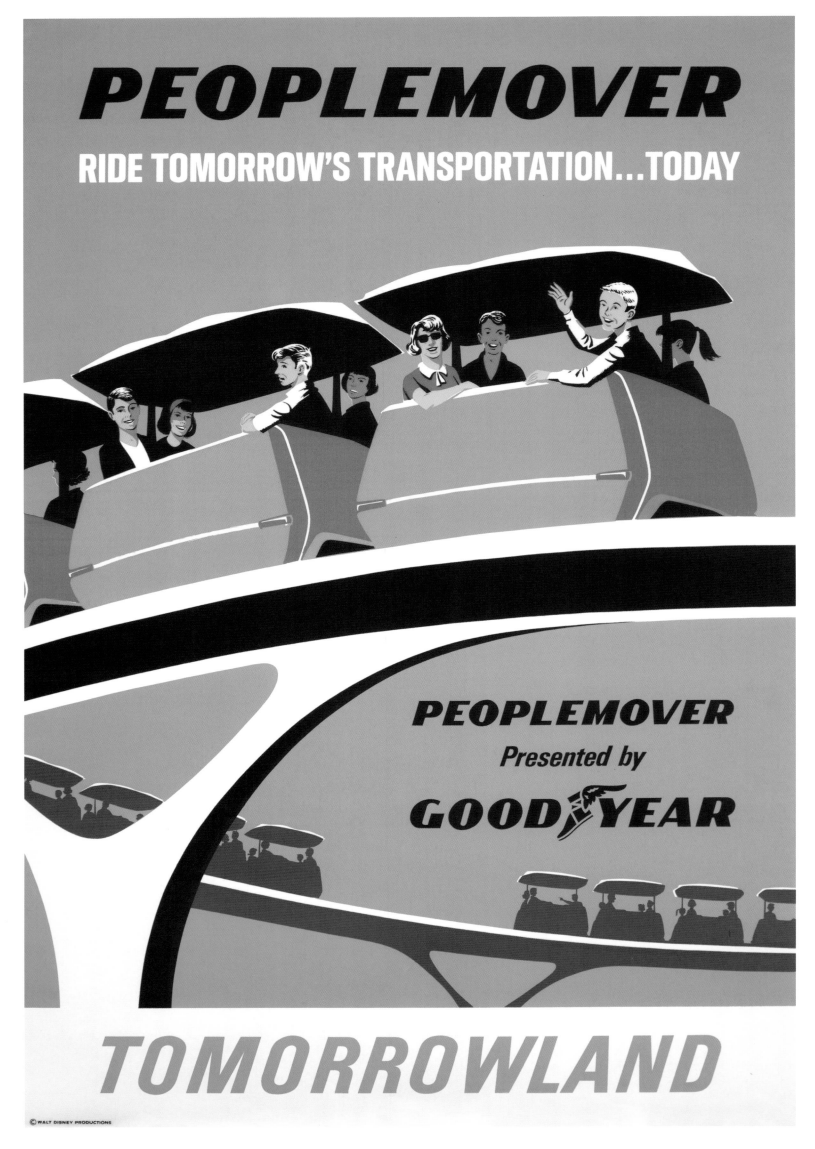

PeopleMover, Disneyland, *Ken Chapman, 1967*

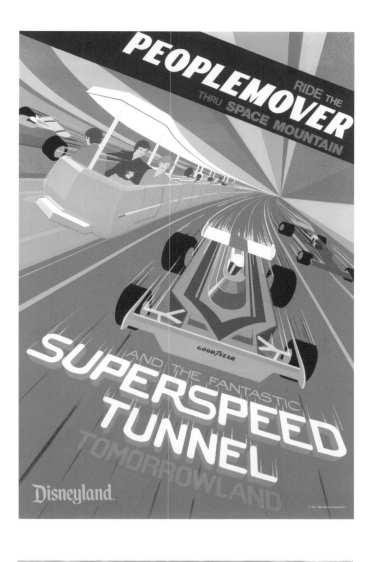

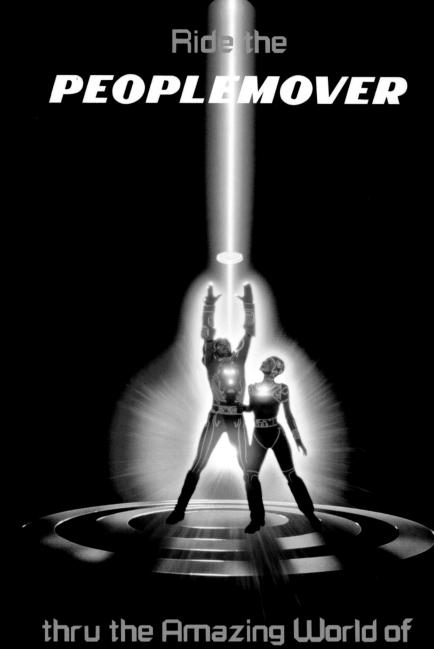

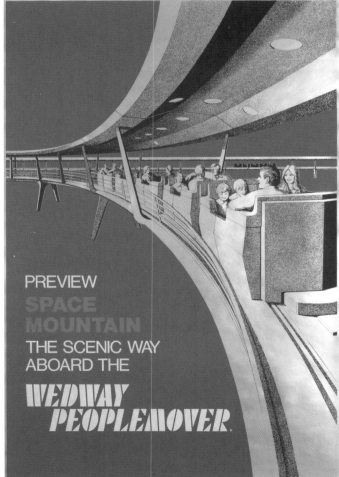

PeopleMover—Tron, Disneyland
Unknown artist, 1982

Top: PeopleMover—Superspeed Tunnel, Disneyland
Tim Delaney, 1977

WEDway PeopleMover, Walt Disney World
Lou Van Derbeken, Rudy Lord, Ernie Prinzhorn, and Jim Michaelson, 1976

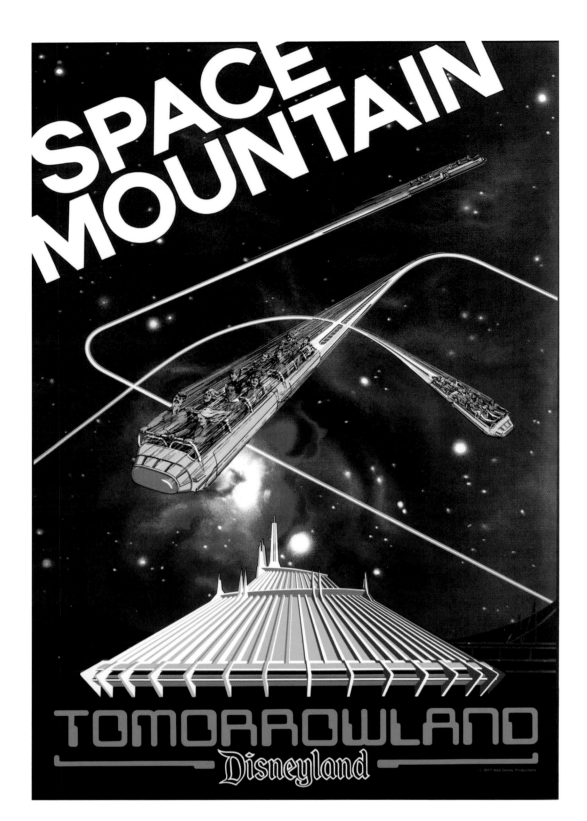

Space Mountain, Disneyland, Walt Disney World, and Tokyo Disneyland
Jim Michaelson, Ernie Prinzhorn, and Rudy Lord, 1977

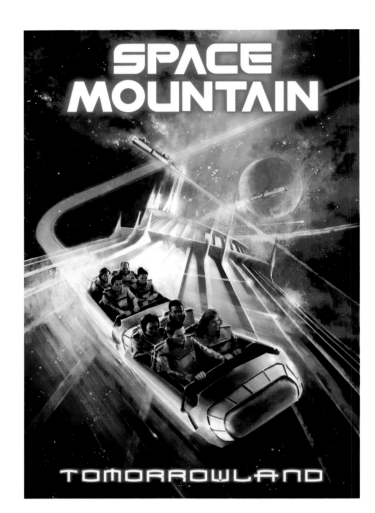

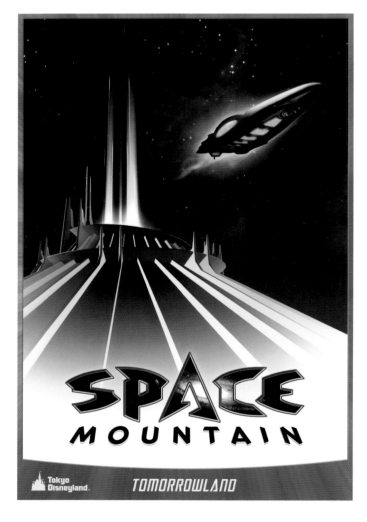

Top: Space Mountain, Disneyland
Greg Pro and Owen Yoshino, 2005

Space Mountain, Tokyo Disneyland
Owen Yoshino, 2007

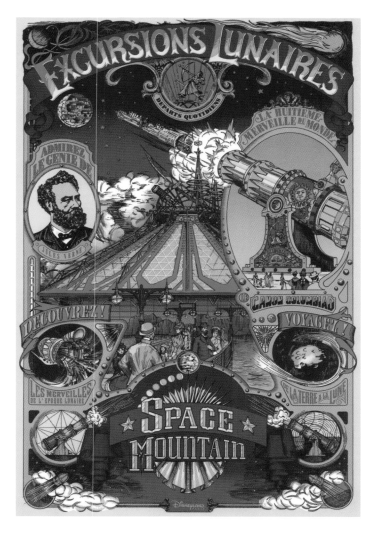

Space Mountain—De la Terre á la Lune, Disneyland Paris
Tim Delaney, Rudy Lord, and Stuart Bailey, 1994

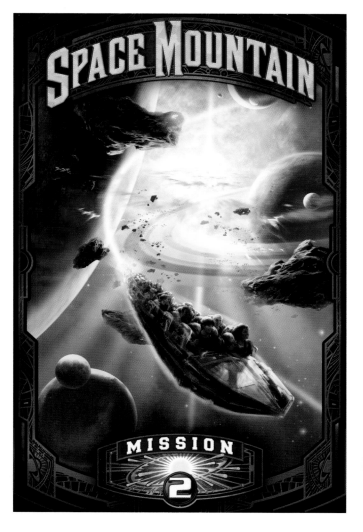

Space Mountain: Mission 2, Disneyland Paris
Greg Pro and Owen Yoshino, 2004

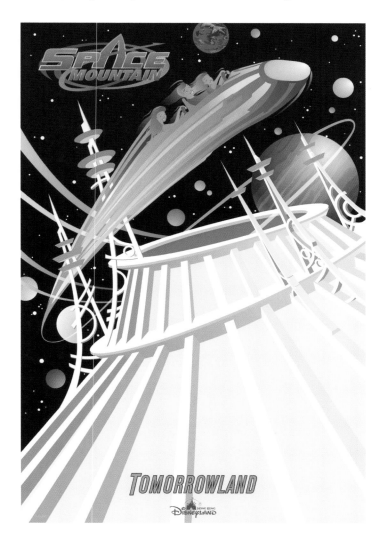

Space Mountain, Hong Kong Disneyland
Tim Delaney and Paul Novacek, 2005

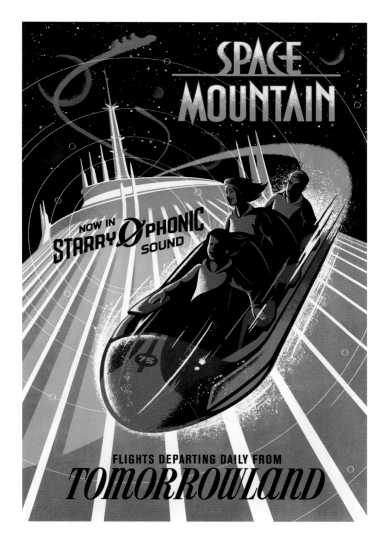

Space Mountain, Walt Disney World
Josh Holtsclaw, 2010

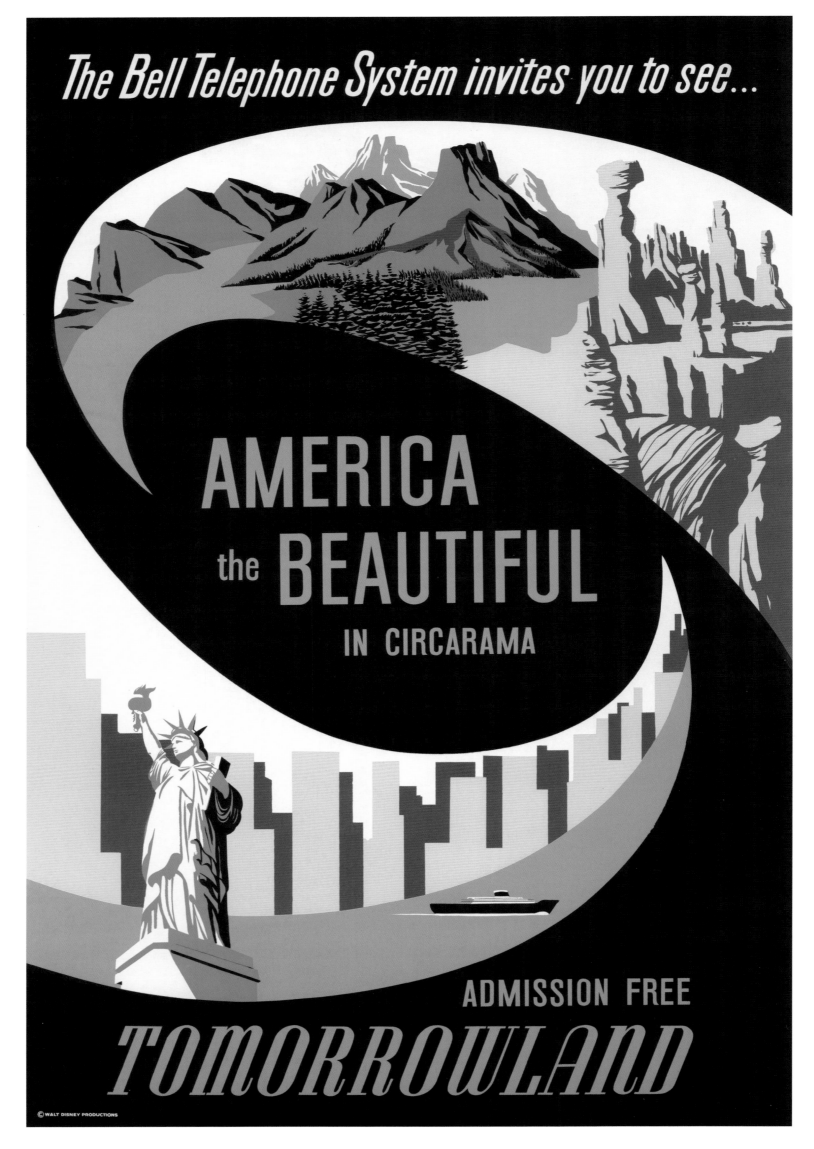

America the Beautiful, Disneyland, *unknown artist, 1960*

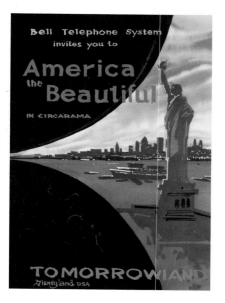

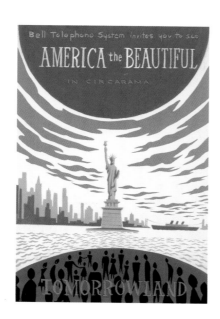

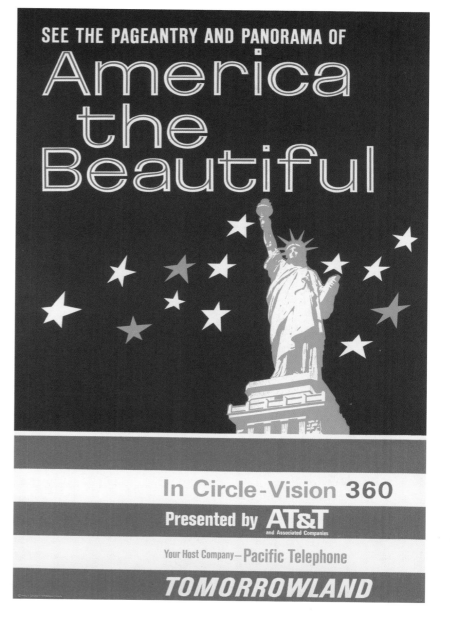

America the Beautiful, Disneyland and Walt Disney World
Ken Chapman, 1967

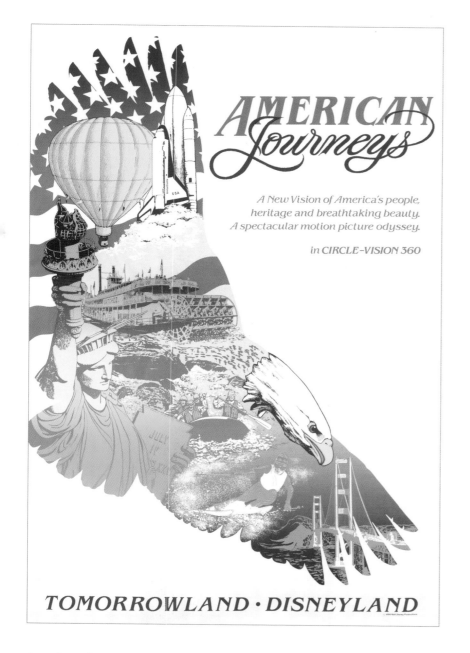

American Journeys, Disneyland, Walt Disney World, and Tokyo Disneyland
Leticia Lelevier, 1984

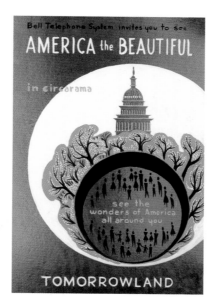

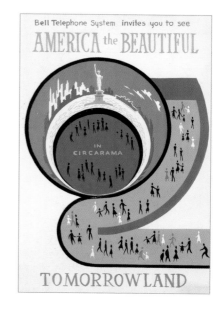

Above and top left: America the Beautiful poster concepts, Disneyland
Unknown artists, 1960

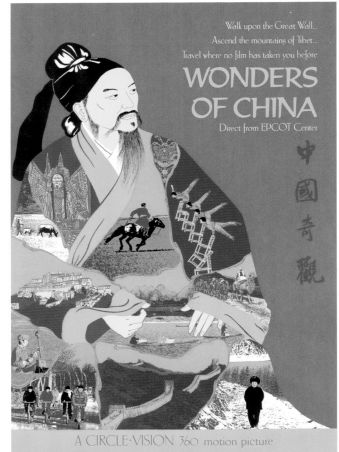

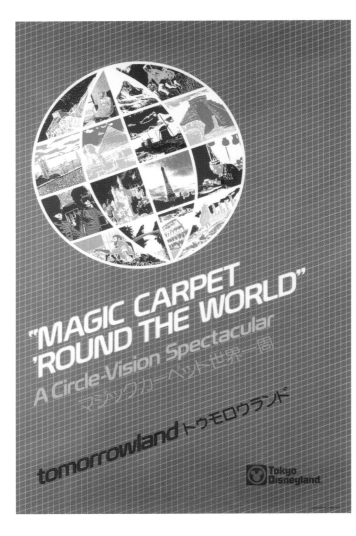

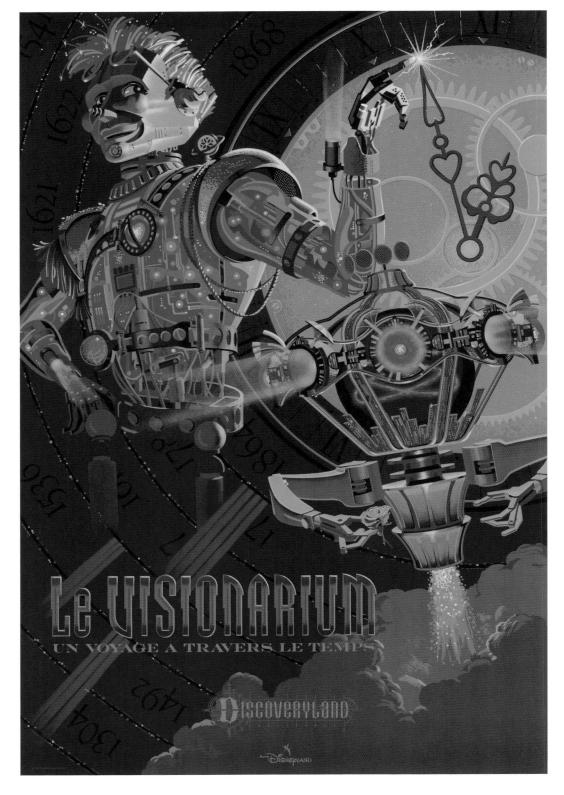

Le Visionarium, Disneyland Paris and Tokyo Disneyland
Tim Delaney, 1992

Top: Wonders of China, Disneyland and Epcot
Leticia Lelevier, 1985

Magic Carpet 'Round the World, Tokyo Disneyland and Walt Disney World
Unknown artist, 1983

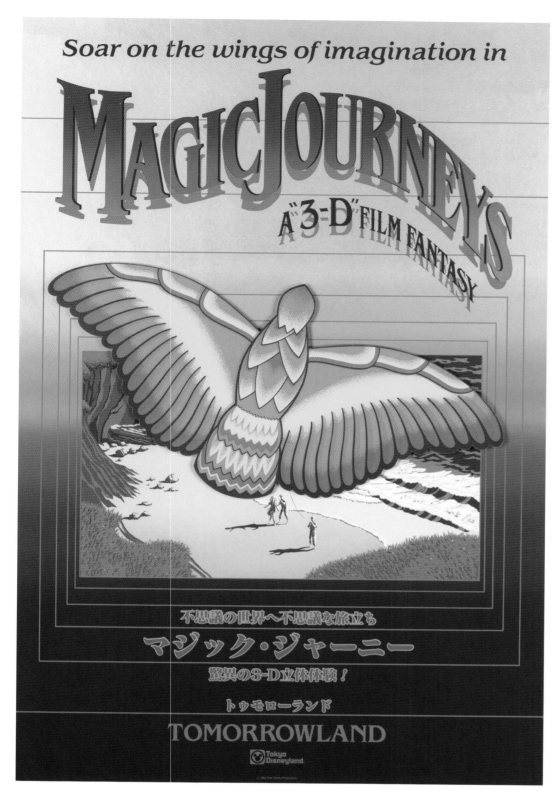

Magic Journeys, Disneyland, Tokyo Disneyland, and Walt Disney World
Norm Inouye, 1984

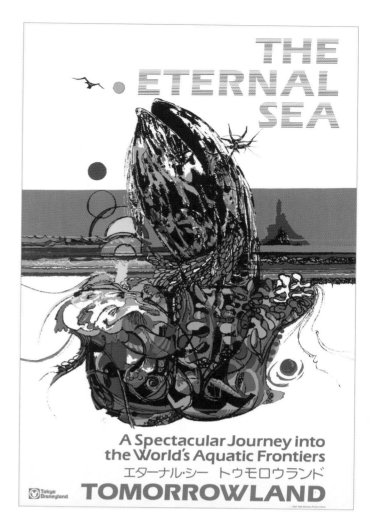

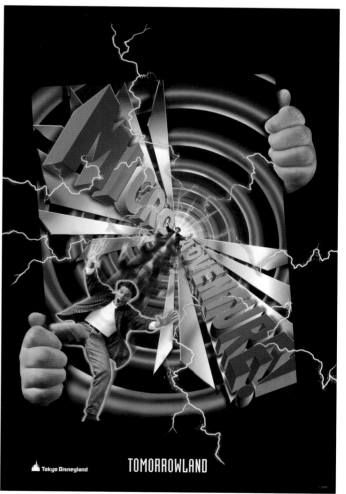

Top: The Eternal Sea, Tokyo Disneyland
Walt Peregoy and Leticia Lelevier, 1983

MicroAdventure! Tokyo Disneyland
Andrea Hom, 1997

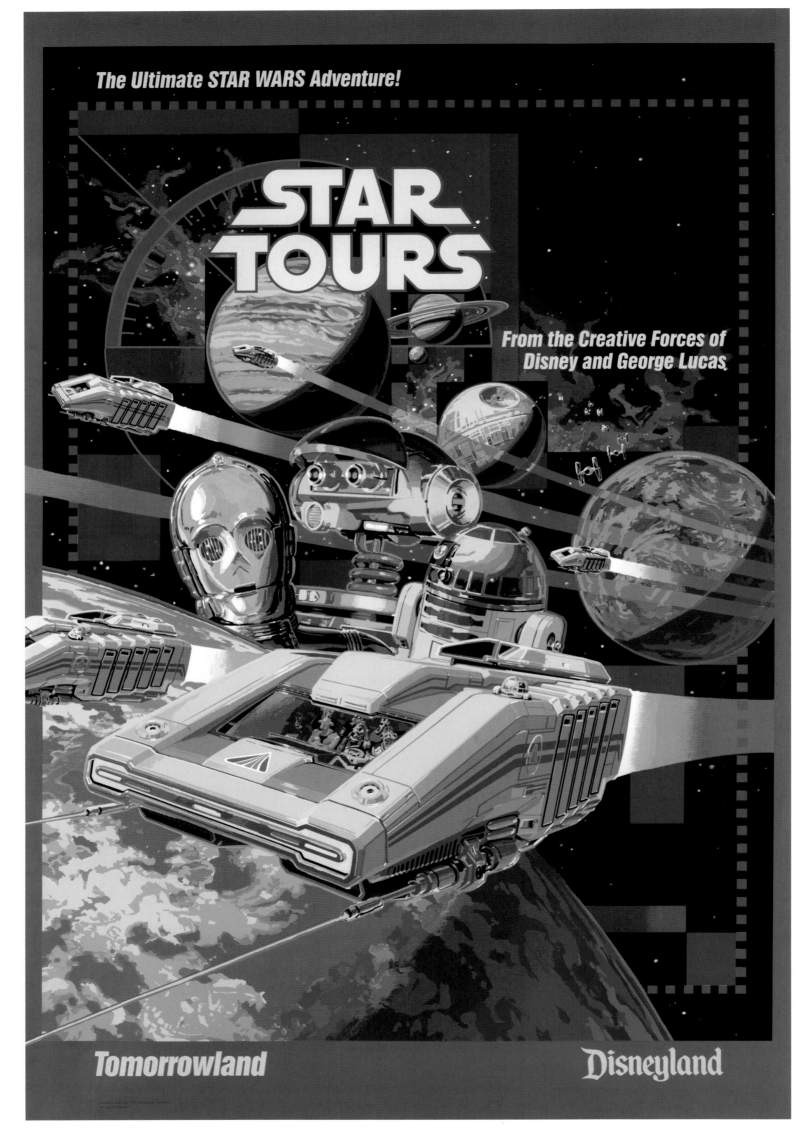

Star Tours, Disneyland, Tokyo Disneyland, Disneyland Paris, and Disney's Hollywood Studios, *Gil Keppler, 1987*

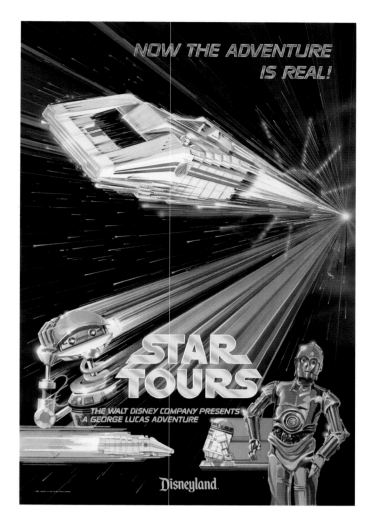

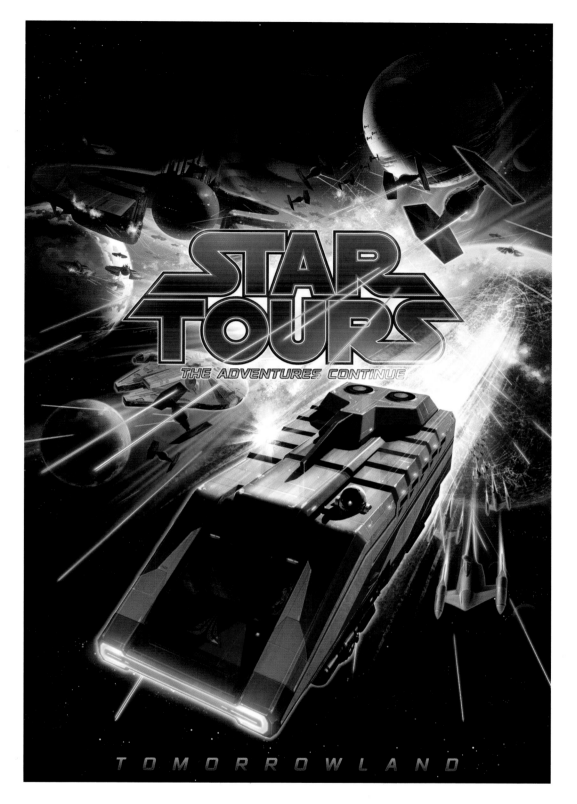

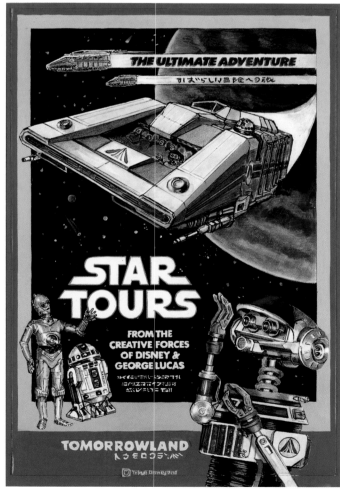

Star Tours—The Adventures Continue, Disneyland and Disney's Hollywood Studios
Scot Drake, 2011

Top: Star Tours poster concept, Disneyland
Tim Delaney, 1986

Star Tours poster concept, Tokyo Disneyland
Anne Tryba, 1988

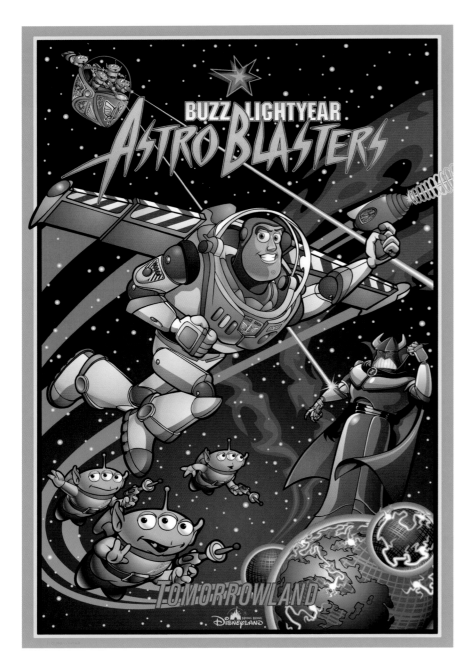

Buzz Lightyear Astro Blasters, Tokyo Disneyland, Disneyland,
Hong Kong Disneyland, and Disneyland Paris
Chuck Ballew, 2005

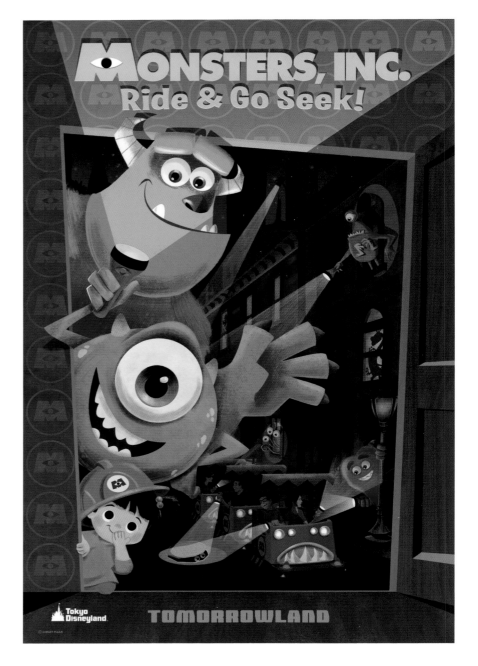

Monsters, Inc. Ride & Go Seek! Tokyo Disneyland
Will Eyerman and Scott Tilley, 2009

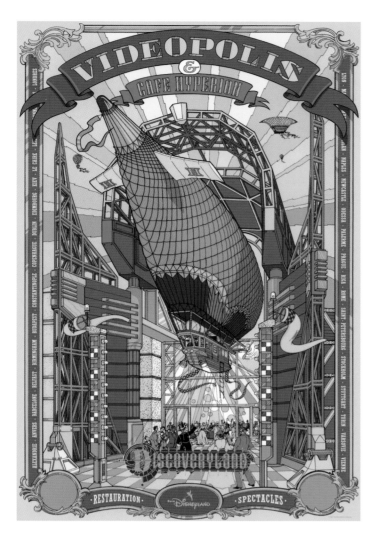

Videopolis, Disneyland Paris
Jim Michaelson, Tim Delaney, and Fred Miwa, 1992

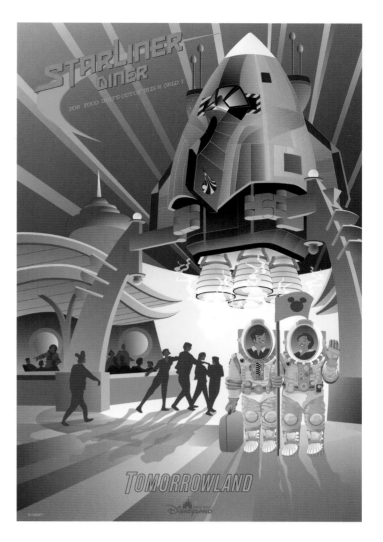

Starliner Diner, Hong Kong Disneyland
Tim Delaney and Paul Novacek, 2005

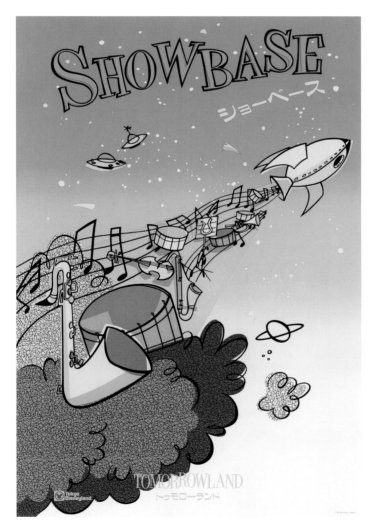

Showbase 2000, Tokyo Disneyland
Yoshi Akiyama, 1996

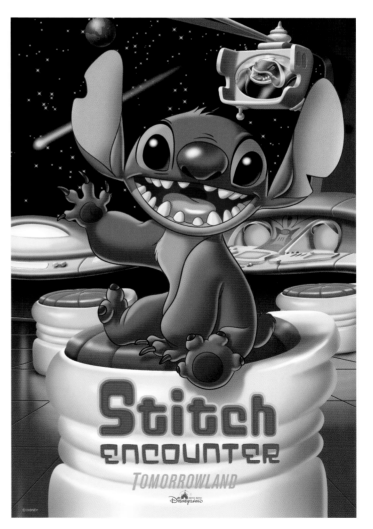

Stitch Encounter, Hong Kong Disneyland
Anne Tryba, 2006

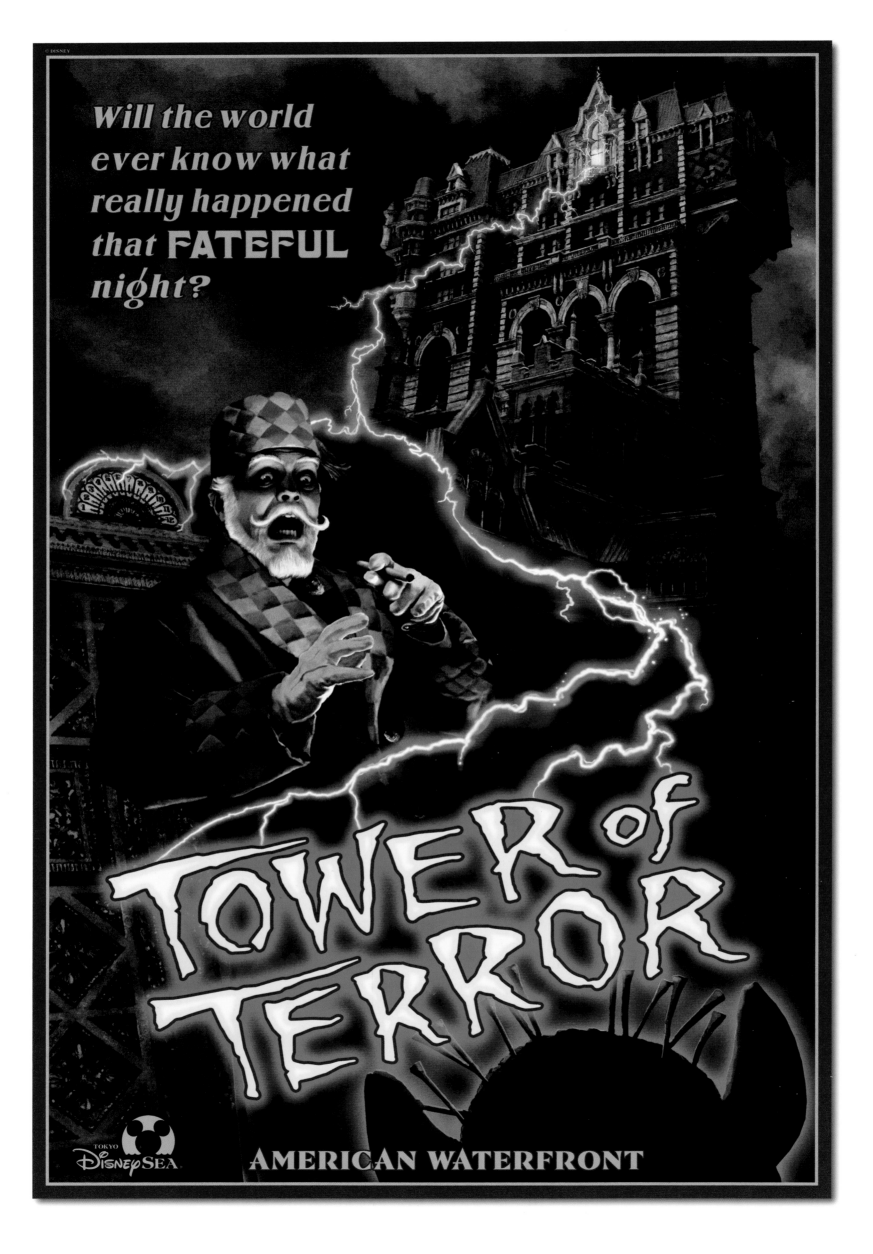

Will the world ever know what really happened that **FATEFUL** night?

TOWER of TERROR

AMERICAN WATERFRONT

Tower of Terror, Tokyo DisneySea, *Sean Sullivan and Will Eyerman, 2006*

120

"Welcome one and all to a world where imagination and adventure set sail. Tokyo DisneySea is dedicated to the spirit of exploration that lives in each of us. Here we chart a course for adventure, romance, discovery, and fun and journey to exotic and fanciful ports of call. May Tokyo DisneySea inspire the hearts and minds of all of us who share the water planet, Earth."

— Michael Eisner

When Tokyo DisneySea opened at the Tokyo Disney Resort on September 4, 2001, the Imagineers utilized all of the promotional tools they had at their disposal to showcase what was going on inside the Park. "The Japanese audience was familiar with the Disney Parks, so we really didn't have to start from scratch," says Walt Disney Imagineering senior principal graphics designer Will Eyerman, "but we wanted to create some excitement when they were buying tickets. So the Imagineers knew that attraction posters could do the trick."

Eyerman put a lot of thought into developing the posters for Tokyo DisneySea. He had helped design the posters for Tokyo Disneyland and believed the assortment for the first Tokyo Disney Resort Park was an interesting mix. Every poster from Park opening in 1983 to the present day had a unique story and a unique look. For Tokyo DisneySea, he decided the posters would reflect an overall statement, but be individual to each attraction.

The next step was choosing the best theme for the designs. The design team researched what Eyerman felt was "the golden age of poster design"—graphically strong posters from the 1890s to the 1920s, from Russian constructivism to the graphics of Toulouse-Lautrec. "The first choice was to keep the look of the posters within that thirty-year time period," says Eyerman. "The second choice was to make the posters individually good enough. I wanted Guests to think, 'Hey, this might be nice to put on my wall.'"

Eyerman talked to various Imagineers to find the right designers for the job. He worked with three artists with distinct styles and a strong sense of design: Larry Nikolai, Chris Turner, and Nicole Armitage. Together, they created the nine original Opening Day posters—Porto Paradiso Water Carnival, Journey to the Center of the Earth, 20,000 Leagues Under the Sea, Mermaid Lagoon Theater, Sindbad's Seven Voyages, The Magic Lamp Theater, Indiana Jones™ Adventure: Temple of the Crystal Skull, StormRider, and Aquatopia. Eyerman massaged and tweaked the color and balance to support the unified vision. The poster designs were cohesive and, more importantly, didn't clash with each other.

The quality standard for Tokyo DisneySea posters continues to this day. New posters added to the gallery are focused more stylistically in their individual lands than their predecessors. Posters for The Legend of Mythica and Sindbad's Storybook Voyage (the name for the re-imagined Sindbad's Seven Voyages attraction) are romantic and colorful, but keep the quality of the art. "That's the philosophy ever since," says Eyerman. "We try to get as good an image as we can and then try to present it well. We still pay attention to color and the general values, but we're getting more specific with the attraction stories than ever before. We're experimenting with new techniques and new ways to tell the story for us, so it isn't always the same texture."

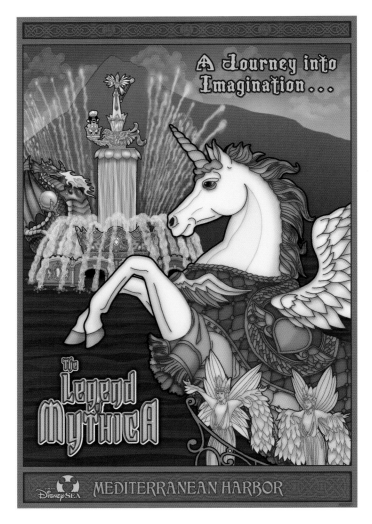

The Legend of Mythica, Tokyo DisneySea
Nicole Armitage and Will Eyerman, 2006

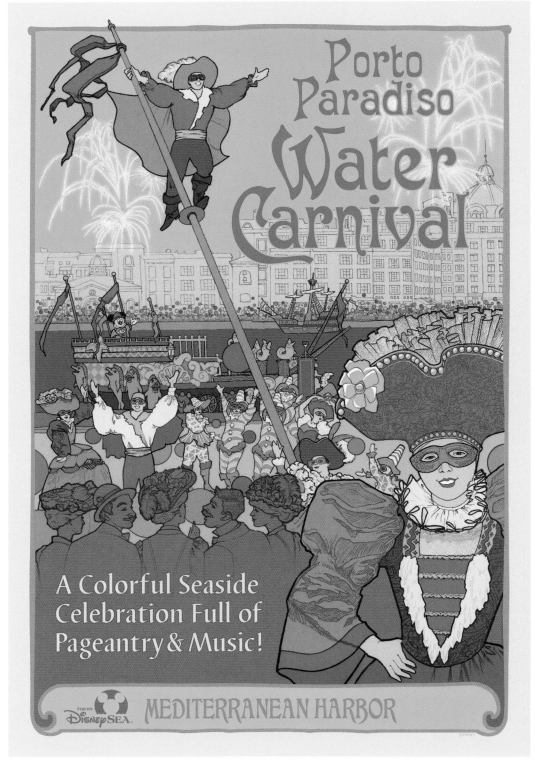

Porto Paradiso Water Carnival, Tokyo DisneySea
Nicole Armitage and Will Eyerman, 2001

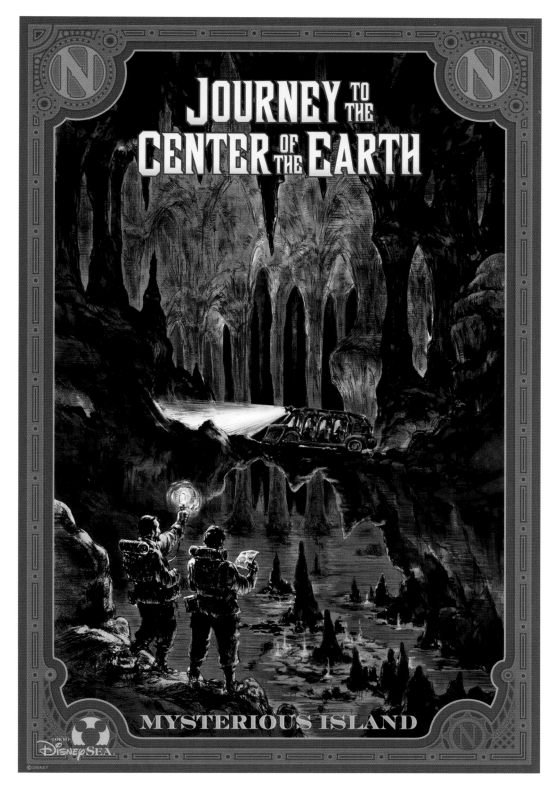

Journey to the Center of the Earth, Tokyo DisneySea
Chris Turner and Will Eyerman, 2001

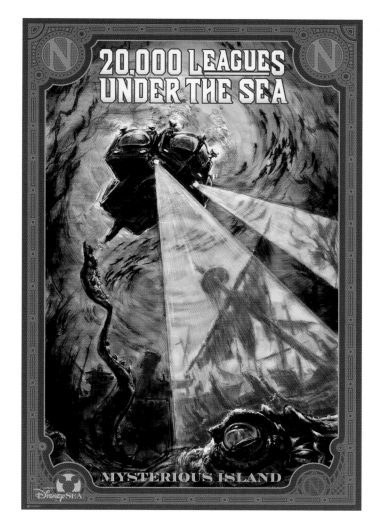

20,000 Leagues Under the Sea, Tokyo DisneySea
Chris Turner and Will Eyerman, 2001

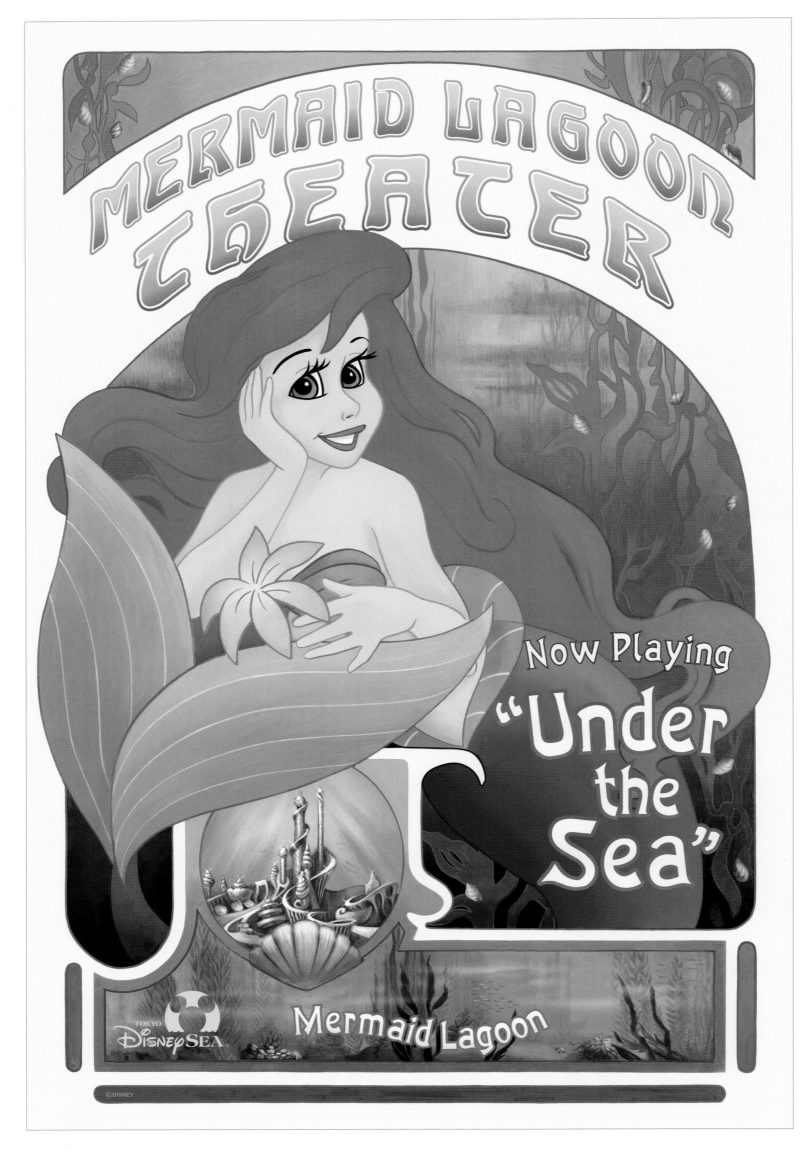

Mermaid Lagoon Theater, Tokyo DisneySea, *Nicole Armitage and Will Eyerman, 2001*

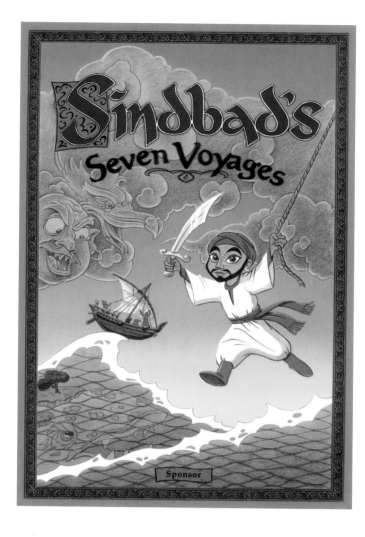

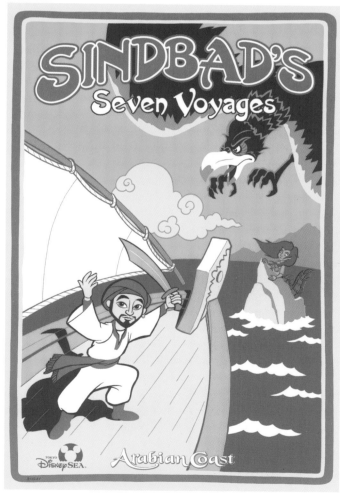

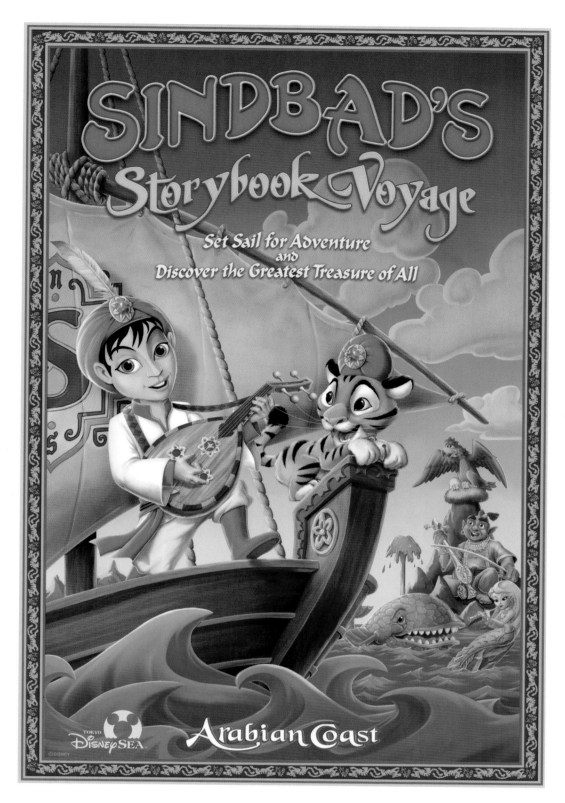

Sindbad's Storybook Voyage, Tokyo DisneySea
Chuck Ballew and Will Eyerman, 2007

Top: Sindbad's Seven Voyages poster concept, Tokyo DisneySea
Larry Nikolai, 1998

Sindbad's Seven Voyages, Tokyo DisneySea
Larry Nikolai and Will Eyerman, 2001

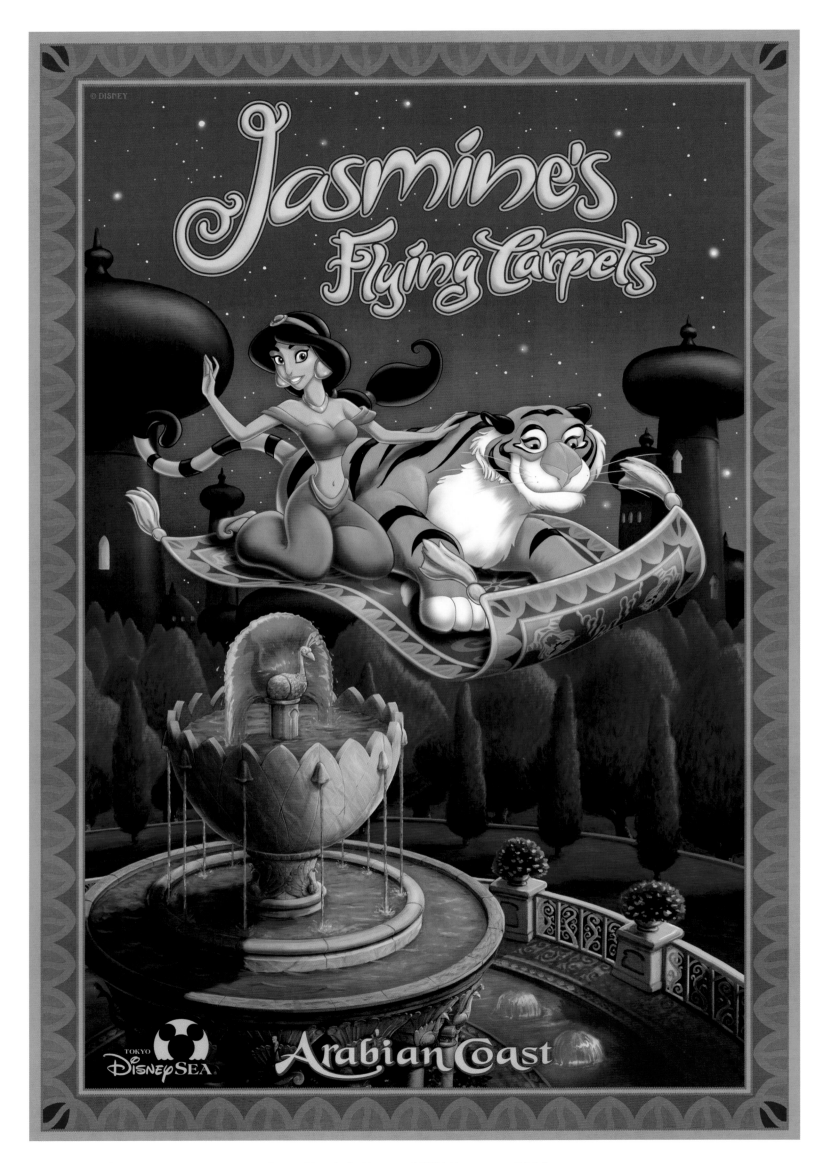

Jasmine's Flying Carpets, Tokyo DisneySea, *Chuck Ballew and Will Eyerman, 2011*

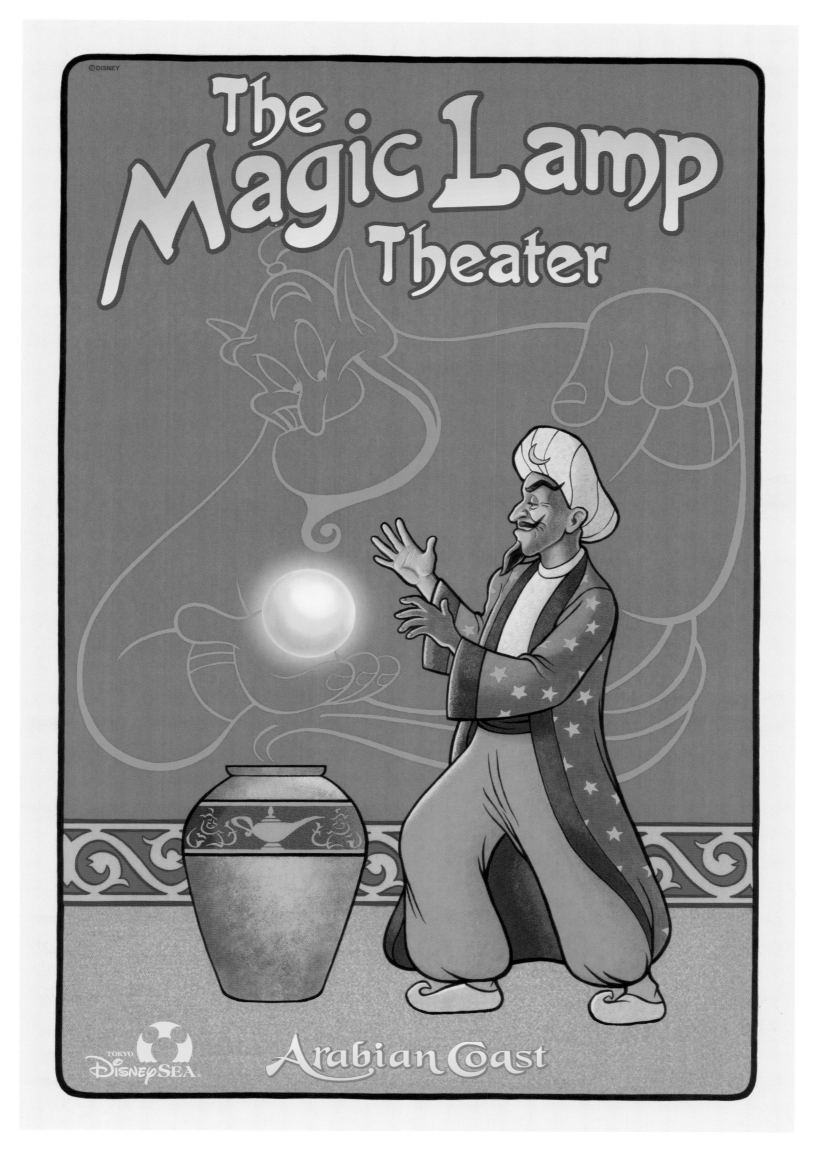

The Magic Lamp Theater, Tokyo DisneySea, *Larry Nikolai and Will Eyerman, 2001*

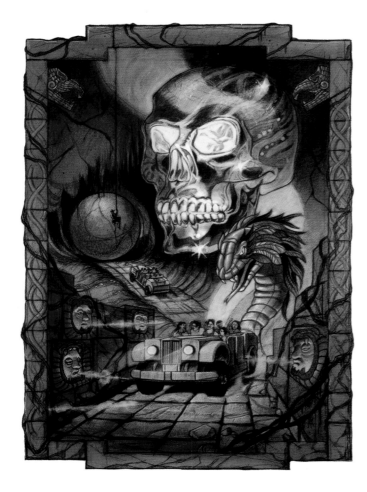

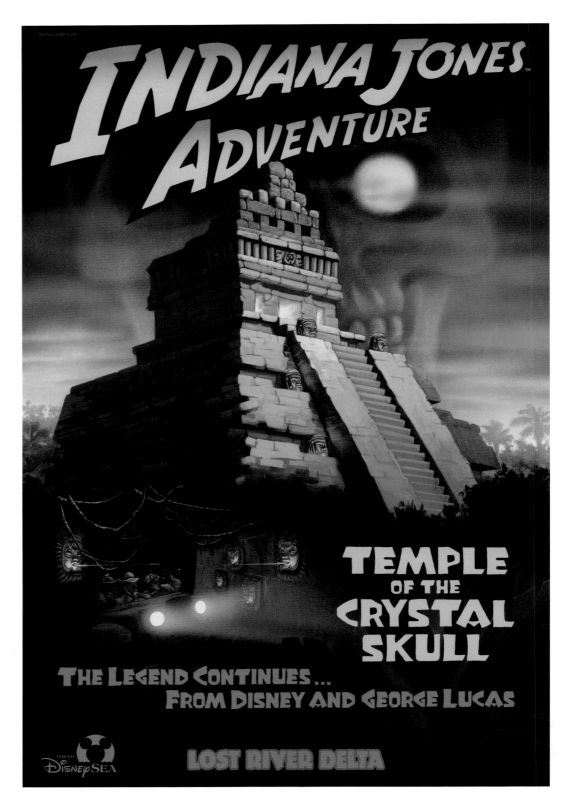

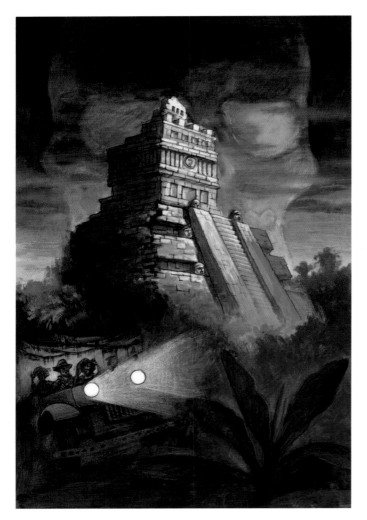

Indiana Jones™ Adventure: Temple of the Crystal Skull, Tokyo DisneySea
Nicole Armitage and Will Eyerman, 2001

Top: Indiana Jones™ Adventure poster concept, Tokyo DisneySea
Phillip Freer, 1996

Indiana Jones™ Adventure background art, Tokyo DisneySea
Nicole Armitage, 2001

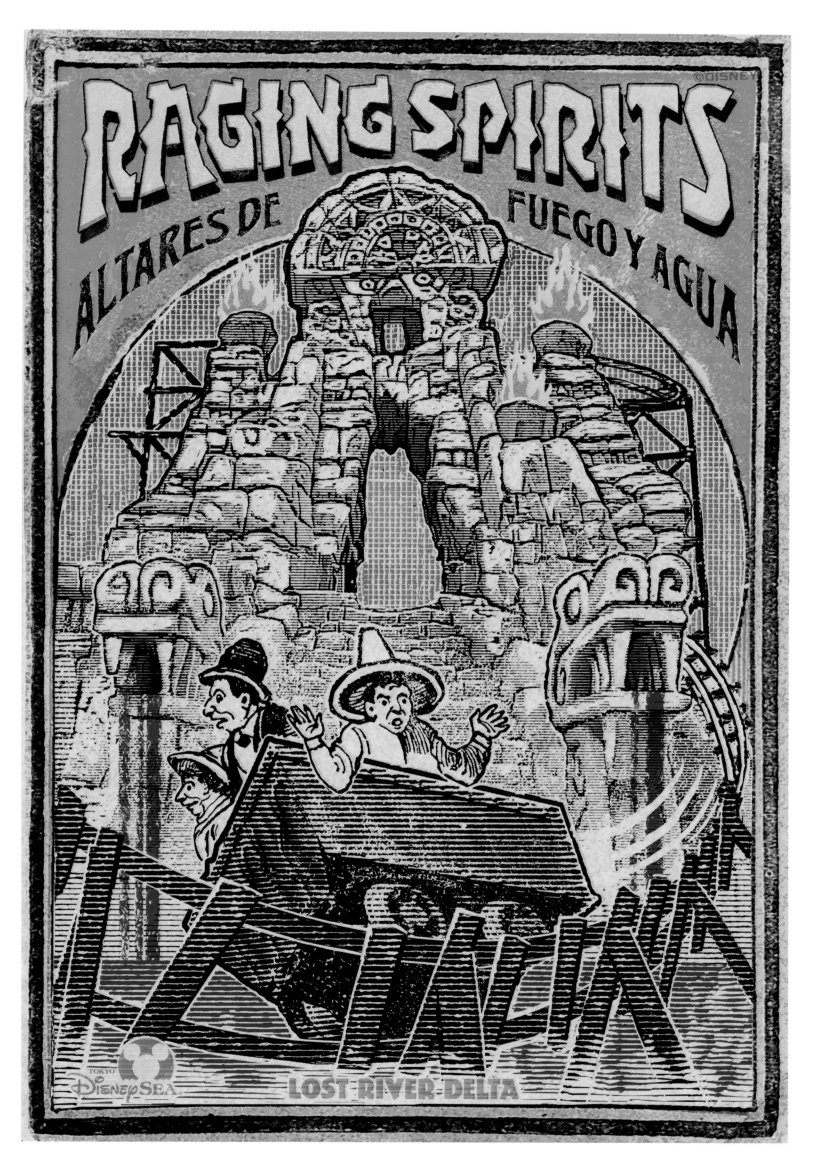

Raging Spirits, Tokyo DisneySea, *Will Eyerman, 2005*

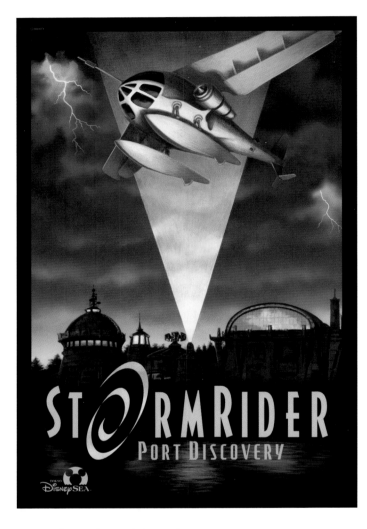

StormRider, Tokyo DisneySea
Nicole Armitage and Will Eyerman 2001

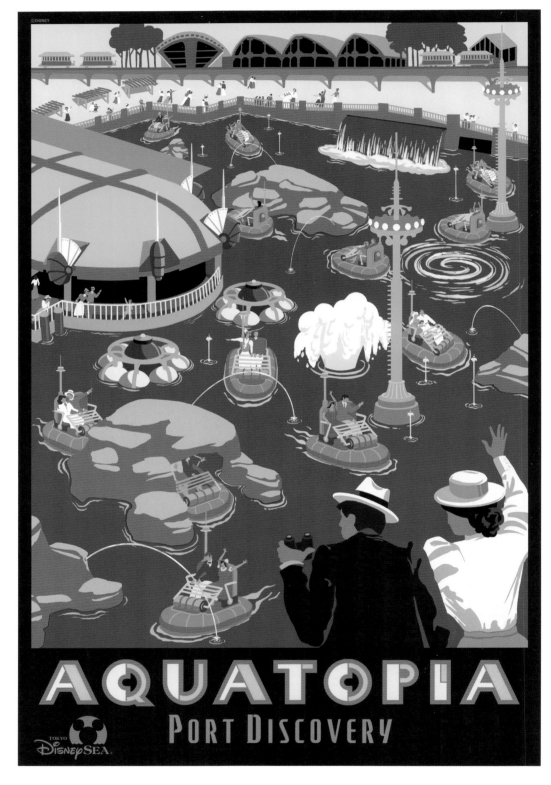

Aquatopia, Tokyo DisneySea
Nicole Armitage and Will Eyerman, 2001

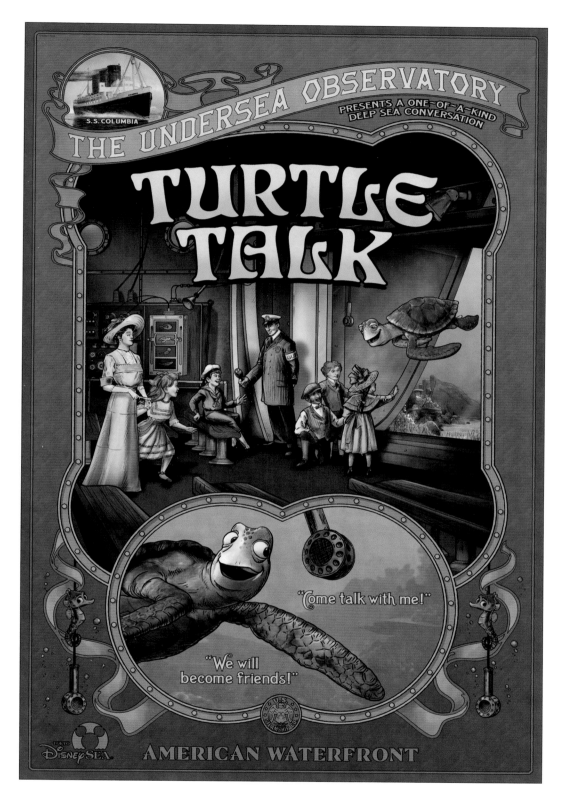

Turtle Talk, Tokyo DisneySea
Chuck Ballew and Will Eyerman, 2009

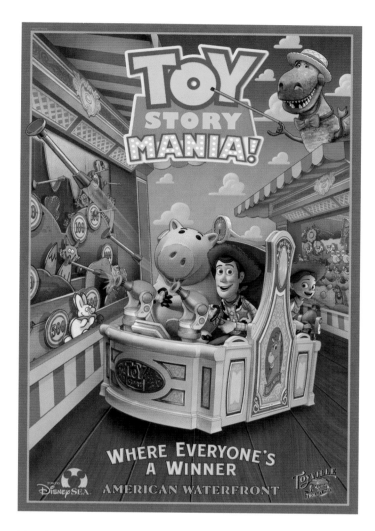

Toy Story Mania!, Tokyo DisneySea
Chuck Ballew and Will Eyerman, 2011

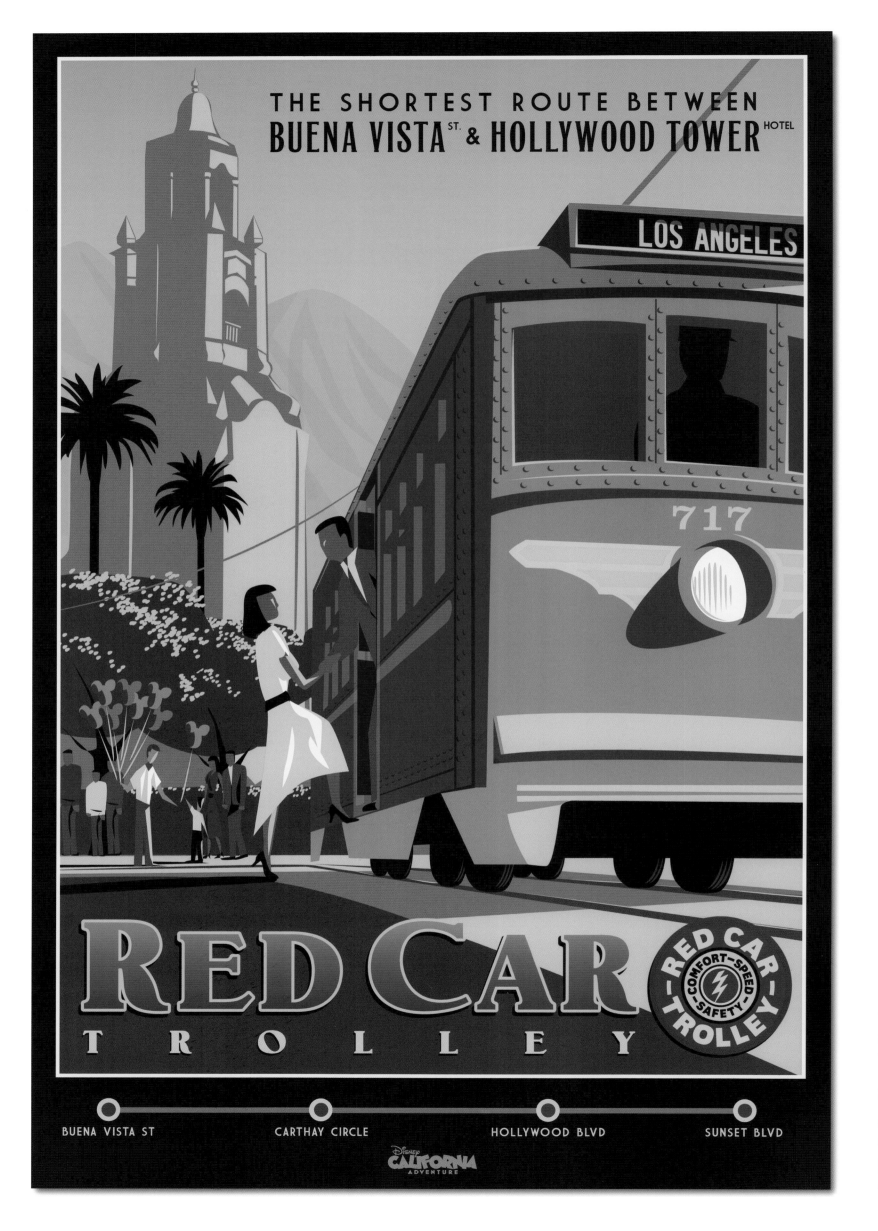

Red Car Trolley, *Disney California Adventure, developed by Greg Maletic, 2010*

"We always default to the great Walt Disney quote: 'Disneyland will never be completed. It will continue to grow as long as there is imagination left in the world.' Disney California Adventure, just like Disneyland and the other Disney Parks, will continue to develop and evolve with its audience, but at its core it's going to remain a place that inspires us to dream and then follow those dreams."
— Bob Weis, Walt Disney Imagineering executive vice president of Creative Development

The latest addition to the attraction poster gallery is a series of posters for the expansion of Disney California Adventure. Under the supervision of executive producer Kathy Mangum and art directors Ray Spencer (Buena Vista Street), Larry Nikolai (Paradise Pier), and Greg Wilzbach (Cars Land), the Disney California Adventure posters were created to capture the enhanced Disney magic of the Park. "We wanted to invigorate these new attractions with posters," says Spencer. "Posters provide identity to the Disney Parks." Nikolai adds, "Our goal was to create simple images for a quick read but capture the spirit and excitement of the new attractions, so we knew to turn to the classic screen printed posters as inspiration."

Graphics designer Greg Maletic, who illustrated several Opening Day posters for Hong Kong Disneyland, was approached to develop twelve Disney California Adventure posters for already existing attractions, as well as new Park additions: Red Car Trolley, The Twilight Zone™ Tower of Terror, Soarin' Over California, Grizzly River Run, The Little Mermaid ~ Ariel's Undersea Adventure, Goofy's Sky School, Mickey's Fun Wheel, Silly Symphony Swings, California Screamin', Radiator Springs Racers, Mater's Junkyard Jamboree, and Luigi's Flying Tires.

Since each land represented a different decade in California's history, Maletic looked to graphics and posters of the periods as inspiration for the designs. "We knew where we were going with Grizzly River Run right from the start. It was going to be inspired by 1930s-era National Park Service posters, which had a very distinct silk-screened style and limited palette of four or five colors," says Maletic. "With Goofy's Sky School, the obvious stylistic choice seemed to be making it like movie

posters of the Goofy animated shorts from the 1940s. The Cars Land posters were straight 1950s-era styling—very primitive, very simple," Maletic adds.

With these posters decorating the entrance to Buena Vista Street, Disney California Adventure becomes the second Disney Park that isn't a Magic Kingdom to have an attraction poster collection. And with new resorts, parks, and attractions constantly in development at Walt Disney Imagineering, attraction posters will never be far behind.

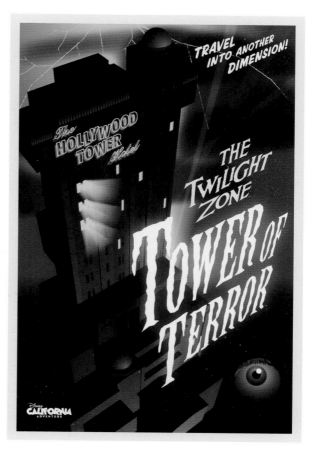

The Twilight Zone™ Tower of Terror, Disney California Adventure
Developed by Greg Maletic, 2010

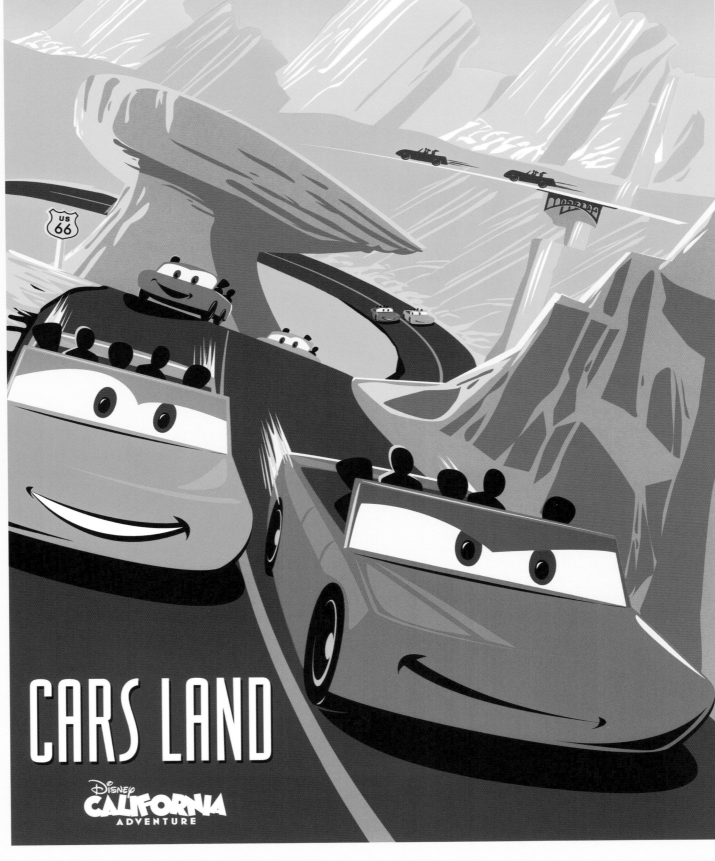

Radiator Springs Racers, Disney California Adventure, *developed by Greg Maletic, 2010*

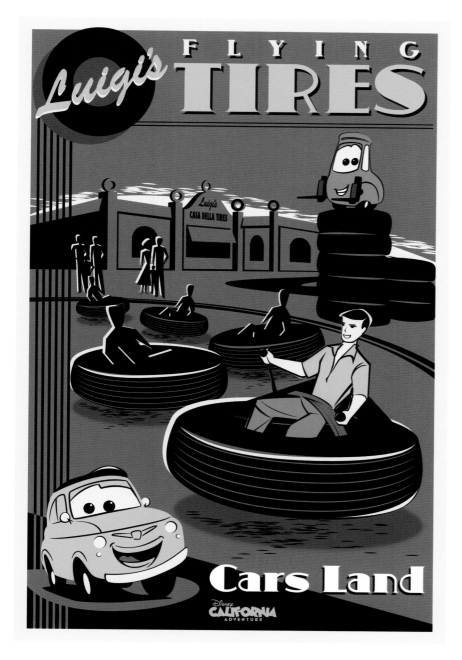

Luigi's Flying Tires, Disney California Adventure
Developed by Greg Maletic, 2010

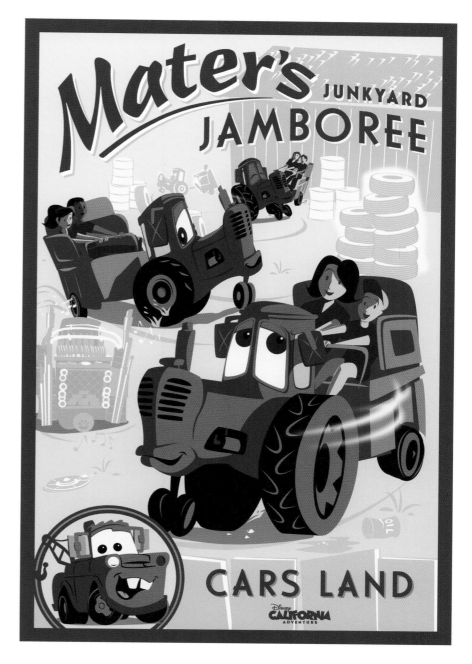

Mater's Junkyard Jamboree, Disney California Adventure
Developed by Greg Maletic, 2010

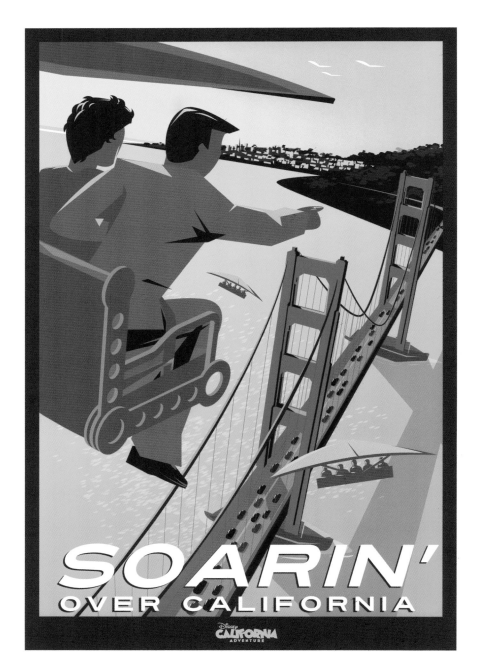

Soarin' Over California, Disney California Adventure
Developed by Greg Maletic, 2010

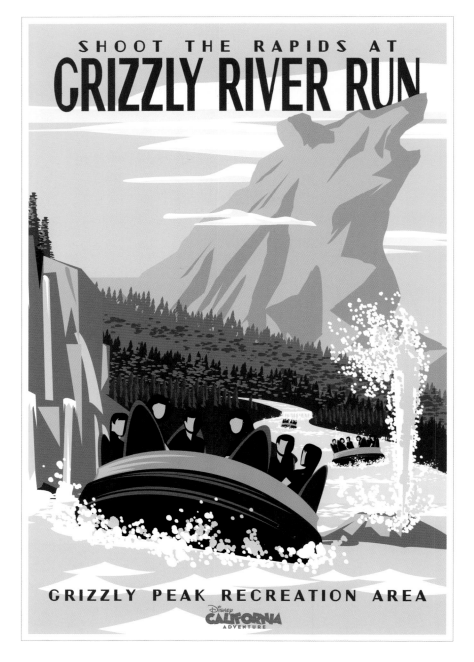

Grizzly River Run, Disney California Adventure
Developed by Greg Maletic, 2010

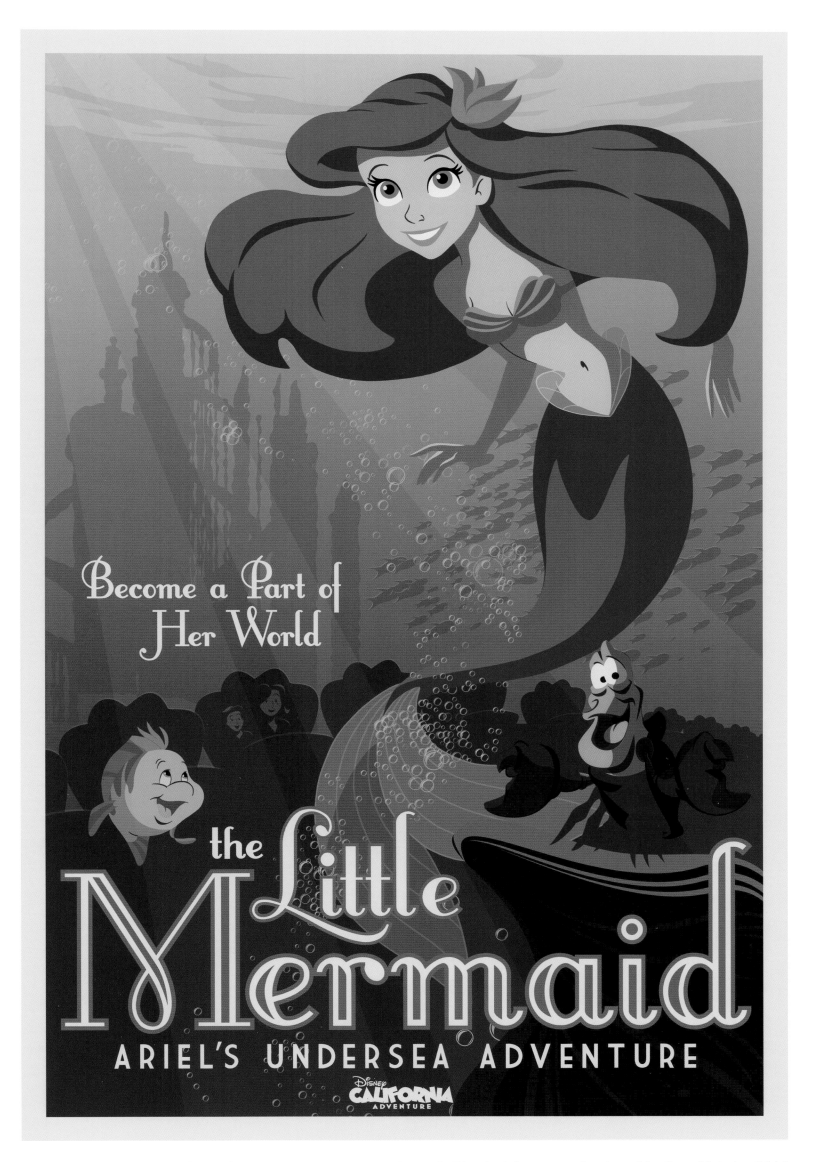

The Little Mermaid ~ Ariel's Undersea Adventure, Disney California Adventure, *developed by Greg Maletic, 2010*

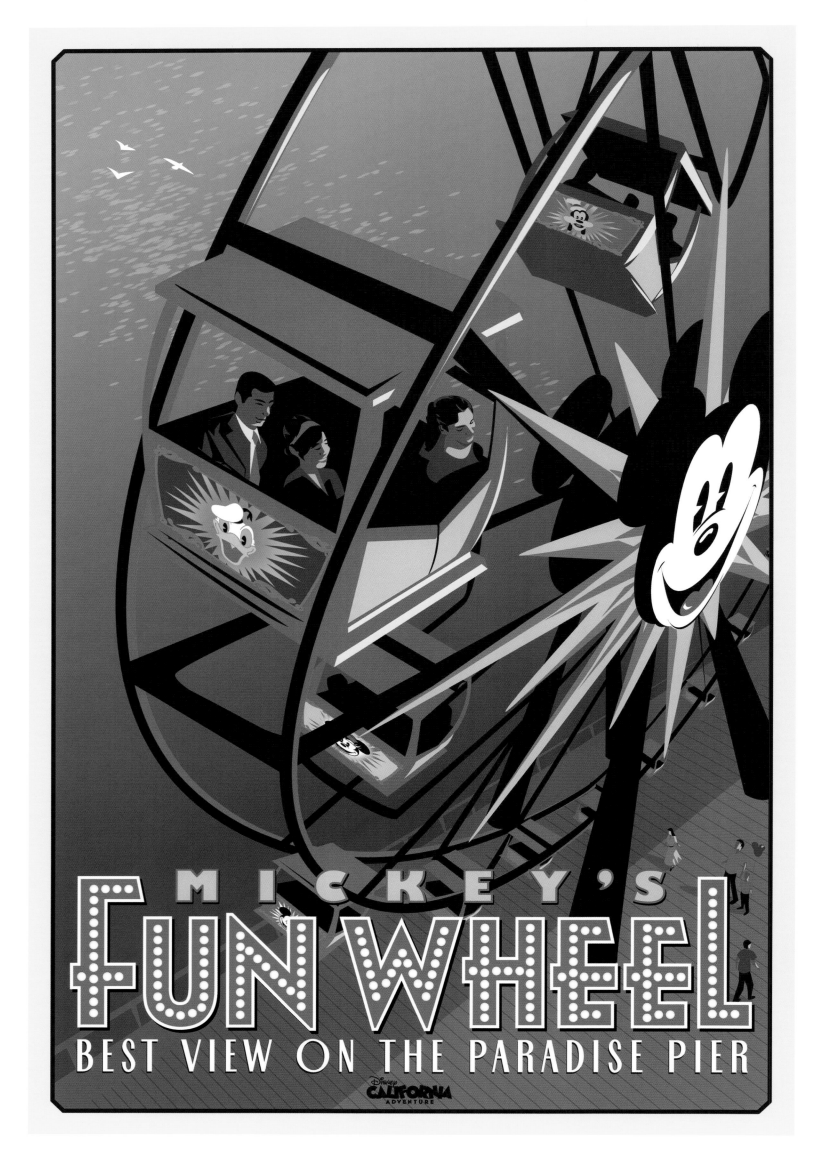

Mickey's Fun Wheel, Disney California Adventure, *developed by Greg Maletic, 2010*

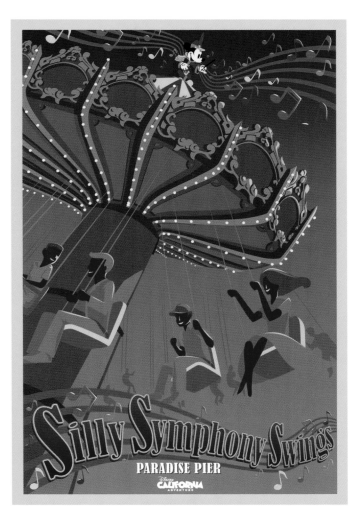

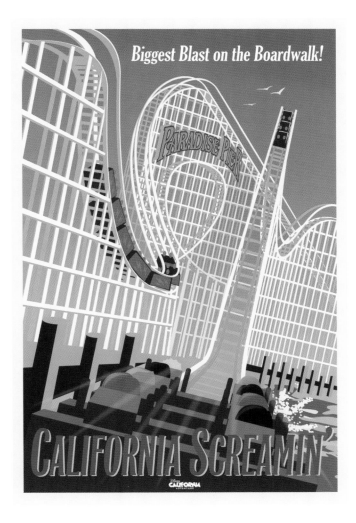

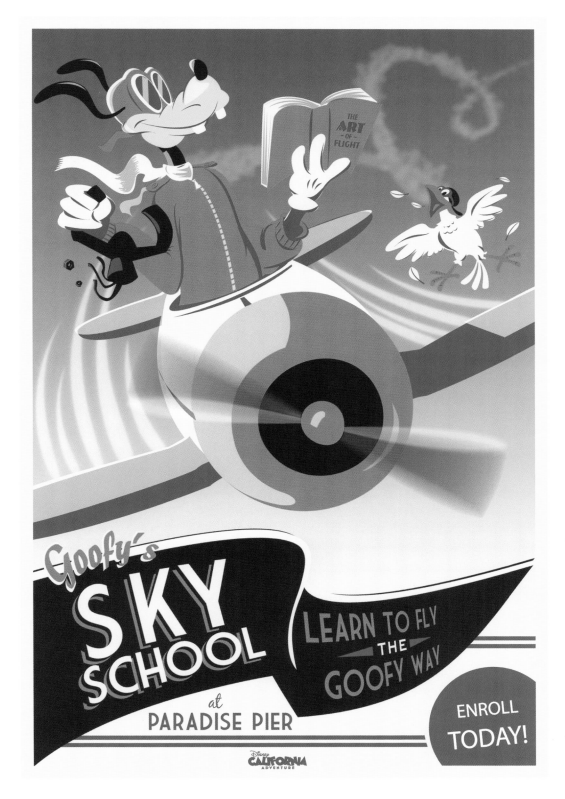

Goofy's Sky School, Disney California Adventure
Developed by Greg Maletic, 2010

Top: Silly Symphony Swings, Disney California Adventure
Developed by Greg Maletic, 2010

California Screamin', Disney California Adventure
Developed by Greg Maletic, 2010

Armitage, Nicole. Personal interview. 28 January 2010.

Baxter, Tony. Personal interview. 6 April 2010.

--- and Drew Struzan. Personal interview. 19 April 2010.

Brown, Denise, and Mike Jusko. Personal interview. 26 January 2010.

Cozart, Mike. "Disney Park Attraction Posters: A Historical Graphic Review of These Exciting
 Works of Art." Available at: http://www.attractionposter.blogspot.com. 22 March 2010.

---. Personal interview. 16 November 2010.

Crump, Rolly. Phone interview. 23 March 2010.

D23: The Official Disney Fan Club. "Inside DCA's World of Color." Available at http://d23.
 disney.com/index. 26 December 2010.

Delaney, Tim, and Marty Sklar. Personal interview. 6 April 2010.

Drury, John. Phone interview. 7 April 2010.

Eggleston, Ralph. Internet interview. 7 April 2010.

Eyerman, Will. Personal interview. 7 December 2009.

---. Personal interview. 28 January 2010.

Horn, George F. *Posters: Designing, Making, Reproducing.* (Worcester, MA: Davis Publications, Inc., 1969).

Imagineers, The. *Walt Disney Imagineering: A Behind the Dreams Look at Making the Magic Real.* (New
 York: Hyperion, 1997).

Janzen, Jack, and Leon Janzen. "Silk-Screen Signage: Disneyland Ride Posters." *The "E" Ticket.*
 Spring 1999, pp. 16–21.

Lelevier, Leticia. Personal interview. 4 May 2010.

Lord, Debbie, and Rudy Lord. Personal interview. 20 April 2010.

Maletic, Greg. Internet interview. 24 March 2010.

---. Internet interview. 25 October 2010.

Mangum, Kathy, Larry Nikolai, and Ray Spencer. Personal interview. 16 November 2010.

Michaelson, Jim. Phone interview. 30 April 2010.

Nikolai, Larry. Personal interview. 2 February 2010.

Paul, Greg. Personal interview. 16 February 2010.

Sotto, Eddie. Personal interview. 27 April 2010.

Acknowledgements

First and foremost we must give our eternal thanks to Jeff Kurtti, whose influence and guidance made this book happen. No words can express how much we appreciate your support—and your uncanny sense of humor too!

Tony Baxter—your passion and love for Disneyland is contagious and your enthusiasm for these posters is admirable. Thank you for writing such an amazing introduction.

Wendy Lefkon, Jessica Ward, Nancy Inteli, Hannah Buchsbaum, Jennifer Eastwood, Scott Piehl, and the incredible team at Disney Editions—thank you for giving us the opportunity to share the story of attraction posters with the world.

Special thanks to the wonderful staff at the Walt Disney Imagineering Information Resource Center for helping us research, and for gathering art and photos—Denise Brown, Mike Jusko, Vivian Procopio, Diane Scoglio, Charles Leatherberry, Aileen Kutaka, Dave Stern, and Lisa Nakamura. And a wholehearted thanks to Jess Allen and Don Saban for their diligent work photographing the art. We will never forget that fateful day when we found that box of uncataloged poster comps in the Art Library vault!

To the Imagineers, Cast Members, artists, and fans who supported this book and helped make it happen—Jed Blaugrund, John Breckow, Collin Campbell, Steve Cargile, Brandon Clark, Mike Cozart, Chris Crump, John Drury, Will Eyerman, Dave Fisher, Tom Fitzgerald, Greg Gujda, Patrick Jenkins, Tamara Khalaf, John Lasseter, Glendon Lee, Tory Lucking-Webb, Greg Maletic, Matt McKim, Chris Merritt, Jim and Jeannine Michaelson, Larry Nikolai, Greg Paul, Frank Reifsnyder, Krista Sheffler, Josh Shipley, Dave Smith, Drew Struzan, Robert Tieman, Scott Tilley, and Staci Yoshiwara.

Most of all, we would like to dedicate this book to all the Imagineers who design these amazing attraction posters and inspire the imaginations of the millions of Guests who visit our Disney Parks around the world. Let's celebrate the past and continue the tradition well into the future!

Danny would like to personally thank Cameron Colletti for her inspiration, love, and support for all aspects of his life; to his family, Don, Sue, and Jeff Handke, for their continuous support and enthusiasm for all things Disney; and to his mentor Scott Hennesy, who encouraged him to write in the first place.

Vanessa would like to personally thank her family, Larry, Patti, and David Hunt, for always supporting her and her dream to work for Disney; to Brandon Kleyla for his support, love, and assisting with interviews; and to her grandpa, for always asking how the book was coming along, which encouraged her to keep going.

141

Index by Artist

Index by Attraction

"The posters from Disneyland had such a huge impact on me as a kid; I can't imagine Disneyland without them. Seeing them as you entered the Park—coming in through the outside gates, going into Main Street through the tunnel underneath the railroad tracks—built this tremendous sense of anticipation. You couldn't wait to get in that Park and ride those rides.

As I grew older I recognized how beautifully designed they were. The Rocket to the Moon in Tomorrowland; the Railroad in Frontierland; the Matterhorn Bobsleds in Fantasyland . . . the ride posters are all so different, but each one is a work of graphic art that's been perfectly tailored to the attraction and to the land it appears in."

—John Lasseter, Walt Disney and Pixar Animation Studios chief creative officer and Walt Disney Imagineering principal creative advisor

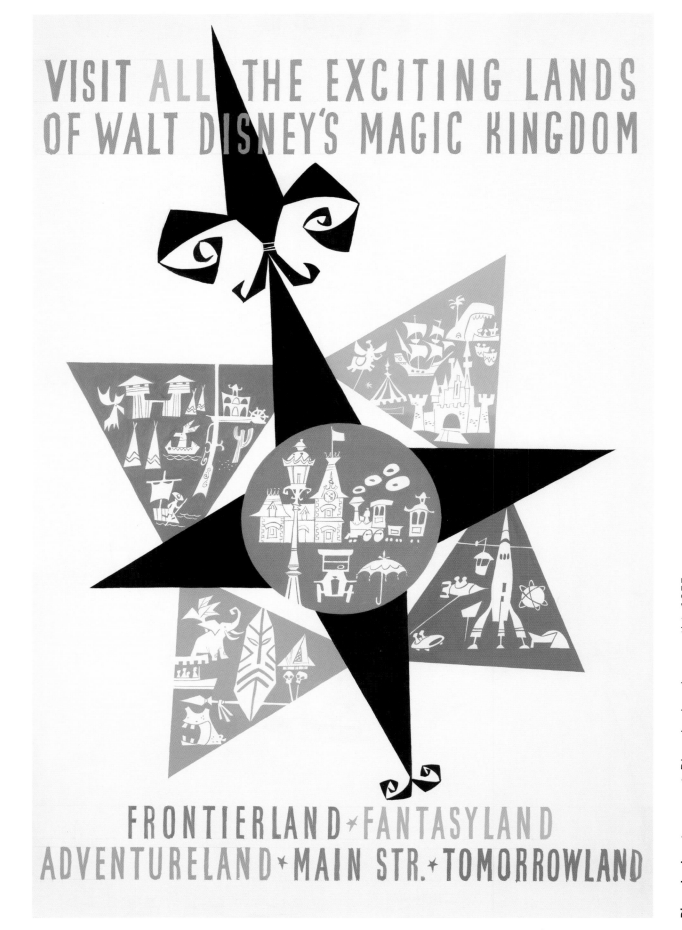

Disneyland poster concept, Disneyland, *unknown artist, 1955*

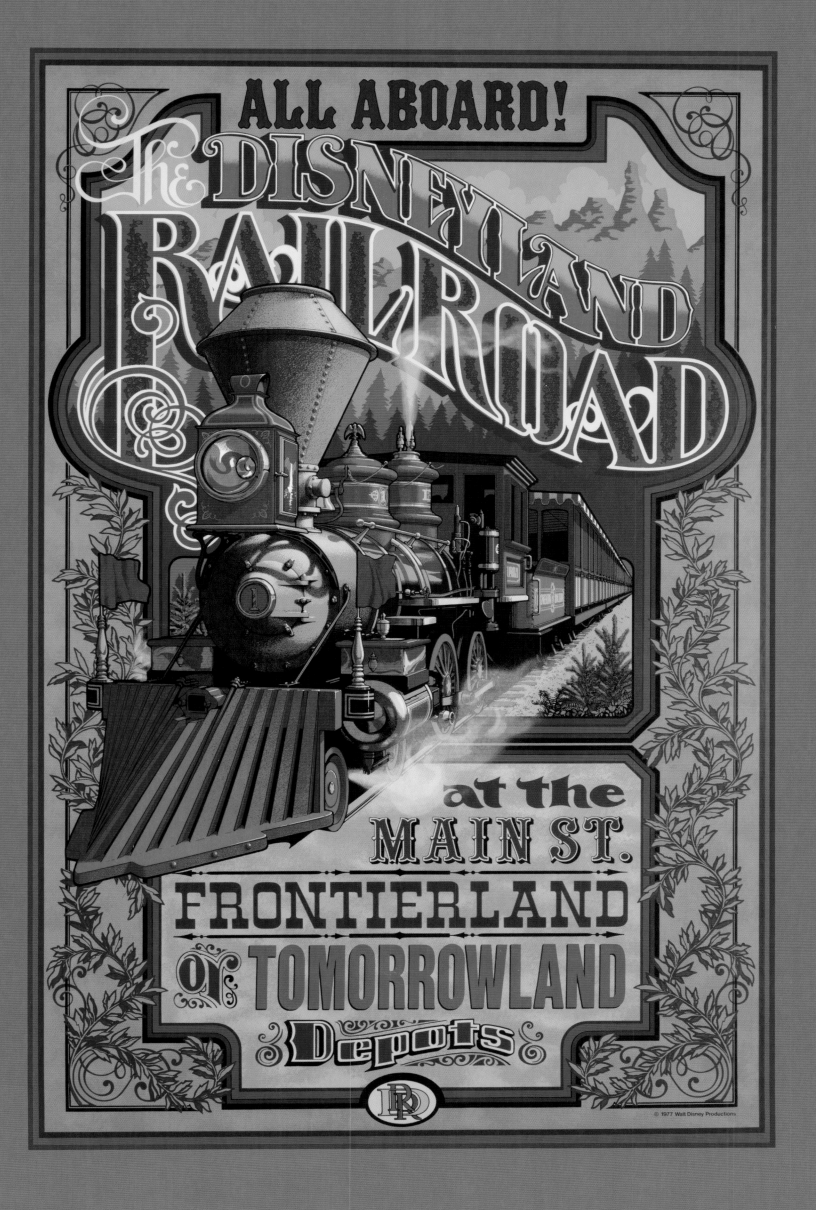